TRAIN STATIONS

THEN AND NOW®

ACKNOWLEDGMENTS

WRITING CREDITS

Frank Hopkinson, pages 6-9, 16-17, 54-55, 72-73, 82-85, 92-93, 112-115, 122-125, 142-143. Michael Rose, pages 10-15. Alexander D. Mitchell IV, pages 18-25, 138-141. Todd Keith, pages 26-27. Patrick Kennedy, pages 28-29. W. Chris Phelps, pages 30-31. Brandon Lunsford, pages 32-33. Kathleen Maguire, pages 34-35, 40-41. Tom O'Gorman, pages 36-39. Kathy Mast Kane and Doreen Uhas Sauer, pages 42-45. Ken Fitzgerald, pages 46-47. Jeffrey Steene, pages 48-51. Cheri Gay, pages 52-53. William Dylan Powell, pages 56-59. Nelson Price, pages 60-61. Darlene Isaacson, pages 62-63. Su Kim Chung, pages 64-67. Dennis Evanosky and Eric J. Kos, pages 68-71. Russell Johnson pages, 74-75. Sandra Ackerman, pages 76-79. Hanje Richards, pages 80-81. Karina McDaniel, pages 86-87. P. David Veasey, pages 88-91. Marcia Reiss, pages 94-99. Doris I. Walker, pages 100-101. Stephen Evans, pages 102-103. Edward Arthur Mauger, pages 104-107. John H. Akers, pages 108-109. Pittsburgh History and Landmarks Foundation, pages 110-111. Kirk Huffaker, pages 116-117. Paula Allen, pages 118-121. Polly Cooper and Ted Eldridge, pages 126-127. Ben Lukas, pages 128-131. Elizabeth McNulty, pages 132-133. Doug Taylor, pages 134-135. Francis Mansbridge, pages 136-137.

PICTURE CREDITS

The publisher wishes to thank the following for kindly supplying the photographs that appear in this book:

Then Photographs

All Then photographs supplied by the Library of Congress with the following exceptions: Arizona State University, page 108. Birmingham Public Library, pages 26, 27. Carolina Room, Charlotte Public Library, page 32. Columbus Metropolitan Library, pages 42, 45. Dallas Public Library, page 46. Detroit Public Library, page 52. Historical Society of Central Florida, page 102. Houston Metropolitan Research Center, pages 56, 59. Indiana Historical Society, page 60 (bottom). Maryland Historical Society, pages 18, 20, 22, 24. Milwaukee Historical Society, pages 78, 79, 81. Museum of History and Industry, Seattle, page 128. Newark Public Library, pages 88, 90. San Antonio Historical Society, page 118. Toronto Public Library, pages 134, 135. Western History Department of Denver Public Library, page 50.

Now photographs

Simon Clay, pages 9, 63, 73, 75, 81, 85, 101, 103, 117. Garry Chilluffo, page 61. Ken Fitzgerald, pages 47, 57, 59, 119, 121. Frank Hopkinson, pages 93, 125, 127. Theo Hopkinson, pages 139, 141. Karl Mondon, pages 19, 21, 23, 35, 35, 37, 39, 41, 53, 55, 69, 71, 77, 79, 111, 113, 129, 131, 133, 135, 137. Phil Mumford, pages 49, 51. Paul Scharbach, page 109. David Veasey, pages 29, 89, 91, 105, 107. Aubrey Watson, page 87. David Watts, pages 11, 13, 15, 17, 27, 31, 33,43, 45, 65, 67, 83, 115, 123. All copyright Pavilion Books.

Carol M. Highsmith, pages 55 (bottom), 63 (bottom), 87 (bottom).
Courtesy of the Library of Congress.

TRAIN STATIONS

THEN AND NOW®

EDITOR
KEN FITZGERALD

PAVILION

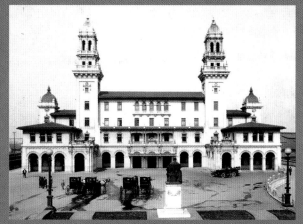

Atlanta, Terminal Station, c. 1912 p. 10

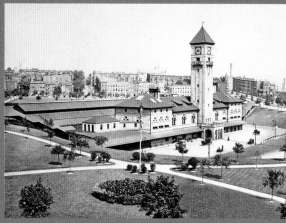

Baltimore, Mount Royal Station, c. 1910 p. 22

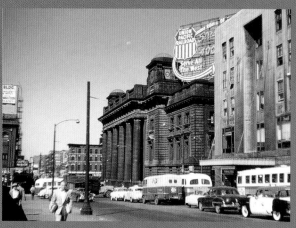

Chicago, Chicago and North Western Terminal, c. 1955 p. 34

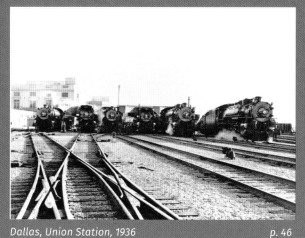

Dallas, Union Station, 1936 p. 46

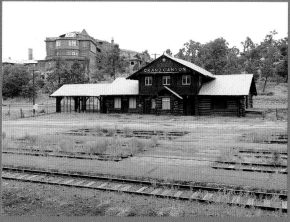

Grand Canyon Station, 1979 p. 54

Houston, Union Station, c. 1940 p. 58

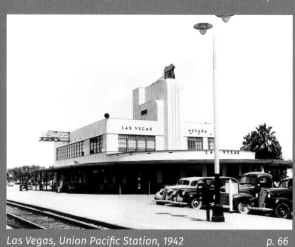

Las Vegas, Union Pacific Station, 1942 p. 66

Los Angeles, Union Station, 1947 p. 68

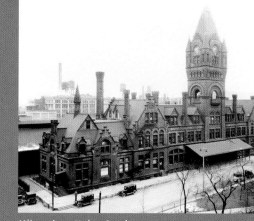

Milwaukee, Union Station, 1931 p. 78

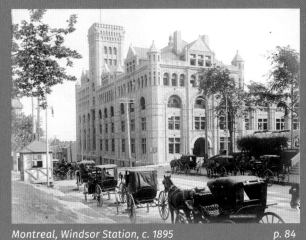

Montreal, Windsor Station, c. 1895 p. 84

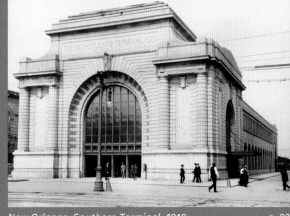

New Orleans, Southern Terminal, 1910 p. 92

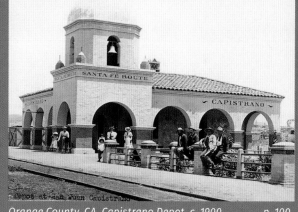

Orange County, CA, Capistrano Depot, c. 1900 p. 100

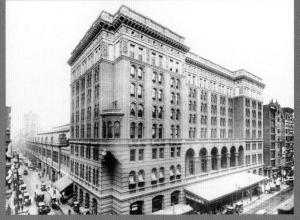

Philadelphia, Reading Terminal, c. 1912 p. 106

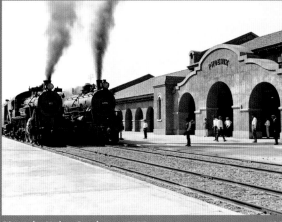

Phoenix, Union Station, c. 1926 p. 108

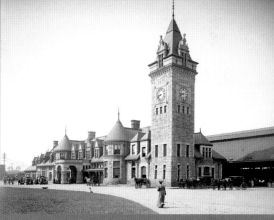

Portland, ME, Union Station, c. 1904 p. 114

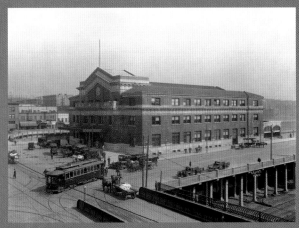

Seattle, Union Station, 1911 p. 130

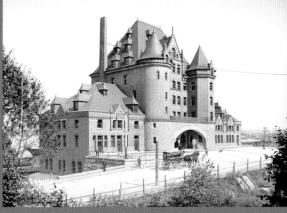

Vancouver, Canadian Pacific Station, c. 1902 p. 136

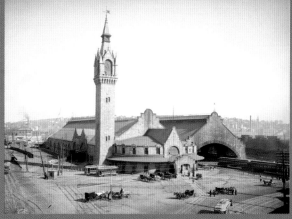

Worcester, MA, Union Station, c. 1906 p. 142

TRAIN STATIONS

THEN AND NOW INTRODUCTION

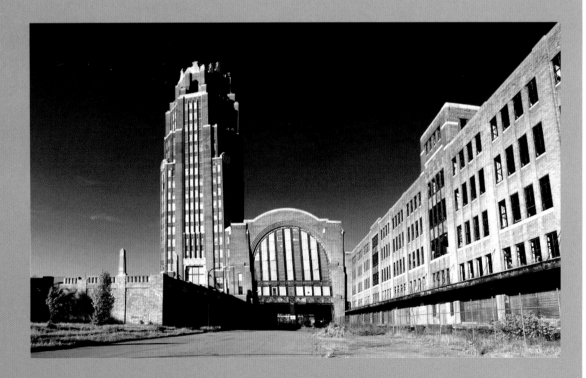

In 1829 the Stourbridge Lion was the first locomotive to run on rails in the United States in common carrier service. It was operated by the Delaware and Hudson Canal Company in northeastern Pennsylvania hauling coal in addition to passengers. The rapid expansion of the railroad network across North America in the nineteenth century made the previous arterial routes of river and canal redundant and pitched railroad barons against each other as they battled to extend their empires.

Much of the early network was funded by freight haulage as farmers and industrialists moved their products to market, but passenger traffic increased too, aided by the consolidation of railroad companies and the introduction of union stations which serviced a number of different railroad lines. The first of its kind was the 1853 Indianapolis Union station which allowed the Baltimore & Ohio, the New York Central, the Pennsylvania Railroad and the Illinois Central to share one point of arrival and departure.

After the hiatus of the Civil War the headlong dash to complete the transcontinental railroad in 1869 re-energized rail travel and the profits made by the railroad companies allowed them to invest in grand stations to impress their growing clientele. The financial panic of 1893, caused in part by the over-investment in railroad stocks, may have put a temporary brake on plans but it didn't stop the building of the great transport cathedrals.

At first the depots were purely functional, ticket offices and waiting rooms thrown up next to a shed and some platforms. But in the second half of the nineteenth century a whole wave of buildings styles were employed to create stations that would surpass anything Europe had to offer. Some

architects chose the Gothic Revival style (Milwaukee), others the Italianate style (Seattle) and some the Renaissance Revival style (Minneapolis). As the century progressed, so train stations reflected the architectural trends of the day. Gothic Revival gave way to the rough-hewn stone exterior of Richardsonian Romanesque (Nashville) or a style attributed to the *Académie des Beaux-Arts* in Paris (Newark). These in turn were viewed as outdated and replaced by simpler Art Deco designs (Las Vegas) or a return to neoclassical columns typified by the government buildings in Washington, D.C.

Then there were the local quirks. The Santa Fe evoked the early Spanish missions of California with their Mission Revival style (Capistrano) of domes and adobe walls, while the Grand Canyon railroad built the biggest depot made of logs for their terminus at the South Rim. One of the least copied styles was that used for the Toledo and Ohio depot in Columbus, Ohio, which had pagoda-like roofs and was dubbed "Shinto Gothic."

This book is a celebration of the incredible diversity of passenger stations erected throughout the United States and Canada. Their fates, as you will find out, have been many and various. William Tecumseh Sherman was perhaps the first to start removing them before they had fulfilled a useful lifespan when he pulled down the Atlanta depot in 1864. Others were razed to be replaced by bigger and better structures as the rail networks expanded up to their heyday in the 1920s.

While many other grand Victorian buildings, such as hotels and courthouses, have suffered the indignity of being turned into parking lots, the siting of passenger depots in high-rent downtown locations has often meant their replacement with "prestige" buildings. No greater example of this can be found than the late, lamented Pennsylvania Station in New York which gave way to Madison Square Gardens and created a wave of outrage from the preservationists. On a smaller scale, the removal of the old pink granite Union Station tower in Portland, Maine, in 1961 generated a local conservation movement eager to keep hold of the city's landmark buildings.

Architectural reputation is no safeguard to a building's future. In New Orleans the city was graced with the Southern Railway Terminal, designed by the man responsible for the 1893 Chicago Exposition, Daniel Burnham, and the Union Station, designed by Louis H. Sullivan assisted by Frank Lloyd Wright. Both disappeared in the space of three years from 1954, the Southern replaced by an arterial road, and the Union by a more modern, functional structure.

But these are the losses. While some of the larger stations live on (Chicago Union, Los Angeles Union), serving their intended purpose, many have found new uses. The 1896 B&O Mount Royal Station in Baltimore now hosts the Maryland Institute College of Art, while the Savannah College of Art and Design has taken over significant Central of Georgia railroad buildings in Savannah, Georgia. Just up the road, the Central of Georgia passenger station is now a visitor center and museum.

Many have profited from their central location and become hotels, others apartment buildings. The Canadian Pacific railroad built grand stations in Montreal and Vancouver that combined rail terminals with luxurious hotels and Montreal's Station Viger will soon be converted to offices and apartments. In the United States, the Union Station in Nashville and the Milwaukee Road depot have been transformed into upscale hotels.

Since the early 1990s there has been a scaling back of diesel-powered buses and a resurgence in the greener technologies of light rail and trolleys and some of the stations have been repurposed as transit centers. In Albuquerque the Santa Fe had demolished the old Alvarado Hotel, but it has been rebuilt as a transport hub in the style of its predecessor. Stations can emerge from mothballs. The Grand Canyon station was closed in 1968, but re-opened in 1989 and trains now take tourists along the 63-mile track from Williams, Arizona, up to the South Rim.

In these 144 pages we have touched on some of the most distinctive stations built in North America, yet there are many more that could have been included. It is a credit to the conservationists and planners that we have so many to choose from and the buildings that remain are a tremendous legacy to future generations of a time when railroads were king.

OPPOSITE: At the time of writing, the magnificent Buffalo Central Terminal of 1929, with its 17-story Art Deco tower, awaits its fate.

ALBUQUERQUE | ALVARADO HOTEL AND STATION

The Santa Fe demolished this much-admired city icon

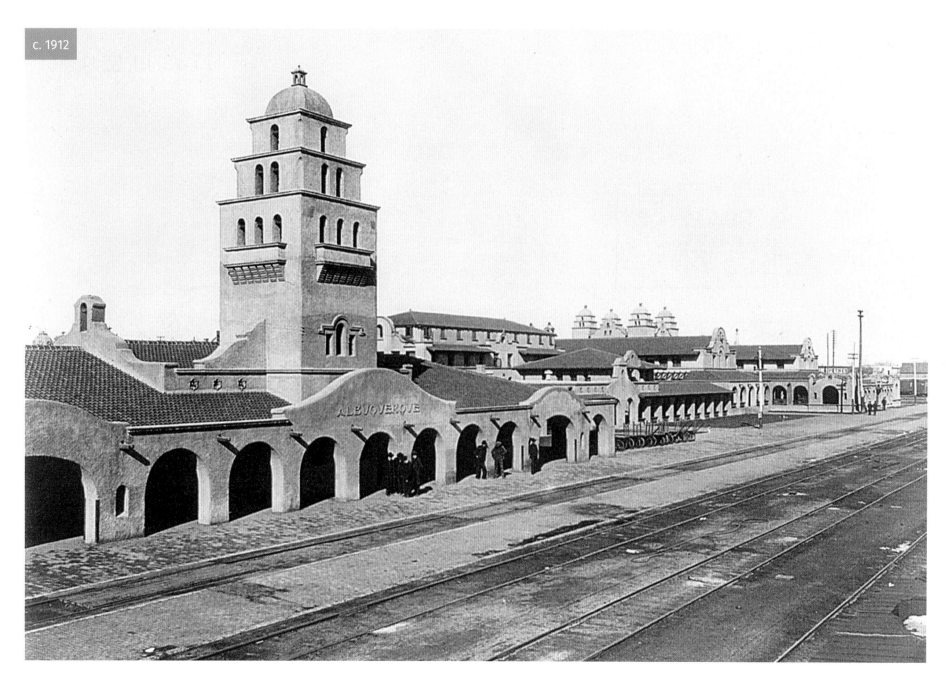

LEFT: The Atchison, Topeka and Santa Fe Railroad arrived at Albuquerque in 1880. Refusing to pay the high land prices demanded downtown it bypassed the existing Plaza, siting the passenger depot and railyards two miles east. New Albuquerque or New Town grew up around it, thus creating a shift in the development of the town. In response to growing demand the Mission Revival style Alvarado Hotel and Station complex was built in 1902 as part of the Harvey House chain across the Southwest. The Harvey Curio Museum and its Native American arts shop linked the station to the hotel via a long, arched arcade which ran parallel to the tracks. The hotel had been named for Hernando de Alvarado of the 1540 Francisco Vásquez de Coronado expedition.

BELOW: As rail travel tailed off in the mid-twentieth century the Alvarado Hotel fell on hard times, failed to be upgraded and was demolished by the Santa Fe railroad in 1970. The site of the former graceful hotel was turned into a parking lot for the station. The demolition of this important Mission Revival building sparked outrage and a preservation drive in the city. When the remaining passenger station burned down in 1993 there was an opportunity to reinvent the past. The Alvarado Transportation Center opened in 2002. Designed by local architects Dekker Perich Sabatini, it was a reinterpretation of the old Mission Revival building. Today it links rail services with a Greyhound depot and local rapid transport routes. Pictured is the New Mexico Rail Runner Express which started in 2006.

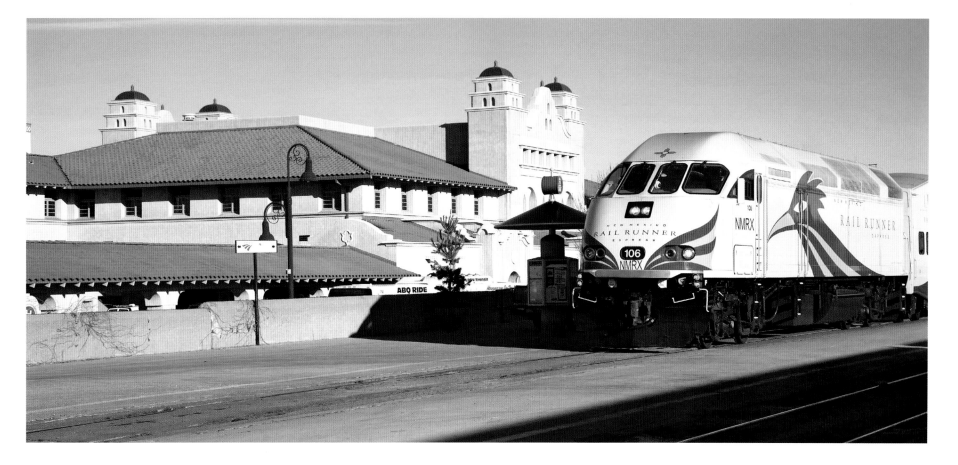

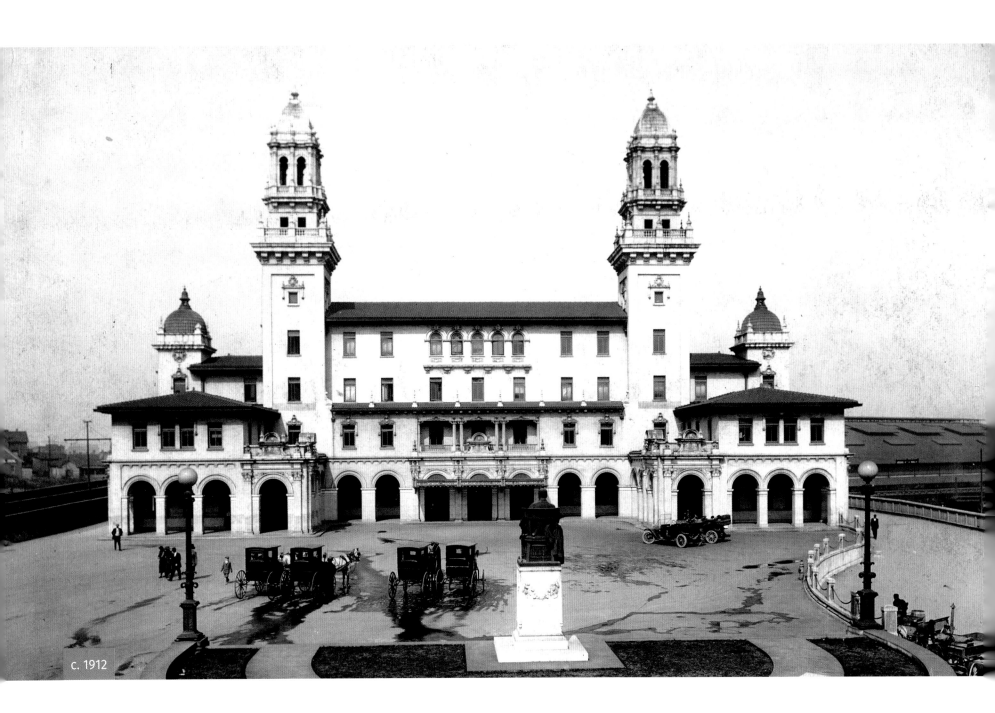

c. 1912

ATLANTA | TERMINAL STATION
The gateway station to the South

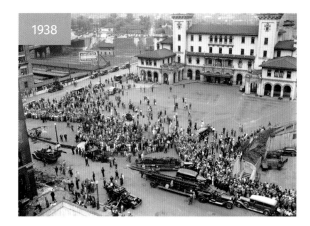

1938

ABOVE: A crowd of people gather in the plaza of Terminal Station on May 16, 1938, the morning after a fire swept the adjacent Terminal Hotel. Twenty-seven people were confirmed to have perished in the disaster.

LEFT: Opening in 1905, Atlanta's Terminal Station was one of two main railroad terminals in downtown Atlanta, along with Union Station. Constructed of reinforced concrete, it was a fanciful gateway designed by P. Thornton Marye, the architect of the equally elaborate Fox Theatre. Completed at a time when the city's railways were its all-important commercial transportation lines, Terminal Station was served by 160 trains per day during its heyday. In the second half of the twentieth century, the station became the victim of automobiles and air travel and was demolished in 1972.

RIGHT: Replacing the rail station at Spring and Mitchell Streets, the Richard B. Russell Federal Building & U.S. Courthouse is named for former Georgia congressman, governor, and senator Richard B. Russell. Begun in 1978, the construction of the building was plagued by delays and cost increases, and technical problems continued for several years after construction was completed. Opening in 1980, the facility consolidated a number of federal court and government agencies that had been scattered throughout the city. Among the original tenants were the General Services Administration, the Department of Justice, Immigration and Naturalization Service, and the Bureau of Prisons.

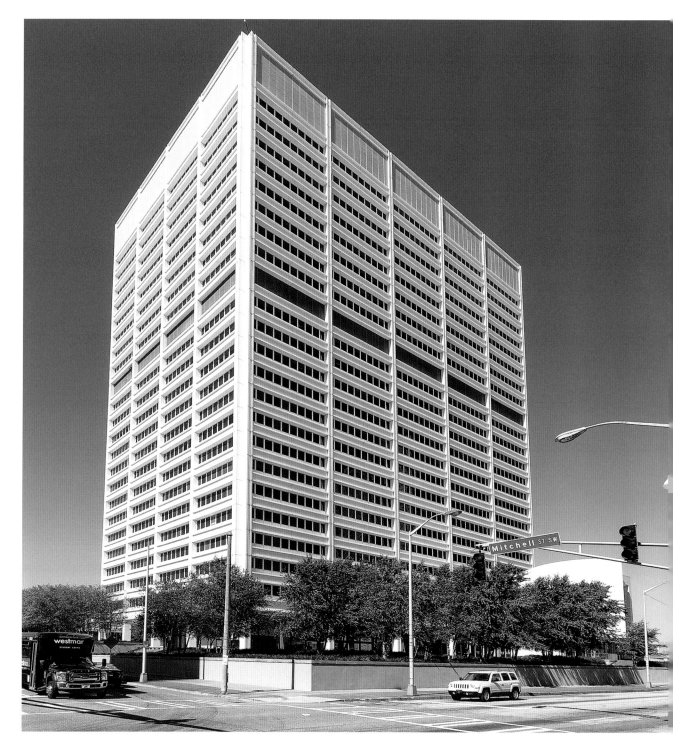

ATLANTA | TRAIN GULCH

The birthplace of Atlanta—the "Sewer of Smoke"

BELOW: Looking from the Whitehall (Peachtree) Street viaduct in 1914, this scene portrays the very heart and soul of the city: the smoky, noisy train gulch. With commerce based on trade and transportation, Atlanta's existence was tied to the rail lines on which it was founded. Yet the same lines were difficult and dangerous to cross, leading to the development of the raised viaduct system. The nearby hotels—literally overlooking the tracks—were convenient for travelers but could not have avoided the noise, commotion, and smell of the depot and rail lines.

RIGHT: Atlanta's Union Station depot—built in 1871 following the destruction of the Civil War—was designed by Atlanta architect Max Corput. It was located at original ground level at what is now Wall Street between Pryor Street and Central Avenue.

FAR RIGHT: The city's first railroad station, the General Passenger Depot, was designed by Edward Arista Vincent and completed in 1853. The massive depot—300 feet long and 100 feet wide—was battered down by Union troops in November 1864 before the March to the Sea.

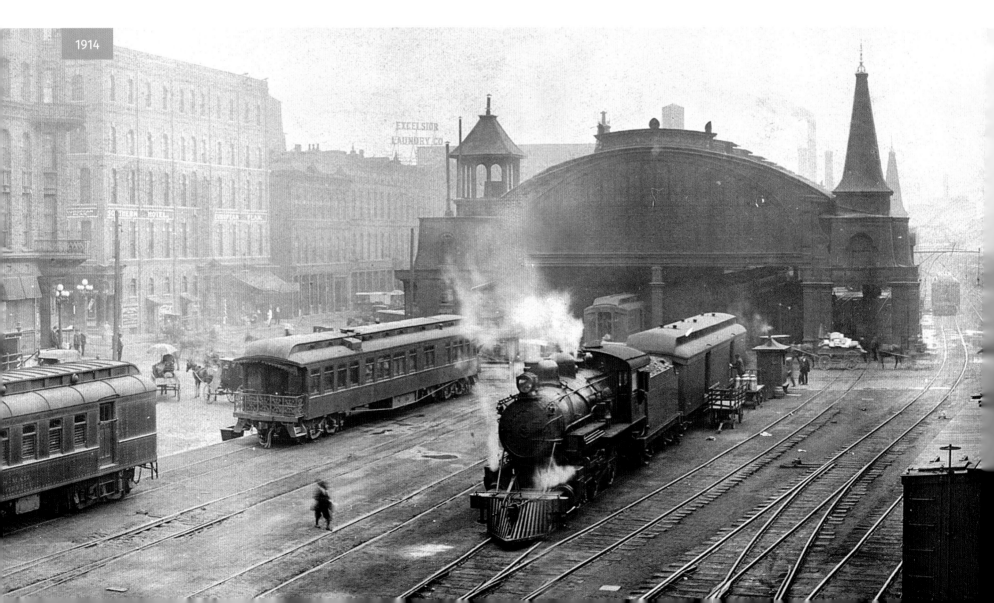

1914

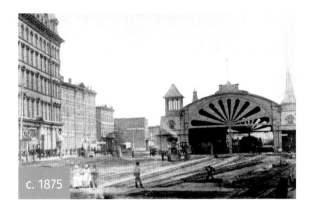

c. 1875

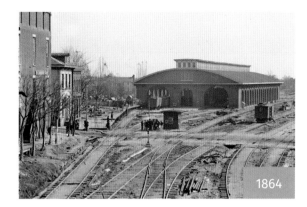

1864

BELOW: A sign at right proclaims the location of Underground Atlanta, situated along the rail lines that founded Atlanta. The site of the old depot, now a parking lot, is to the left of the MARTA lines seen at center. The gilded dome of the Georgia state capitol appears above the Underground building, home of the area's Visitor Information Center. The sculpture atop the building, *Birth of Atlanta*, was designed by the architectural firm of Lord Aeck Sargent: it represents the city's symbol, the phoenix, and commemorates the founding of Atlanta in 1837.

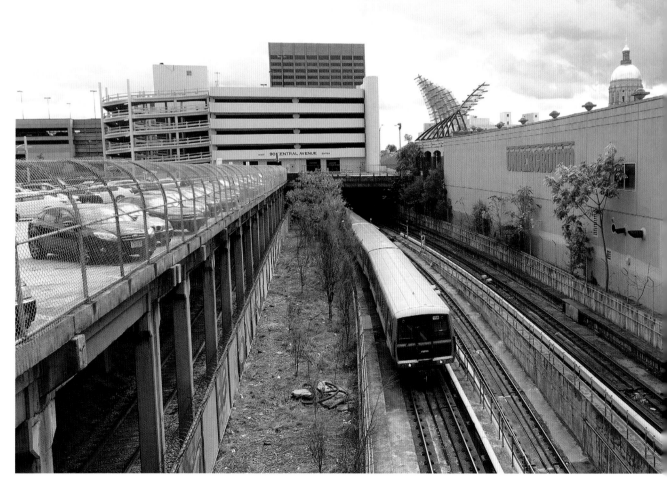

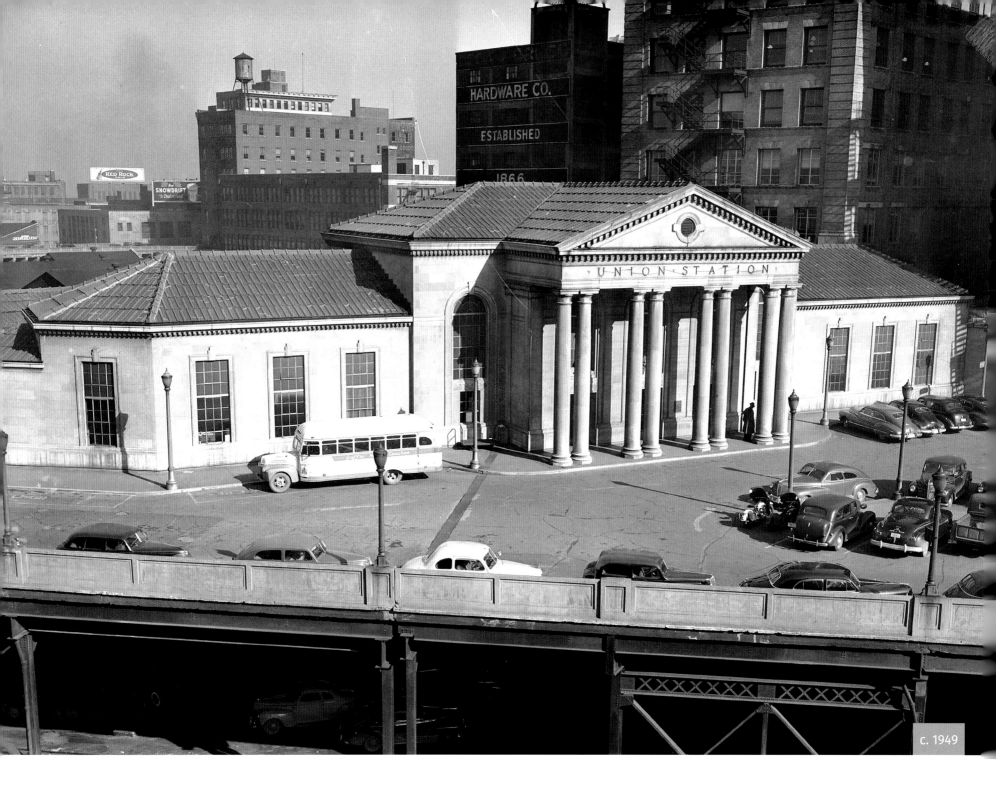

c. 1949

ATLANTA | UNION STATION
The last of Atlanta's great downtown stations disappeared in 1971

LEFT, RIGHT AND BELOW: Built in 1930 atop the Forsyth Street viaduct, Union Station was the last of Atlanta's four rail depots to be constructed. The Kimball House Hotel (pictured right with the corner turret), built in 1885, was once considered the South's premier hotel, featuring a seven-story atrium and an architectural style considered a combination of "Old Dutch, the Renaissance, and the Queen Anne." In the distance of this photo can be seen the classical portico of Union Station, where a huge Atlanta crowd greeted golfer Bobby Jones in 1930 when he returned from his victories in the U.S. Amateur, U.S. Open, British Amateur, and (British) Open Championship.

BELOW RIGHT: With the Kimball House demolition in 1959 and that of Union Station in 1971, the remnants of Atlanta's origins as a rail center disappeared from downtown. Instead, where rail lines and depots had once defined Atlanta, expanses and layers of automobile parking surfaces literally cover old Atlanta. As the railroads diminished, Atlanta's airport grew, and following World War II the national highway system established the city as a freeway hub linked through three major interstate highways.

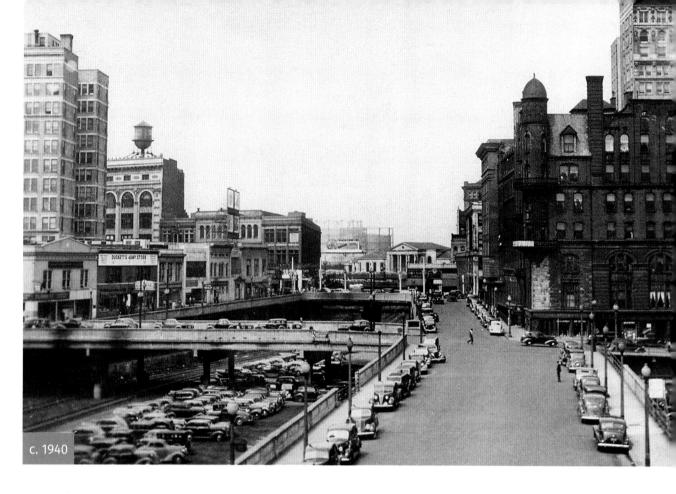

c. 1940

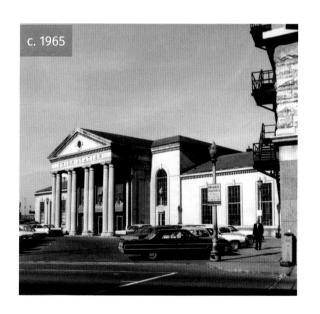

c. 1965

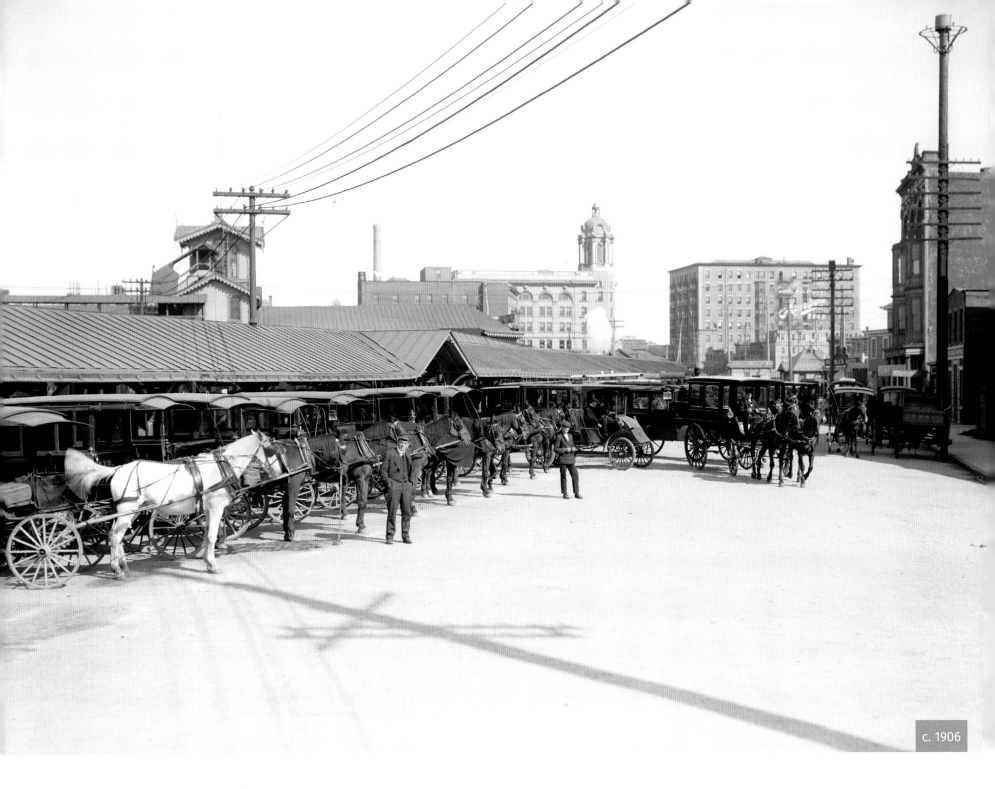

c. 1906

ATLANTIC CITY | READING RAILROAD DEPOT
Welcoming tourists to the premier resort of the early twentieth century

1910

LEFT AND ABOVE: Atlantic City may be located on a sandy spit of land deposited there by the stormy Atlantic, but the great resort superimposed on its dunes was a creation of the railroad companies. On July 1, 1854, the first 600 tourists traveled by rail to Atlantic City from Philadelphia. Actually, they embarked in Camden and stopped at the marshlands near Absecon Island, where they were rowed across to Atlantic City. No bridge had yet been built to connect the new city to the mainland. The Camden and Atlantic Railroad monopolized rail travel to the resort until a competing line opened for business in July 1877. Its new terminal at Arkansas and Atlantic avenues was fabricated from sections of a station erected for Philadelphia's 1876 Centennial Exhibition. After the fair closed, the building was disassembled and carted to Atlantic City. This terminal for the Philadelphia and Reading Railway Company would eventually become the Reading Railroad of Monopoly fame. By 1925, 99 trains a day were arriving in Atlantic City.

ABOVE: During the Great Depression the two rival rail companies were forced to merge, forming the Pennsylvania-Reading Seashore Lines: the nineteenth-century stations were demolished and a new Union Station was built in 1934. The Atlantic City block originally designated for the wheels of the Reading Railroad is now called "the Walk," a three-block cluster of a hundred discount name-brand stores. The 1934 station at Arctic and Arkansas was torn down in 2001. Today convention visitors are a major source of income, as the daytrippers were of old, so it is appropriate that Atlantic City is served by a three-platform terminal located inside the Atlantic City Convention Center.

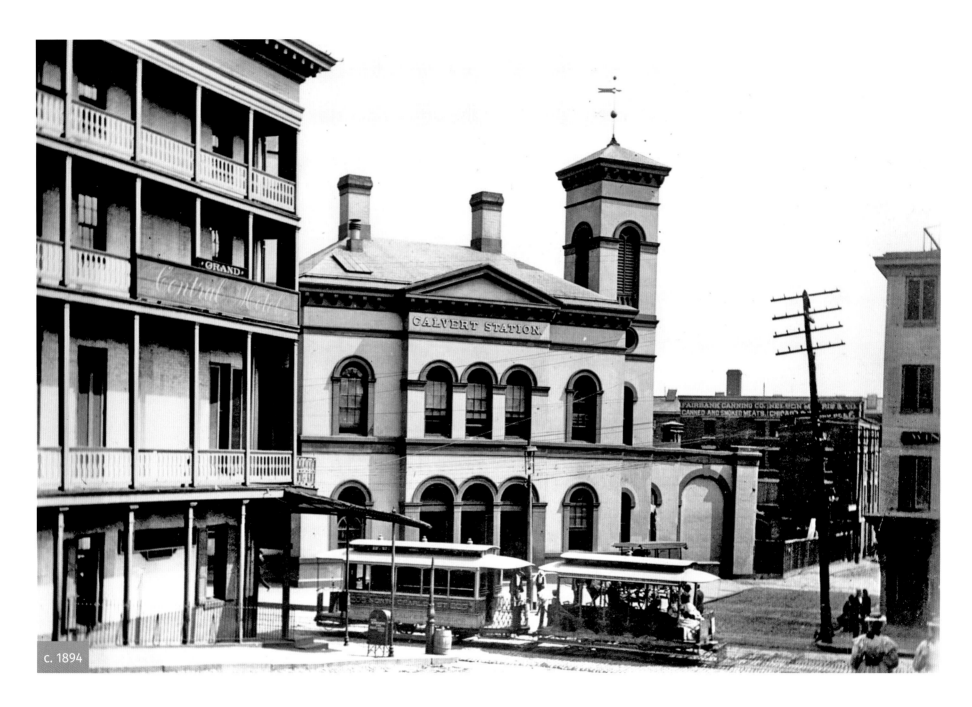

c. 1894

BALTIMORE | CALVERT STATION

The Italianate building lasted a century before making way for newspaper offices

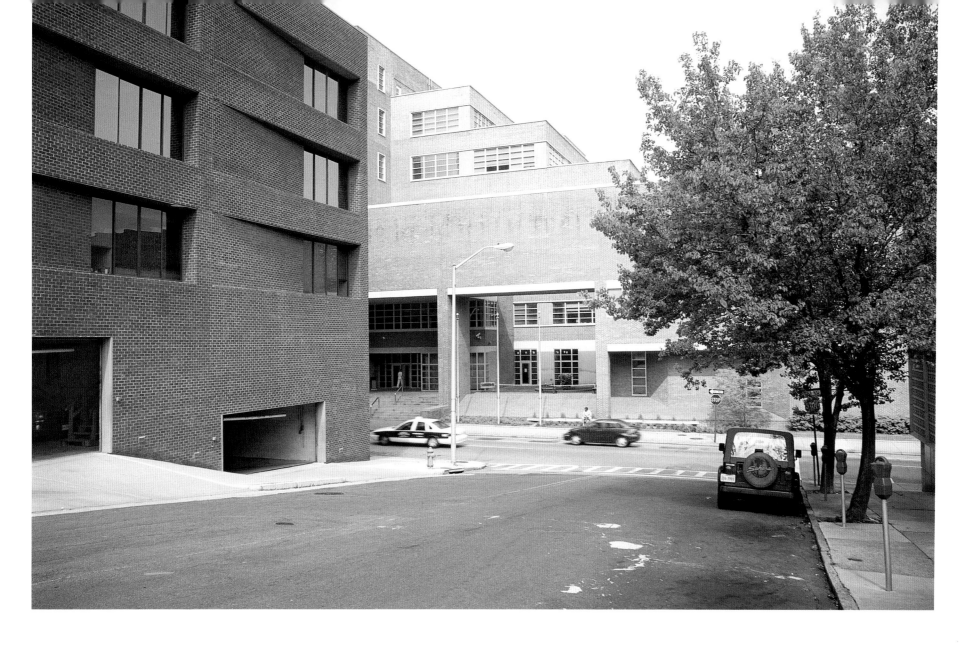

LEFT: Built in 1848–1850 for the Baltimore & Susquehanna Railroad, which was later absorbed by the Northern Central RR and then the Pennsylvania RR, this oddly-slanted Italianate building at the northeast corner of Calvert and Bath streets served as the terminus for trains operating north to Pennsylvania and Lake Ontario, as well as headquarters for the Northern Central. A massive brick train shed, built in 1865 to add additional freight facilities, later stretched behind this headhouse. When the PRR built another route through the city via two tunnels and Union Station in the early 1900s, this station became primarily a commuter station. To the left is the old Grand Central Hotel; to the right stands the Windsor Hotel. The streetcars in the foreground of this photo are not electric cars, but examples of the Baltimore City Passenger Railway's short-lived cable car operation, similar to the still-surviving system in San Francisco.

ABOVE: The depot was razed in 1948 for construction of the new offices and printing plant of the *Baltimore Sun* newspaper, which were opened in 1950. The Sun building was remodeled in later years and expanded in 1981; the main entrance is just out of sight to the left of the far wall. The 1865 freight trainshed to the north was saved, albeit in altered form, and now houses the Baltimore Athletic Club, which was formerly a neighbor of Pennsylvania Station further north. (Coincidentally, the newspaper would erect a new building in the 1990s in Port Covington, also atop former railroad property in South Baltimore.)

BALTIMORE | CAMDEN STATION

A rare survivor of downtown development

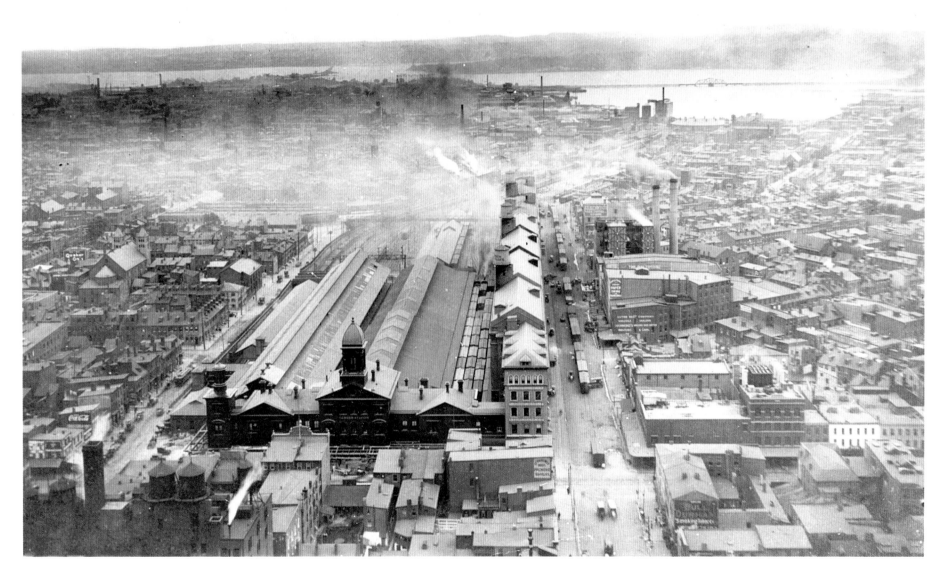

LEFT: This spectacular photograph, taken around 1912 from the recently completed Emerson Tower (better known as the Bromo Seltzer Tower), shows the Baltimore & Ohio Railroad's Camden Station and surrounding facilities stretching almost to the water (a roundhouse for locomotives is at upper right). Camden Station, built from 1857 to 1866, was the B&O's major terminal in town, and dozens of freight cars can be seen between the passenger shed and the railroad's long (1,100 feet) and narrow 1899–1905 warehouse, as well as on Eutaw Street to the warehouse's right. To the upper left of the trainshed can be seen a train heading into or out of the Howard Street Tunnel, which still runs under downtown Baltimore to the Mount Vernon area and Mount Royal Station. The air in the distance is thick with coal smoke from the B&O's steam locomotives and local industry. Formerly a heavily residential area, the Camden neighborhood was home to a large number of English and German immigrants. Among them was a tavern owner named George Herman Ruth, Sr., the father of baseball legend Babe Ruth. Through the distant haze, the Western Maryland Railroad can be seen crossing the Middle Branch of the Patapsco River on trestles and a swing bridge to access Port Covington.

BELOW: The air is clearer in a modern view from the tower. To the left is the red brick Federal Reserve Building, built in 1980. Urban renewal robbed the Camden area of many residences and businesses; by 1980 the railroad company had proposed another high-rise office and residential complex on the former railroad yard site. City and state officials, however, wanted a sports stadium to replace the aging Memorial Stadium uptown, and from 1986 worked to acquire the site and build the 48,000-seat Oriole Park at Camden Yards, opened in April 1992. The design, which also incorporated the B&O Warehouse and former Eutaw Street, has been hailed as one of the most successful and popular stadium designs in America. It was followed by the opening in September 1998 of the 69,000-seat PSINet Stadium (now M&T Bank Stadium, seen at top right), built for use by the new Baltimore Ravens football team. The original station building, altered many times over the years, was completely restored to a close approximation of the original (Italianate) design, and is now occupied by a pop culture museum (Geppi's Entertainment Museum). Commuter trains to and from Washington, D.C. still use the station, as do Light Rail transit cars on the tracks to the left.

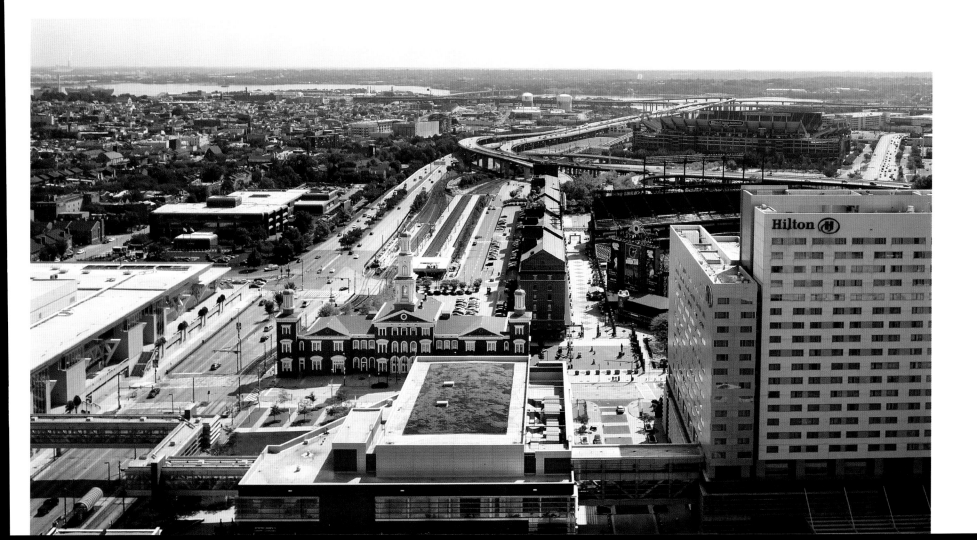

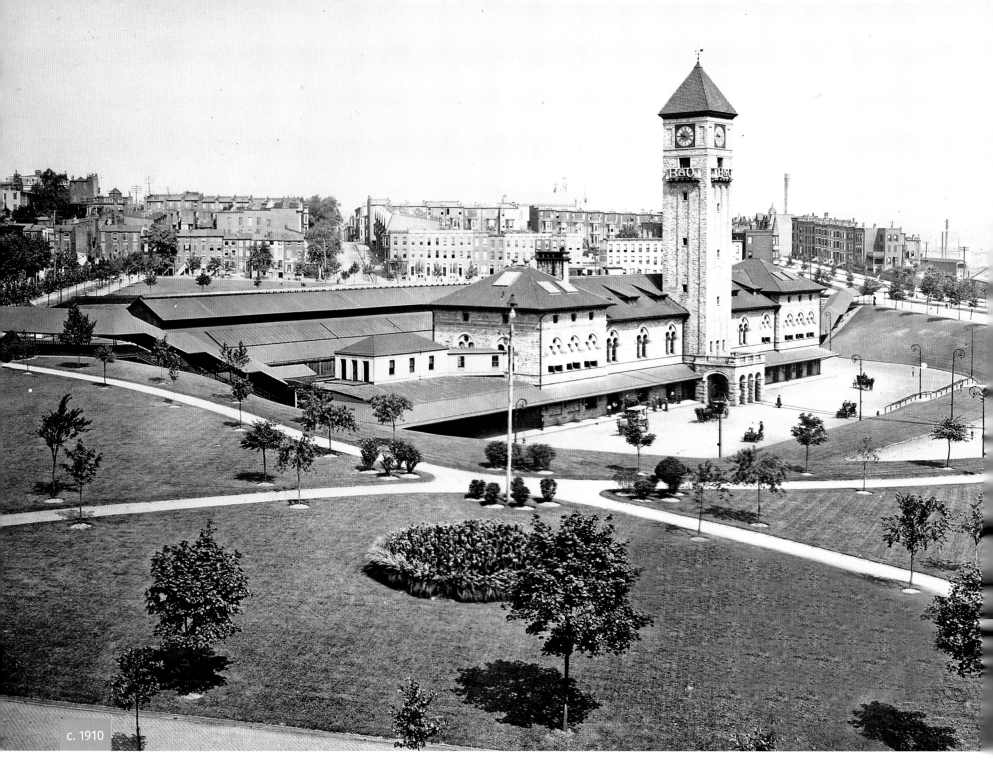

c. 1910

BALTIMORE | MOUNT ROYAL B&O STATION

Mount Royal lives on as an art college

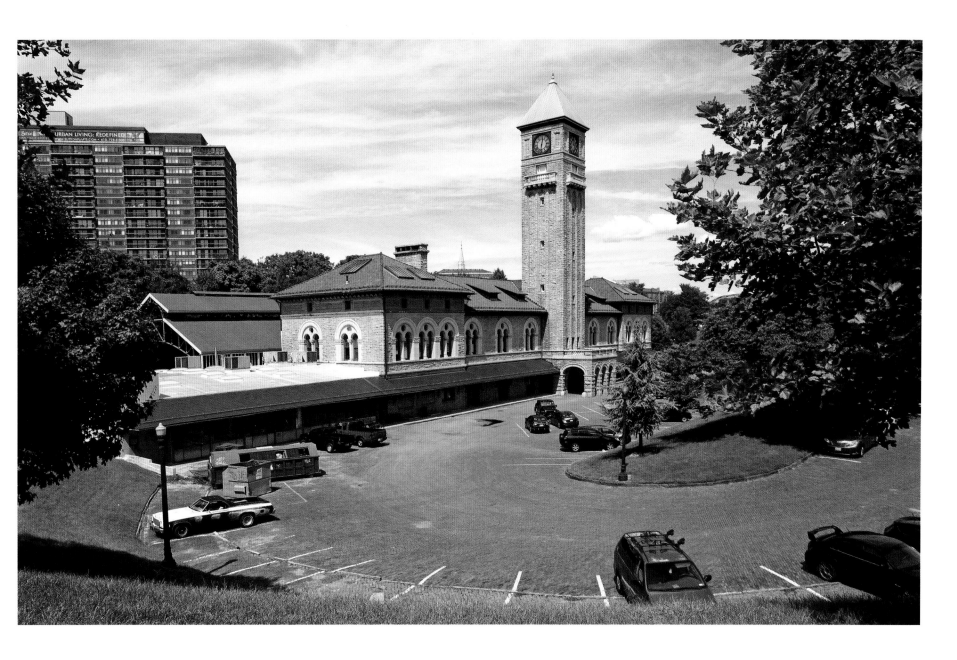

LEFT: Designed by Baltimore architect E. Francis Baldwin, this elegant stone Romanesque-Renaissance station opened in September 1896 as part of the Baltimore Belt Line, a B&O Railroad bypass of central Baltimore. Located at the north end of the tunnel under Howard Street and intended as the B&O's primary intercity passenger station, it remained a high-class facility right through to its closure in April 1961.

ABOVE: Happily for preservationists, the station was sold to the Maryland Institute College of Art, which had relocated from downtown to a then-crowded building a block away from the station. Reopened in 1967, the interior has been heavily rebuilt to accommodate art studios and galleries, but the station and its clock tower remain neighborhood landmarks. Amazingly, the original 1896 trainshed behind the station remains over a still-active freight railroad after the shed's restoration in the 1980s.

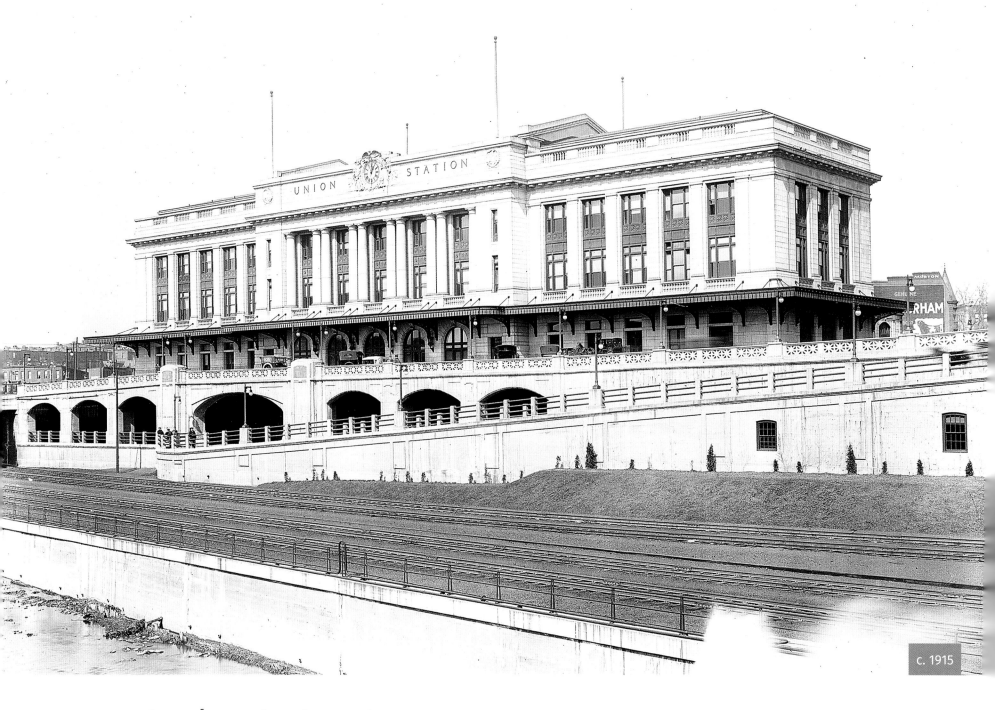

c. 1915

BALTIMORE | UNION STATION
The third Union Station on the site

ABOVE: Upon completion of two long tunnels to the east and west to form a through route between Philadelphia and Washington, Union Station was opened by the Philadelphia, Wilmington & Baltimore RR (later the Pennsylvania RR) in 1873 between Charles and St. Paul streets. The original wooden structure was replaced by a brick structure in 1885, which was demolished to make way for the present-day Beaux-Arts granite structure. This was designed for the PRR by New York architect Kenneth MacKenzie Murchison and is seen here shortly after its completion in 1911.

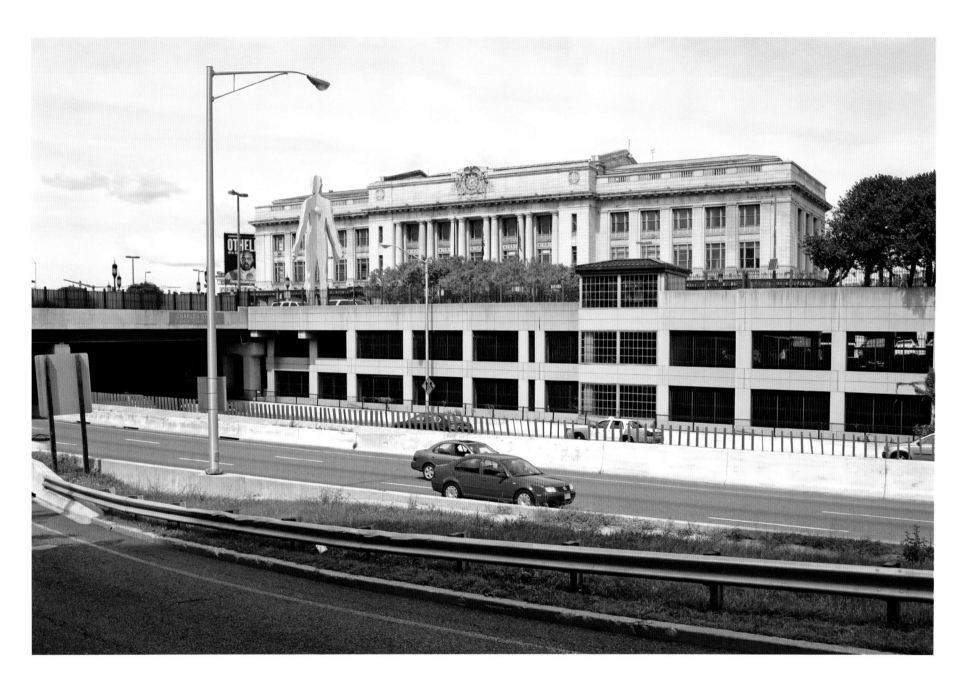

ABOVE: Renamed Pennsylvania Station in 1928 after its owning railroad, the station (generally known as Penn Station) continues to be used by Amtrak, MARC (Maryland Area Regional Commuter), and MTA light rail trains. The Jones Falls Expressway has covered its namesake waterway in front, and a parking garage and plaza replace former freight trackage in front of the station. In the centre of the plaza, Jonathan Borofsky's 51-feet-high aluminum sculpture entitled *Male/Female* has caused controversy since its erection in 2004; viewers either love it as a striking addition to the urban landscape or hate the way it appears to dominate the station building.

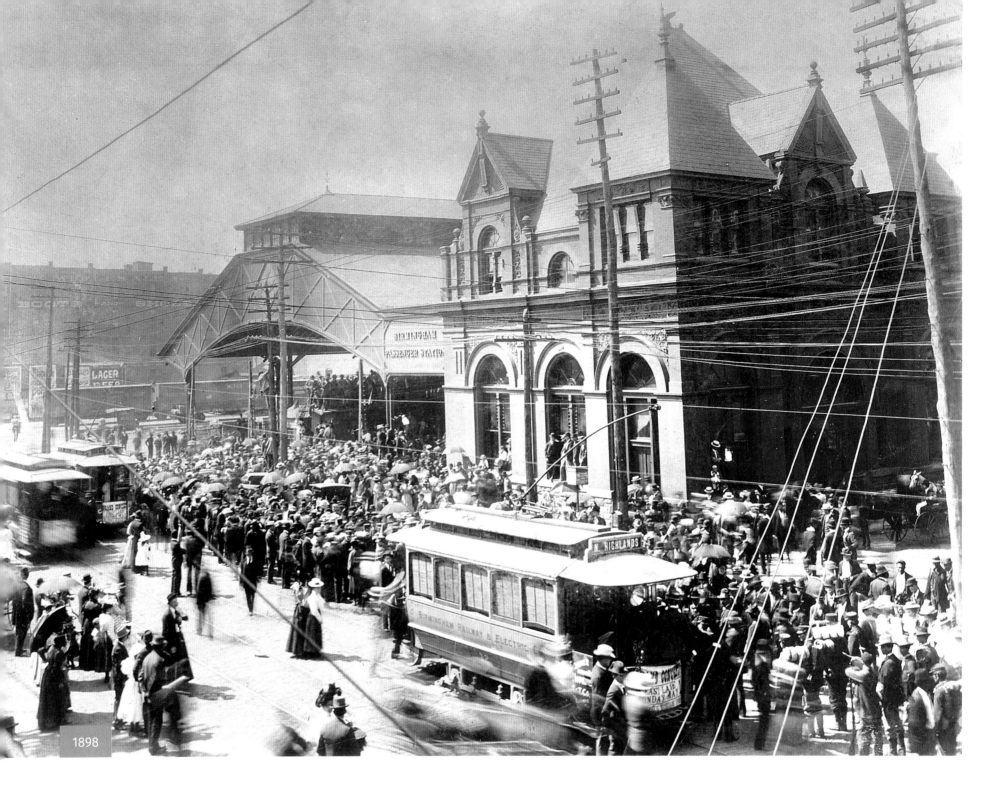

1898

BIRMINGHAM, AL | LOUISVILLE AND NASHVILLE RAILROAD STATION

The Louisville and Nashville Railroad Station was where soldiers bound for the Spanish-American war said their farewells

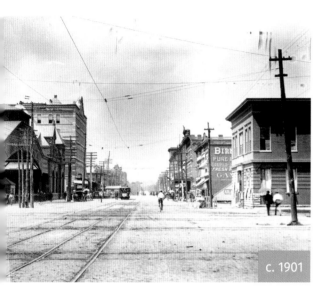

c. 1901

ABOVE: This turn-of-the-century photo of Twentieth Street North looks north from the railroad tracks at Morris Avenue and features the Union Train Station and the Metropolitan Hotel on the left. To the right is the Louisville and Nashville freight depot.

LEFT: This frenetic, energized scene from May 1, 1898, shows recruits gathered at the Louisville and Nashville Railroad Station on Morris Avenue getting ready to depart aboard a special train bound for Miami and then Cuba, to fight in the Spanish-American War. Bands were playing and older Confederate veterans greeted the young soldiers. Some 700 recruits from the vicinity signed up to serve their nation. The Woodlawn Light Infantry (nicknamed "Higdon's Hobos" for their colonel, Elijah L. Higdon), the Bessemer Rifles, East Lake's Huey Guards, and the Pratt City's Clark Rifles completed Jefferson County's recruits in the First Alabama Division. Company F, led by Lieutenant Dabney Luckie, joined the "colored regiment" known as the Third Alabama. They didn't make it to Cuba before the war was over, but by then the ravages of the southern Florida heat, dysentery, and typhoid had taken their own toll. Most returned home in the fall to equally enthusiastic crowds.

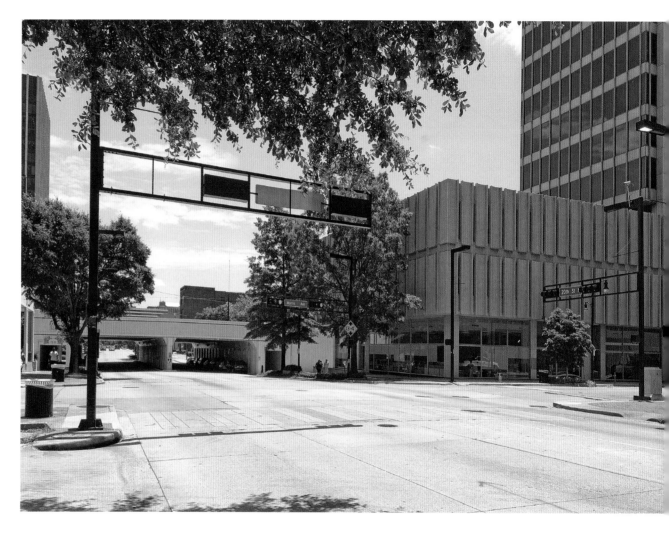

ABOVE: Listed in the National Register of Historic Places, Morris Avenue and First Avenue North have been recognized for their many warehouses located in the 2200–2400 blocks of Morris and the 2100–2500 blocks of First Avenue North. Morris Avenue is a popular spot for photographers who want to capture the cobblestone streets and quaint storefronts, just out of frame to the left of this view. The railroad line is now elevated over Twentieth Street and the streetcar lines, electrified back in 1891, were taken up or paved over in the 1950s. Across the street from where the station used to be is the 17-story Two North Twentieth Building. It was formerly the Bank for Savings Building, the first significant building constructed in downtown Birmingham since the Depression.

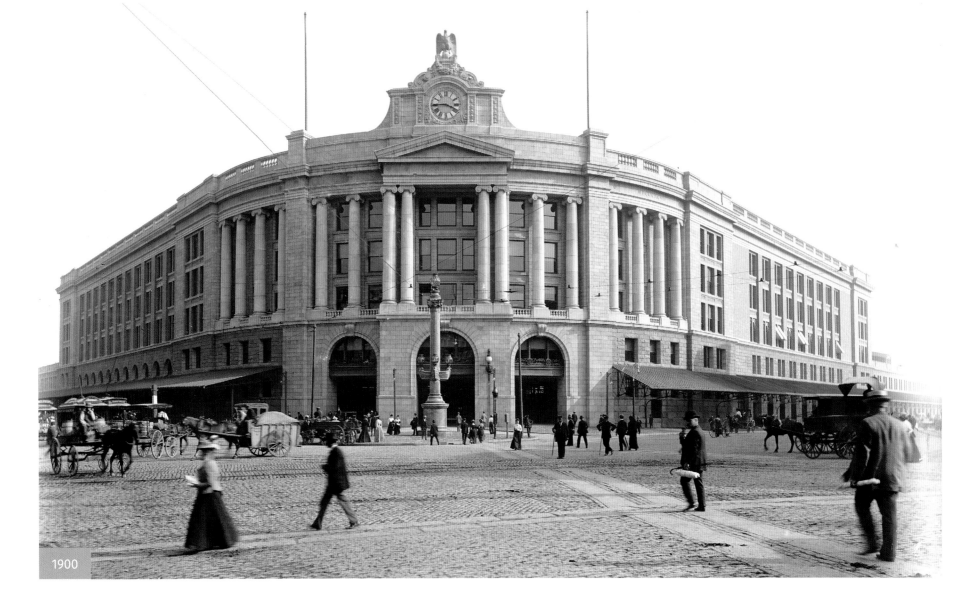

1900

BOSTON | SOUTH STATION

Providing a rail link to the South Shore and beyond

ABOVE AND RIGHT: In the nineteenth century, five railroad companies served Boston's South Shore, Rhode Island, and routes to New York City. Seeing the success of a union station across town on Causeway Street, these companies combined as the Boston Terminal Company to build one here at the corner of Summer Street and Atlantic Avenue. Taking inspiration from architect H. H. Richardson, the firm of Shepley, Rutan and Coolidge designed the granite structure in the neoclassical revival style. When South Station opened in 1899, it was the largest railroad terminal in the world. It also had a lower level of tracks that were never put into service. Plans for the basement included an "immigrant waiting room and lavatory." (Later, the level would house employee parking and a bowling alley.) In 1901 an elevated railway (pictured right) opened on Atlantic Avenue to conduct traffic between the North and South stations. The Atlantic Avenue Elevated operated from 1901 to 1938.

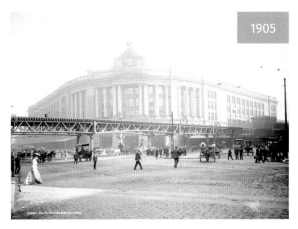

1905

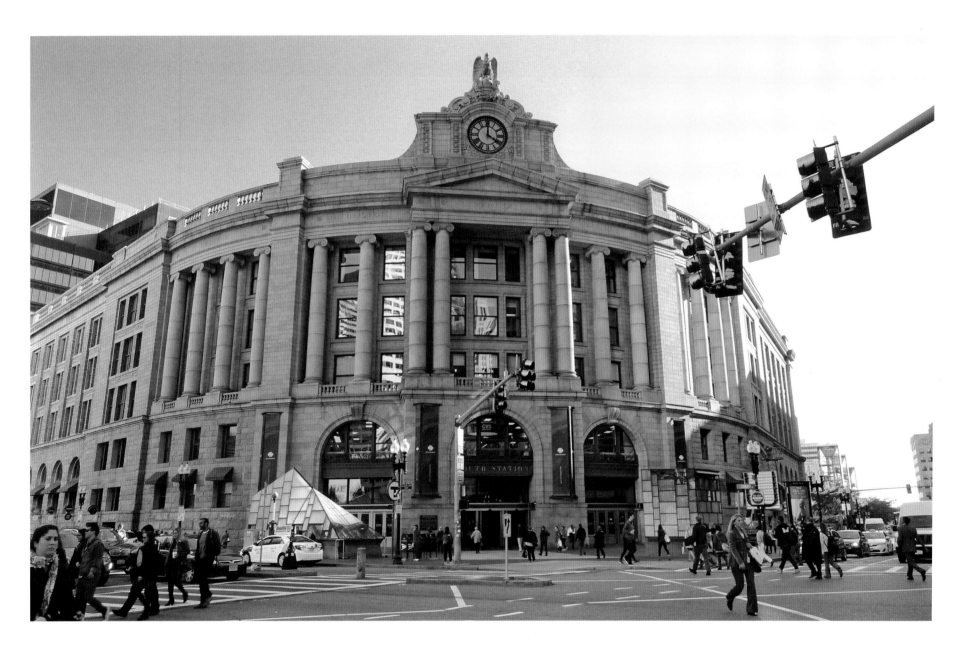

ABOVE: More than 700 trains used South Station on a daily basis in the early twentieth century. Its busiest day ever, June 8, 1912, saw 1,001 trips on the schedule. South Station was remodeled between 1929 and 1931, closing the front entrance to automobile traffic. The Atlantic Avenue Elevated closed and was dismantled for scrap metal during World War II. Rail service declined in the 1950s, and South Station's primary occupant, the New Haven Railroad, ended all its passenger service in 1959. The Boston Redevelopment Authority (BRA) bought the building in 1965, considering the site for an office high-rise. With a rail revival in the 1970s, the BRA sold South Station to the Massachusetts Bay Transportation Authority (MBTA), which today operates it with Amtrak. South Station underwent a thorough refurbishment in the 1980s, with the addition of eateries and shops on its impressive concourse. A bus terminal was added to the complex in 1995.

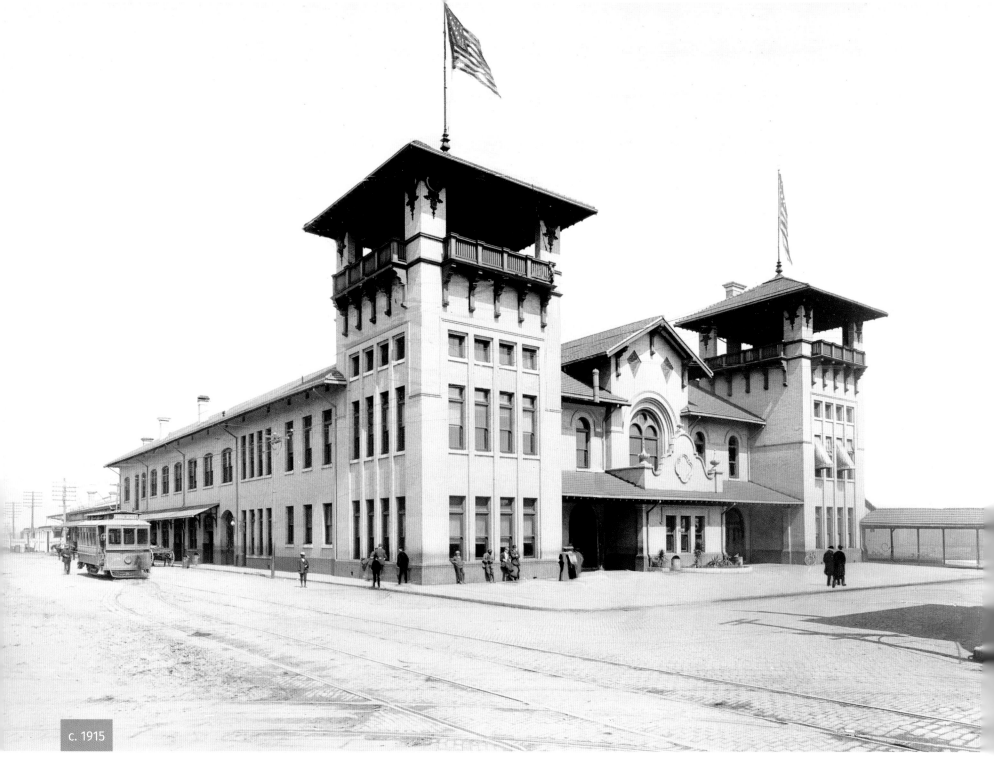

CHARLESTON | UNION STATION
The building suffered a sudden demise in 1947

LEFT: In 1902, the South Carolina General Assembly commissioned the Charleston Union Station Company to build and operate a station in Charleston. The Charleston Union Station was designed by Frank Milburn in Spanish Renaissance style. Construction of the station cost $250,000 and lasted from 1905 to 1907. It was located on the corner of Columbus Street and East Bay Street, facing out toward the bay. In addition to the two railroad companies that owned the Charleston Union Station, the Atlantic Coast Line Railroad, the Southern Railway and the Seaboard Air Line also used the station for a while, before the SAL built its own depot on Grove Street in 1931.

ABOVE: On January 11, 1947, the Union Station caught fire and was destroyed. The train shed behind the station was not damaged and remained until 1954 when it was decided to locate the new station elsewhere. The site of the old station was sold to the South Carolina State Ports Authority, which merged it into its extensive dockside property. A new station was built by the Atlantic Coast Line in 1956. It is located near North Charleston's Park Circle and is known as the Charleston Amtrak station. However, in 1997 planning began for a new intermodal station to replace the Amtrak depot. The old Charleston Union Station is the inspiration for the design of the new building. Discussions about the location for this "intermodal transportation hub" are still ongoing.

CHARLOTTE, SC | SOUTHERN RAILWAY STATION

A symbol of Charlotte's emergence as a key railway and transportation center

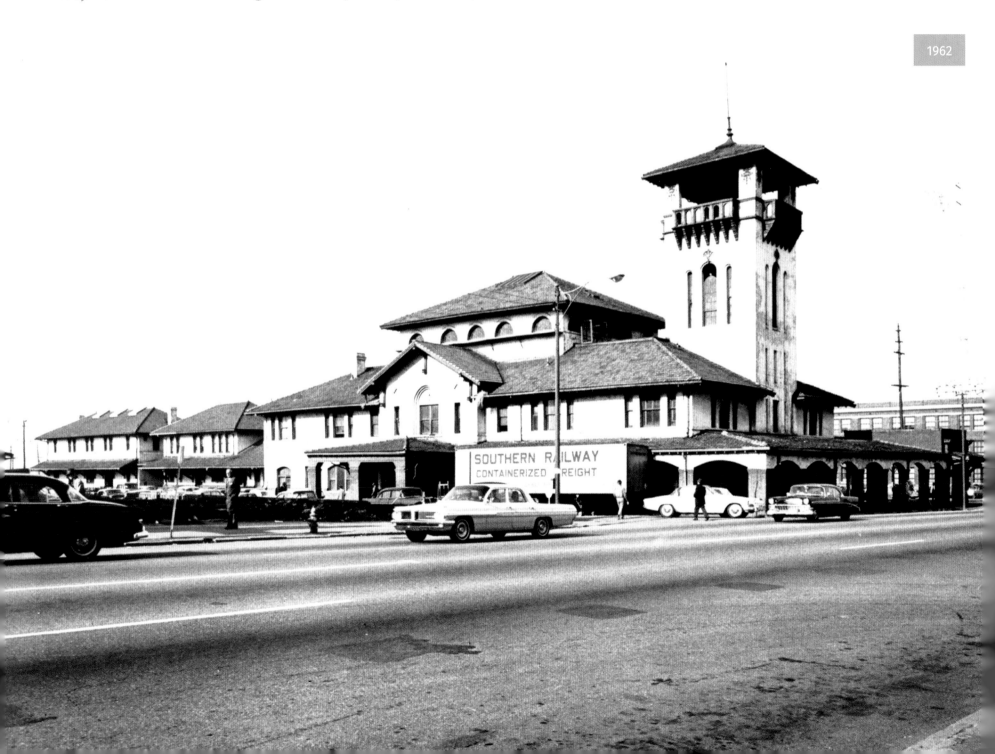

1962

LEFT: The coming of the railroads in 1852 triggered an explosive population growth in Charlotte that made it one of the flagship cities of the South. By 1861 four rail lines converged in the town and linked it with key ports on the coast. It had become an important center for Southern trade and industry. The booming cotton industry caused Charlotte, which had been one of several similar-sized cities in the Piedmont, to quadruple in population from 1,065 to 4,473 during the years 1850 to 1870. In 1894 four of the six local lines were consolidated by the Southern Railway system. In 1900 this station on West Trade Street was built, and the area became the "gateway" into the city. By the 1960s, most of Charlotte's historic train stations were being abandoned or demolished, and the Southern Railway Station was torn down in 1962, the year this photograph was taken.

BELOW: Unfortunately, Charlotte has few remaining landmarks that recall its place as a historic railway junction. By the 1970s, the West Trade area, formerly the major port of entry to the city, had declined and most of its tenants had moved. It was largely resurrected as a "gateway" in the 1980s, as new development clustered around the AT&T Building, and this is the first view of Charlotte for many visitors coming off the exit from Interstate 77. The former site of the Southern Railway Station, which had been situated beside the Trailways and Union Bus Terminals to form a nexus of transportation, has once again become a key point for people coming in and out of the city: Charlotte's only Greyhound bus terminal now sits here.

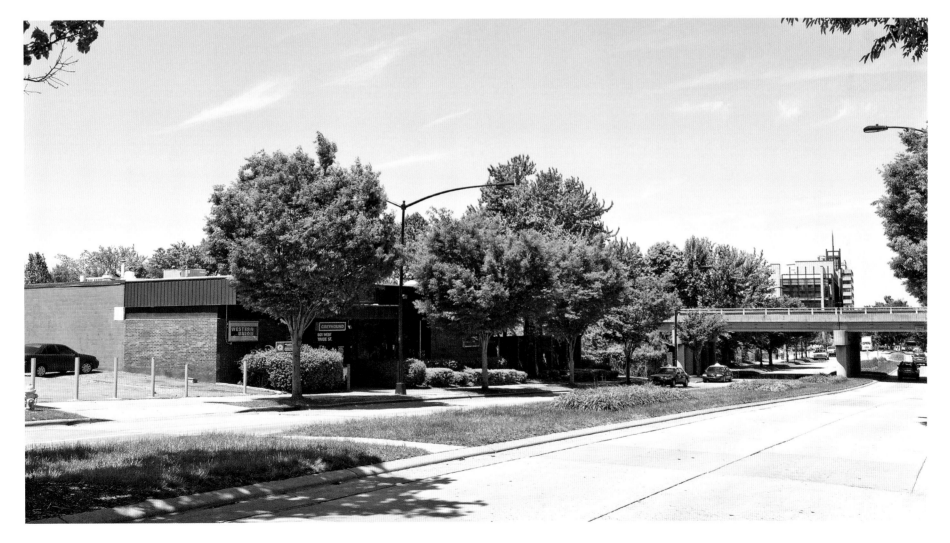

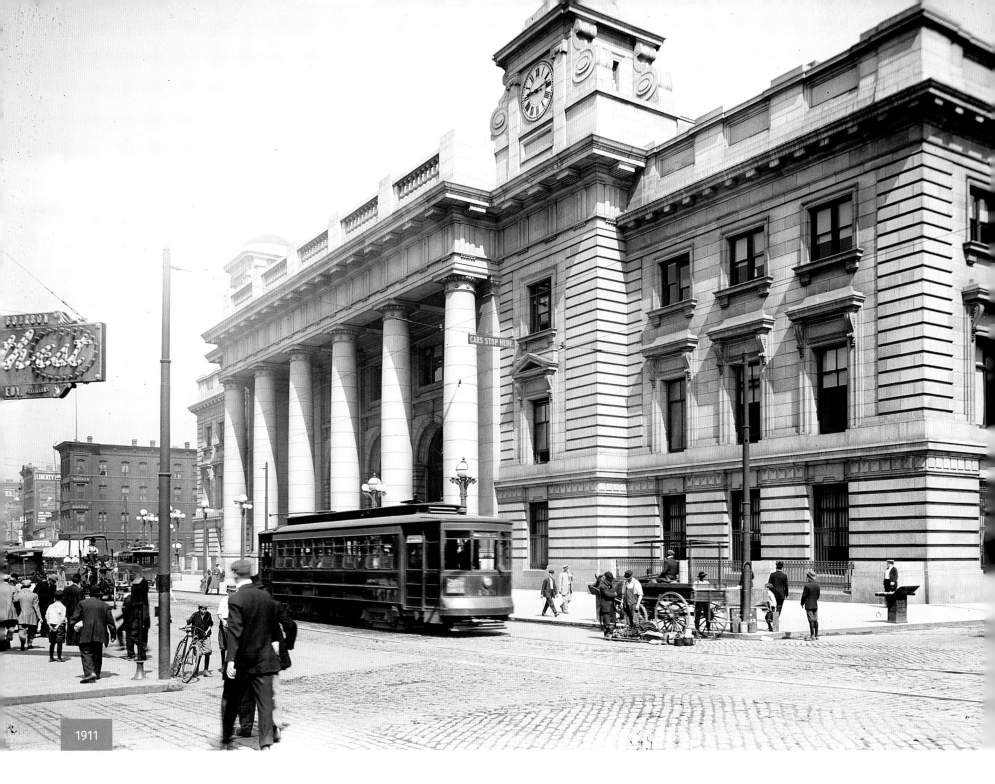

1911

CHICAGO | CHICAGO AND NORTH WESTERN TERMINAL
A grand Renaissance Revival building located on a valuable piece of real estate

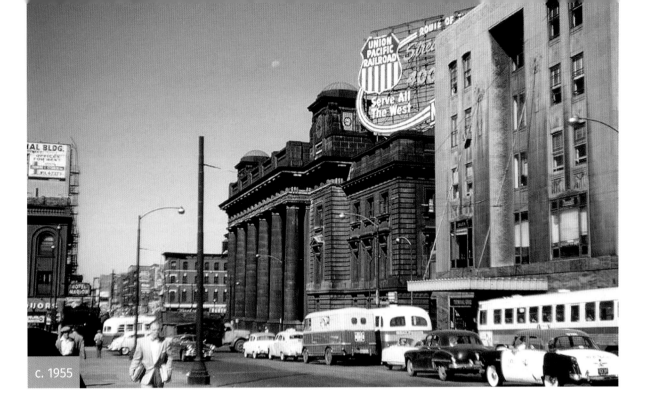

c. 1955

BELOW: The new building—known variously as the Northwestern Station and the Ogilvie Transportation Center—opened in 1987. Architect Helmut Jahn was already a controversial figure in Chicago architecture. His design for the new terminal at 500 West Madison was in keeping with what had become his signature style—forward-looking, high-tech, and cutting-edge. The massive glass-and-steel skyscraper comprised 42 stories and nearly 1.5 million square feet of floor space, including a five-story atrium filled with restaurants and retail stores. Although the building has been compared to a giant cash register, it sports an Art Deco flair. Its reflective, blue-tinted glass is the source of both its high-tech shimmer and its organic fusion with Chicago's western skyline.

LEFT AND ABOVE: Newly designed downtown rail terminals were beginning to include space for restaurants, retail businesses, and even offices to accommodate the growing number of passengers commuting to work. The Chicago and North Western (C&NW) Terminal on Madison Street between Clinton and Canal replaced the original C&NW Wells Street station in 1911. Bordered by the Chicago River on the south and west, the Wells Street station had limited options for expansion. The 1911 C&NW Terminal, a huge Renaissance Revival structure designed by Chicago architects Charles S. Frost and Alfred H. Granger, included an elaborate three-story waiting room trimmed in bronze and marble, a main dining area, a tearoom, smoking lounges, writing desks, newsstands, and 20 telephone booths. Services available for female travelers included manicures and hairdressing, while men could get their shoes shined or receive a shave and haircut. For the comfort of visitors, the building's ventilation system brought in freshly cleaned and cooled air every 20 minutes. The main building was demolished in 1984.

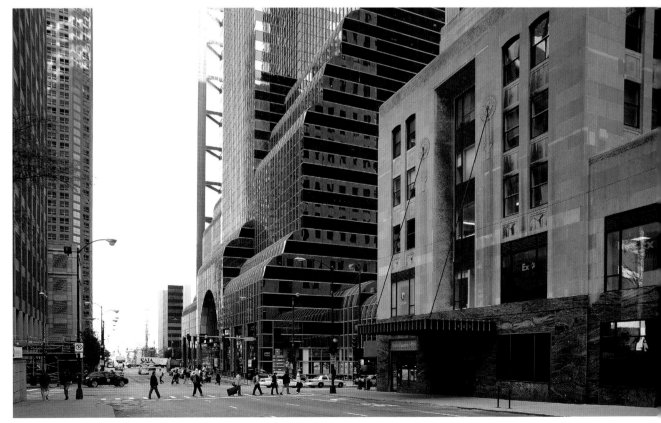

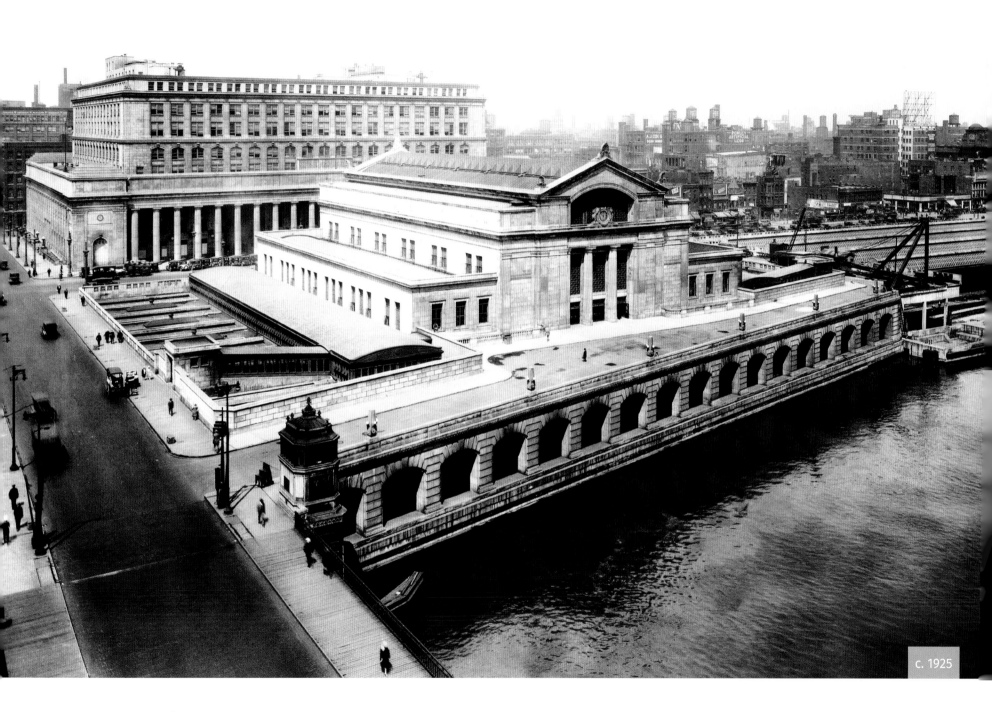

c. 1925

CHICAGO | UNION STATION
Daniel Burnham's legacy to downtown Chicago

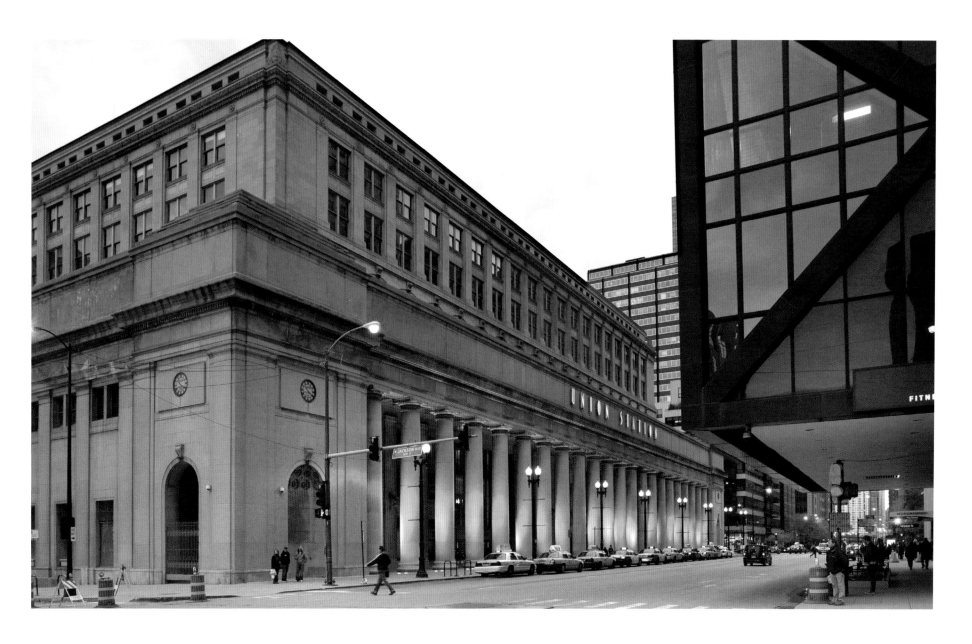

LEFT AND ABOVE: By the mid-nineteenth century, Chicago had become the center of American rail traffic. By 1860 the world's largest train station opened in Chicago in time for the city's first Republican National Presidential Convention. From then until the mid-twentieth century, the railroads were at the heart of Chicago commerce. Union Station was built at 225 South Canal Street between 1916 and 1925. It replaced the 1881 Union Station, itself a replacement of the 1874 Union Station built following the Great Fire of 1871. The station's interior is a massive, eight-story, 100- by 269-foot space with a shimmering glass ceiling. Union Station's interior grandeur matches the exterior majesty of its Doric columns and travertine walls. The photo on the left shows a panorama of the station and concourse across Canal Street from the terminal along the South Branch of the Chicago River. Refined engineering within this Beaux-Arts–inspired terminus reflects the importance of America's national rail system. Nowhere was this more muscular or bold than in Chicago. At its height, more than 300 trains a day rolled into Chicago's Union Station.

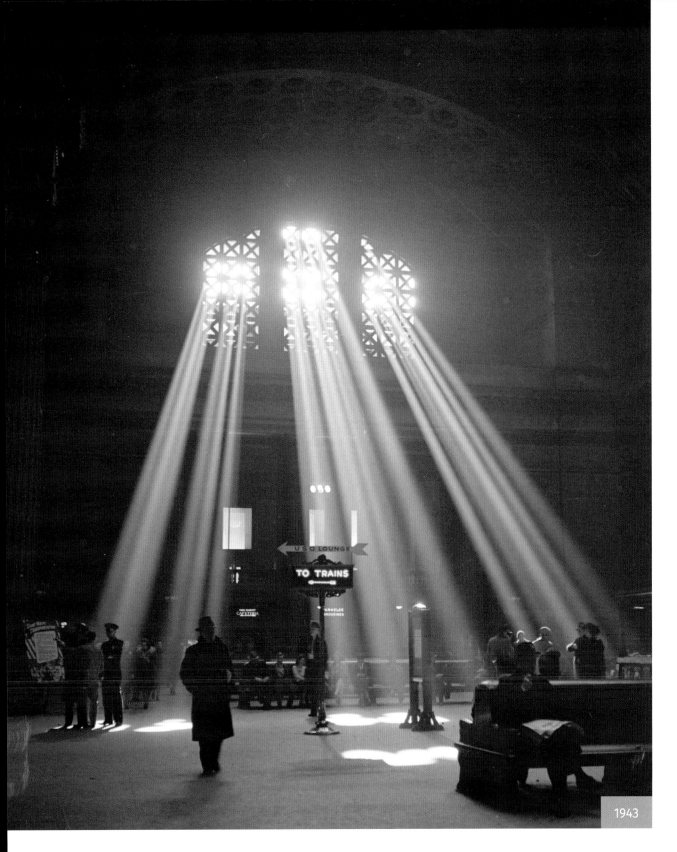

1943

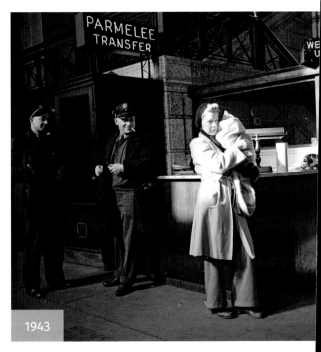

1943

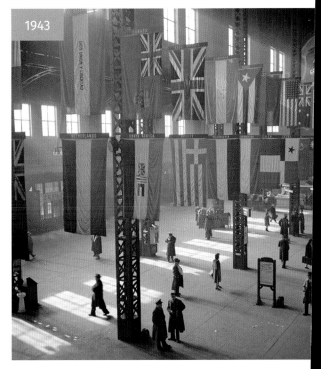

1943

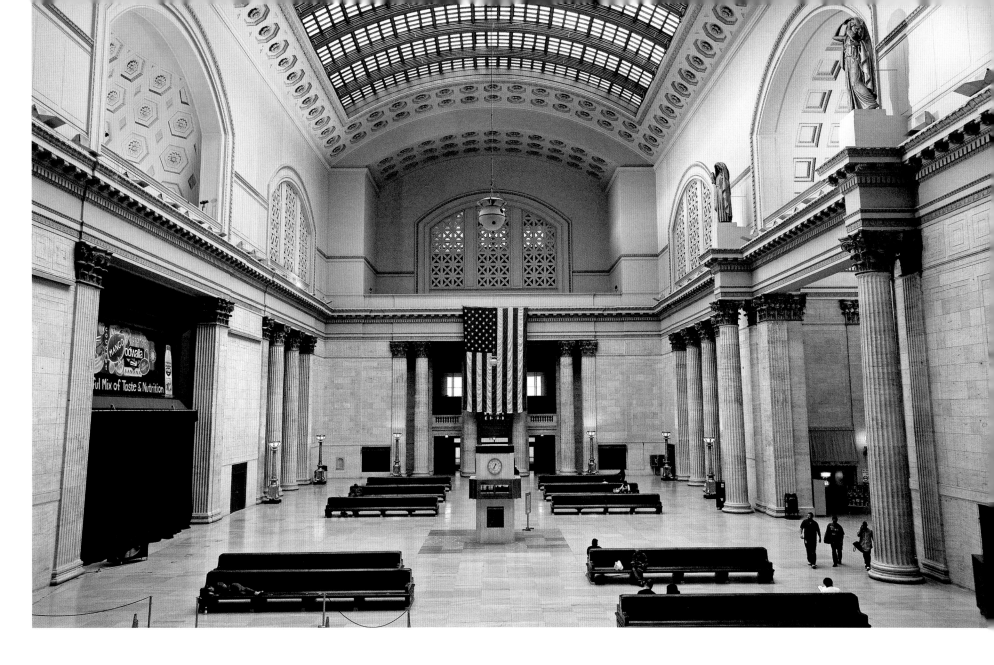

ABOVE LEFT: A mother waits by the Parmelee Transfer Company desk at Union Station. The Parmelee Company was a Chicago institution transferring passengers between Chicago's downtown railroad stations, the hotels and docks from as early as 1853 when Franklin Parmelee set up the business. His stables were among the first buildings destroyed in the great 1871 fire but he was back in business within eight weeks. The Parmelee family are still involved in passenger transfer, running the Continental Airport Express service.

OPPOSITE AND ABOVE: The old glamour and adventure of rail travel lives on in the architectural wonder of a neoclassical terminal like Union Station. The Concourse Building along the riverfront was razed in 1969 and in its place now sits a five-story, black Corten steel structure with prominent X-beams. The structural design includes a great cantilevered overhang above the commuter rail station for the suburban rail line station. With the Union Station itself, much of the internal operations of the headhouse, as the terminus is technically called, are belowground, complete

with rail lines and track beds. Rail service has been consolidated over the decades under Amtrak. Architect Lucien Lagrange undertook a largescale renovation of Union Station in 1991. Today the glamorous interior of the station is a favorite venue for events; with the vast Great Hall transformed into a party space, its elegance enhances any charity ball or high-end social. More than 100,000 people use the station each day during the commuter rush.

CHICAGO | DEARBORN STREET STATION
Printer's Row made use of the station on the doorstep

c. 1890

LEFT: Designed by noted New York architect Cyrus Eidlitz, Dearborn Station (1885) features a twelve-story clock tower and stepped gables along steep rooflines. The building's tall arches and sturdy horizontal design reflect principles of the Richardsonian Romanesque aesthetic, a heavy influence on architects of the First Chicago school of the 1880s. Located at the south margin of the Loop's business district, Dearborn Station became the central point of rail transit for major passenger and freight lines on Chicago's Near South Side, hosting 25 railroad lines and as many as 17,000 passengers per day. Already a key site for cross-country rail transit, Chicago was a prime location for large-scale printing due to its lower rates for bulk shipping. As printing companies took residence in large loft buildings on the streets around Dearborn Station, the area became known as Printer's Row. The South Loop was already a notorious vice district, but police raids in the early 1900s cleared most of the brothels and saloons out of Printer's Row.

BELOW: The old Dearborn Street Station has anchored a vast revitalization in a neighborhood that was once crisscrossed with rail lines. The old station has been stretched beyond landmark status and has come back to life with restaurants, bars, boutiques, and art and cultural venues. Acres of new homes stretch for blocks, forming a new urban community created on the railroad right-of-way. Chicago's oldest passenger terminal has survived the upheavals of history, including a 1922 fire that destroyed its original, steep-roofed tower. Its replacement is a Renaissance tower that would be at home in Florence. More than 35 years after the closure of the station to rail services, Dearborn Station is as alive as ever. Although the 1922 fire destroyed the building's hipped roof, it is the only rail station in Chicago still standing in its original form.

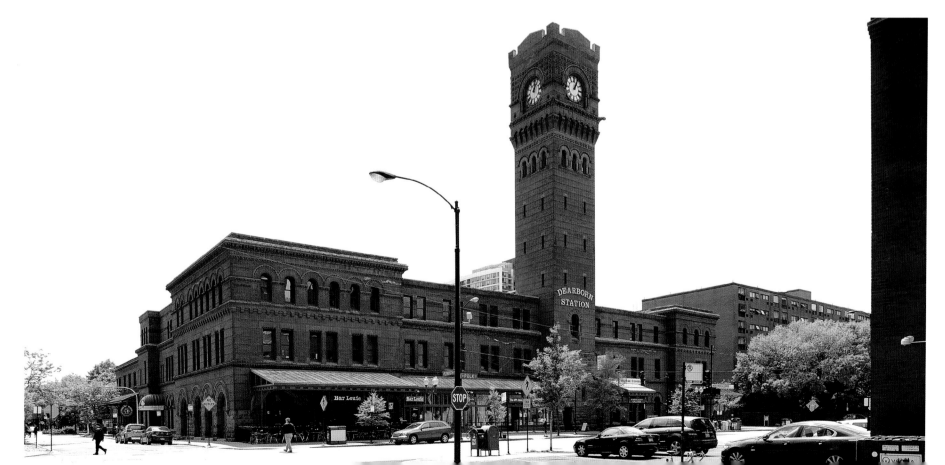

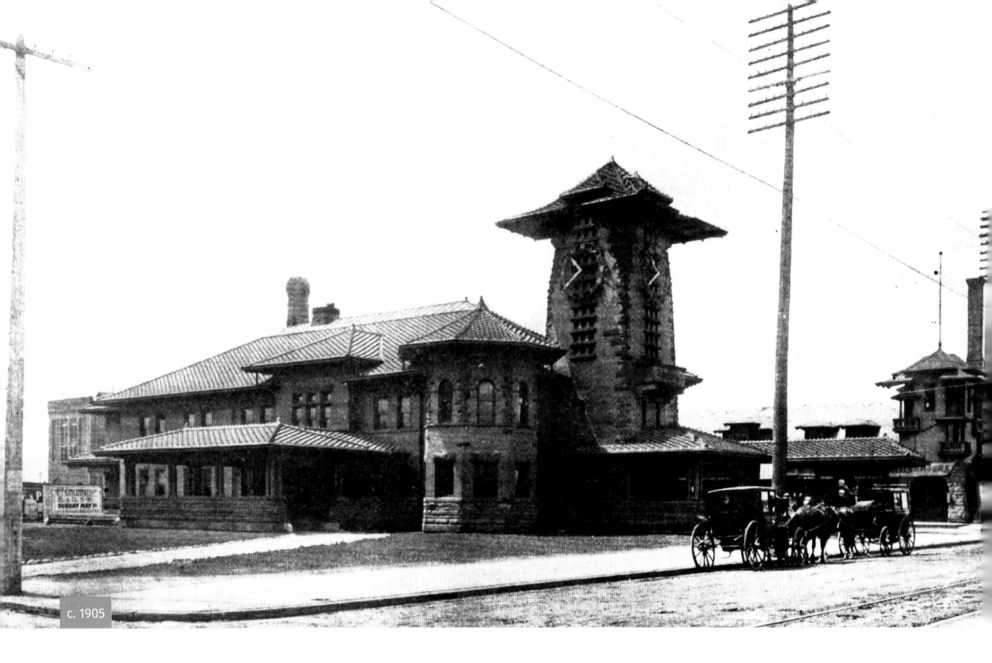

c. 1905

COLUMBUS | TOLEDO AND OHIO RAILWAY STATION
A remarkable design for a railroad depot

ABOVE: Built in 1895, the old Toledo and Ohio Station has been called a cross between "a Chinese pagoda and a Moroccan bathhouse," though it is more affectionately referred to locally as "Shinto Gothic." Built by the Columbus architectural firm of Yost and Packard for use as the principal depot of the Toledo and Ohio Railroad, it was eventually used by the Hocking Valley line. Until 1955, a similar but smaller building existed on the other side of the tracks (the tracks were at grade level until 1911), and it is speculated that this was the original depot. For many years, up until its closing,

it was a restaurant. Inside the present building is a large barrel-vaulted ceiling and a balcony that spans the south wall. Though the station survived floods in 1898 and 1913, it almost did not survive fire. In 1975 fire destroyed most of the interior and nearly all the roof, and it was only through the commitment of the Volunteers of America, longtime caretakers of the building since 1930, that the fire was turned into an opportunity to upgrade and renovate.

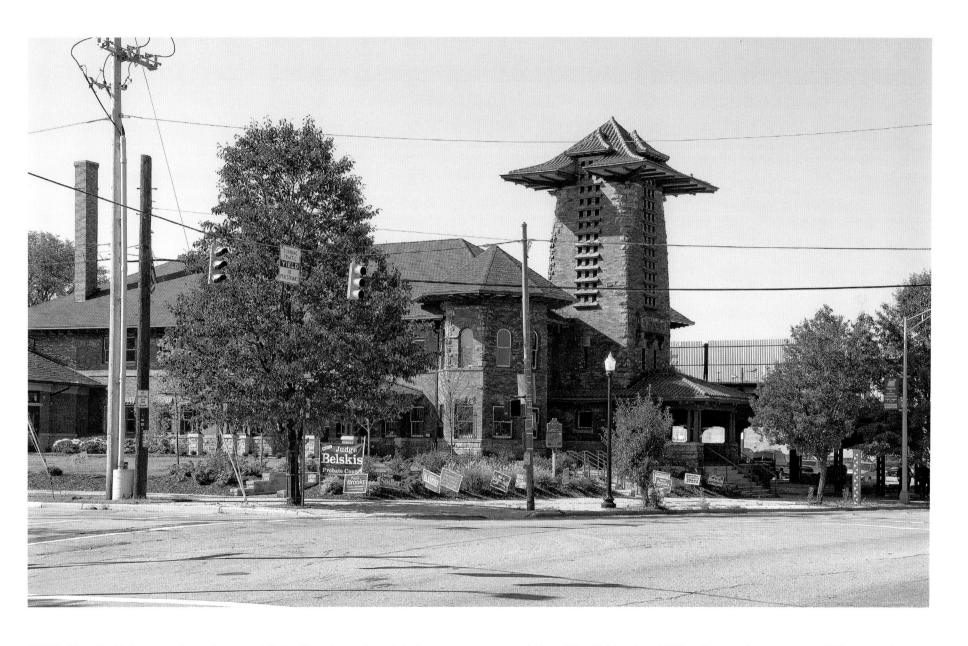

ABOVE: When the Volunteers of America moved their offices to another historic building across from Franklin Park, the City of Columbus purchased the building, intending to return it to public use. Three potential caretakers of the building at the time included: the Columbus Historical Society, for use as a museum; the Harley-Davidson dealership in Franklinton (the oldest in the country), for a restaurant and transportation venue; and the municipal firefighter's union, for offices and public space. It was purchased, rehabilitated, and expanded in 2007 by the International Association of Fire Fighters Local 67 for offices and a reception hall. They took down a sizable late addition on the east side of the building, which had been used by the Volunteers of America for donations and sales, and replaced it with the architecturally compatible reception hall. The project was substantially paid for by an increase in union members' dues and volunteer labor, and is listed in the National Register of Historic Places.

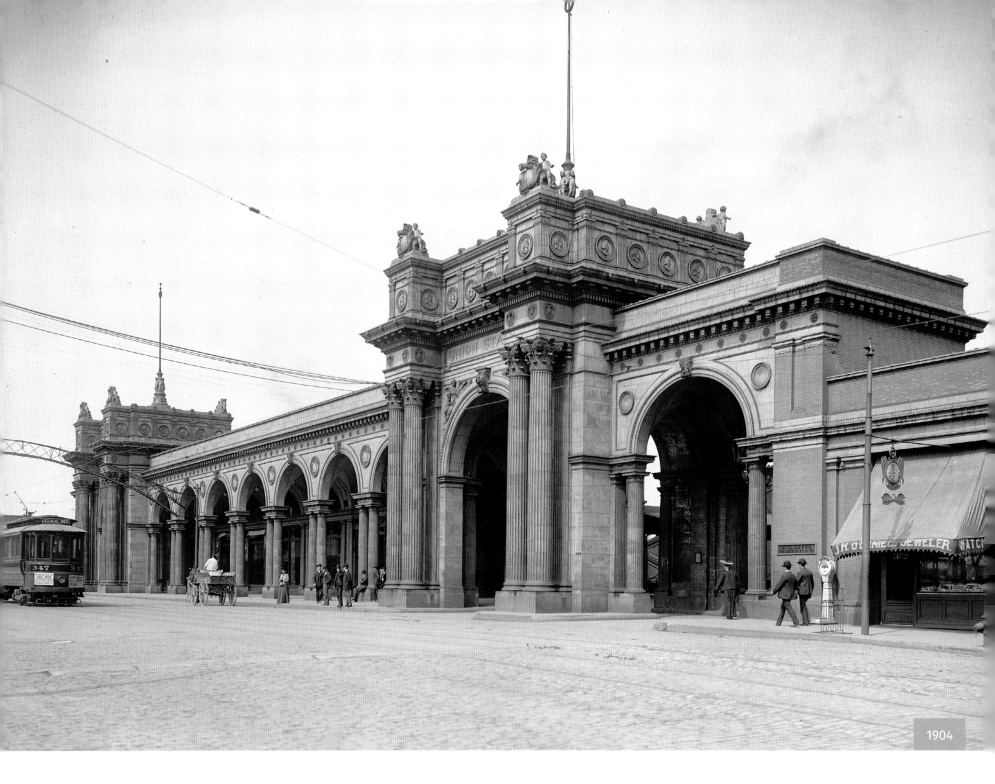

1904

COLUMBUS | UNION STATION
The design of the new station bore a great similarity to pavilions at the Chicago Exposition

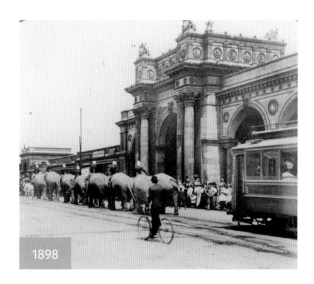

1898

LEFT AND ABOVE: By the late nineteenth-century, Columbus had hundreds of passenger trains coming and going each day. A passing Shriners' parade or elephants from the Columbus-based Sells Brothers Circus (as seen in this 1898 photo) were a little rarer, but not unusual. As Henry Howe, an early Columbus historian, wrote, "The railroads, of course, run their tracks where they please . . . across the streets and thoroughfares . . . but as railroads go . . . when they run over a streetcar, a cab, or a citizen, they usually express regret." After two Union Stations were built at the ground level where railroad, pedestrian, and vehicular traffic met, and after a failed 1875 attempt at a tunnel under the tracks, the third Union Station was built in 1897 on a viaduct over the tracks. Classically designed by Daniel Burnham, famous for the architecture of the 1893 World's Columbian Exposition in Chicago, the new Union Station's paired and fluted Corinthian columns, cherub statues, and arched facade were set over small shops on the east side of High Street. It was one of only two Burnham-designed buildings in Columbus.

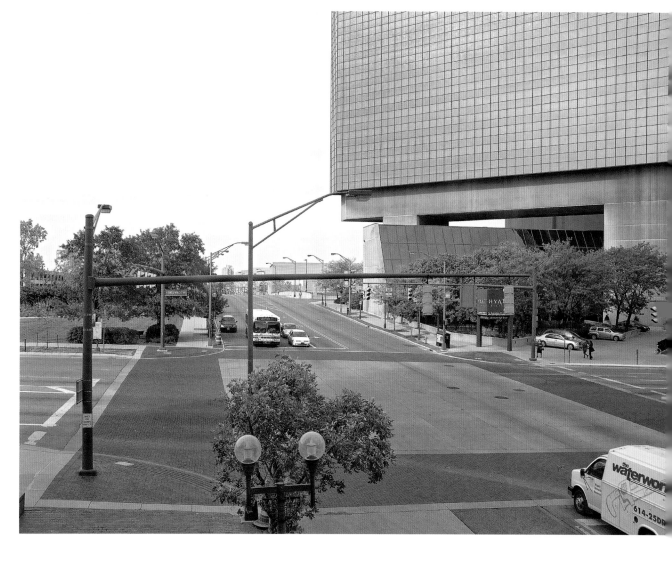

ABOVE: Union Station was torn down in 1976. Its loss sparked the formation of the Columbus Landmarks Foundation. The contemporary Hyatt Regency Hotel and the Ohio Center (1980) were built on the site of Columbus's former Beaux-Arts–style train station. North of the hotel, the Greater Columbus Convention Center was built in 1993 and expanded in 2000. Architect Peter Eisenman designed the building's Deconstructivist-style exterior to appear fragmented into multiple units of different pastel colors. These units relate to the scale of the commercial buildings across the street in the North Market Historic District. The rear facade of the center mimics the twisting and elongated old train sheds, but in pastel colors, prompting the *Washington Post*'s description: "colliding Necco Wafers." Today there are no passenger trains, interurbans, or streetcars to serve Columbus, but the return of modern alternatives is being hotly debated.

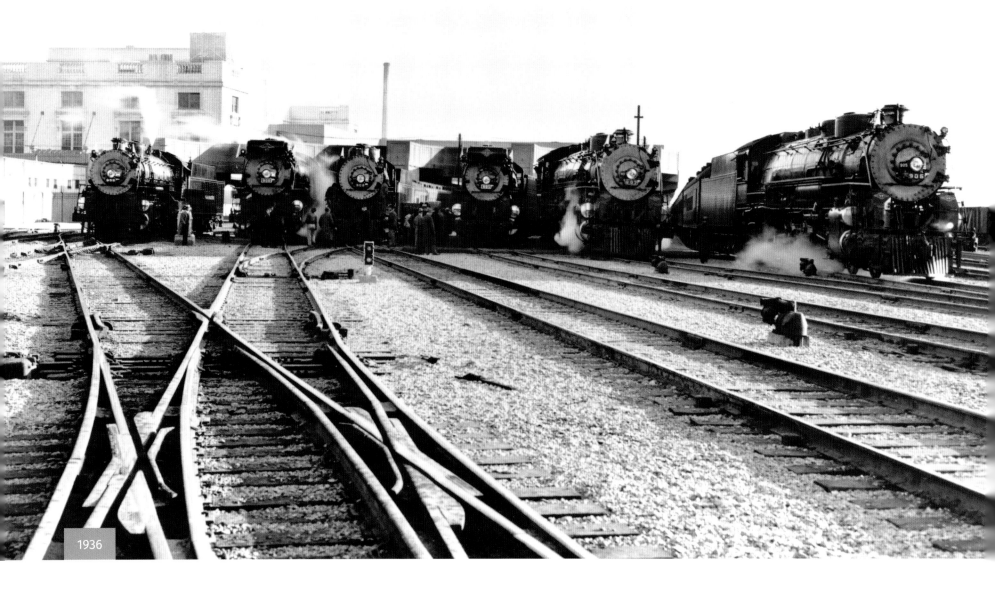

1936

DALLAS | UNION STATION

With eight stations serving Dallas, there was an urgent need for simplification

ABOVE: By the early 1900s, Dallas had grown into a transportation hub served by eight different railroad companies, each with its own passenger station. The resulting difficulties in transferring people and freight between all the different stations resulted in Dallas city planner George Kessler presenting a plan for a Union passenger station to serve all the railroads. Despite initial resistance from the different lines, the terminal opened in 1916 with capacity to handle

50,000 passengers a day; at its peak it handled up to 80 trains in 24 hours. In this photo from 1936, six Texas and Pacific football specials are in the station waiting to take dedicated fans to California for the Rose Bowl game between Southern Methodist University and Stanford.

RIGHT: Designed by Chicago architect Jarvis Hunt, Union Station opened on October 14, 1916.

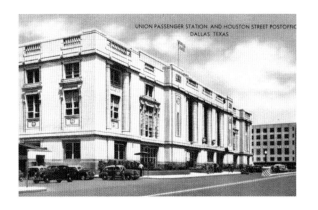

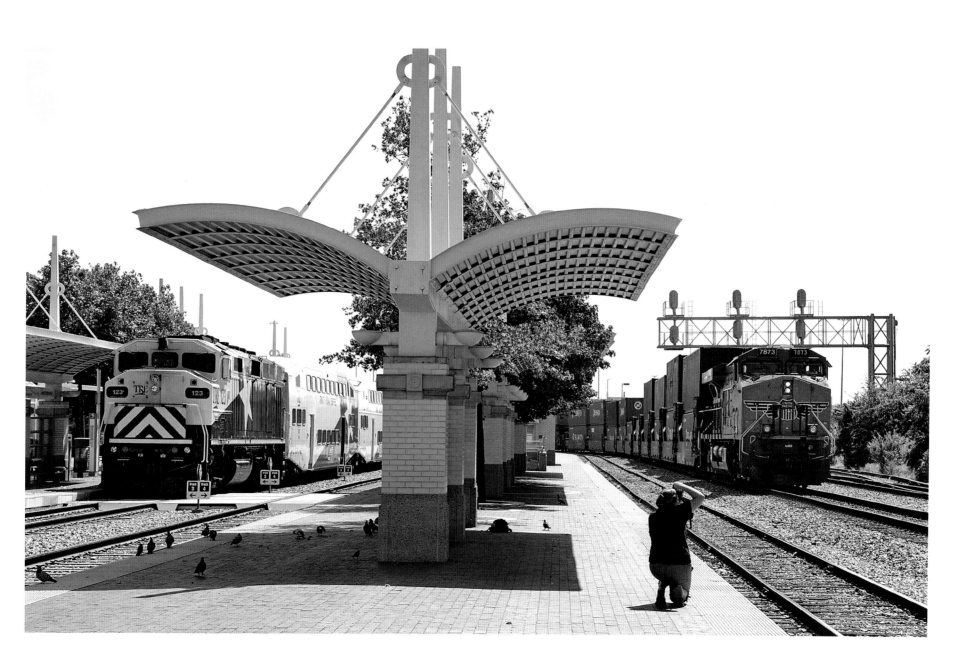

ABOVE: The last passenger train owned by an individual railroad left Union Station on May 31, 1969. The U.S. government under the guise of the National Railroad Passenger Corporation, later called Amtrak, took over almost all passenger service nationwide in 1971. Today Dallas Union Station serves Amtrak's Texas Eagle running daily between Chicago and San Antonio; the Dallas Area Rapid Transit (DART) light rail serving Dallas and its suburbs; and the Trinity Railway Express (TRE), offering heavy rail commuter service between Dallas and Fort Worth. Freight trains operated by the Union Pacific, Burlington Northern Santa Fe and Dallas Garland Northeastern pass through the station area. Dallas Union Terminal is a favorite stopping point for railroad buffs and in this scene an eastbound UP intermodal train bound for California is having its picture taken while on the left a TRE commuter train will be leaving soon for Fort Worth.

DENVER | UNION STATION

The Denver Pacific connection helped guarantee the city's prosperity

BELOW: Were it not for railroads, Denver, an inland territory with no major river ports, would not be the city it is today. When it was decided in 1867 that the Union Pacific line would run through Cheyenne rather than Denver, many considered Denver—a metropolis that hinged on the bygone Colorado Gold Rush—"too dead to bury." Thankfully entrepreneurs like David Moffat and William Byers of the *Rocky Mountain*

News—among others—built the Denver Pacific line to connect with the main line in Wyoming. The first train of the new line arrived in Denver in 1870, and quickly became the link to connect the East and West coasts. With this integral connection in place, the city, along with Denver's railway system, thrived.

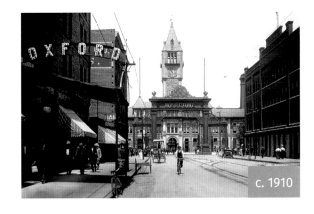

c. 1910

c. 1908

BELOW: It is dining and shopping now, more than railways, which drives traffic into Union Station. Since World War II, there has been a steady decline in the demand for train transportation. Only a handful of Amtrak lines still carry Denver's rail passengers west across the great divide or east through the plains. A revitalization of the area in 2013 and 2014 has focused attention on this historic space. Now, the restored Union Station building—brimming with shops and restaurants, and surrounded by newly minted housing—will draw both travelers and locals. Additionally, the space marked by 15th Street to 18th Street and Wynkoop to Wewatta will be the home of a consolidated transportation hub, housing eight rail tracks for RTD's commuter rail lines, Amtrak, and ski trains, as well as a 22-bay bus facility and three light rail lines.

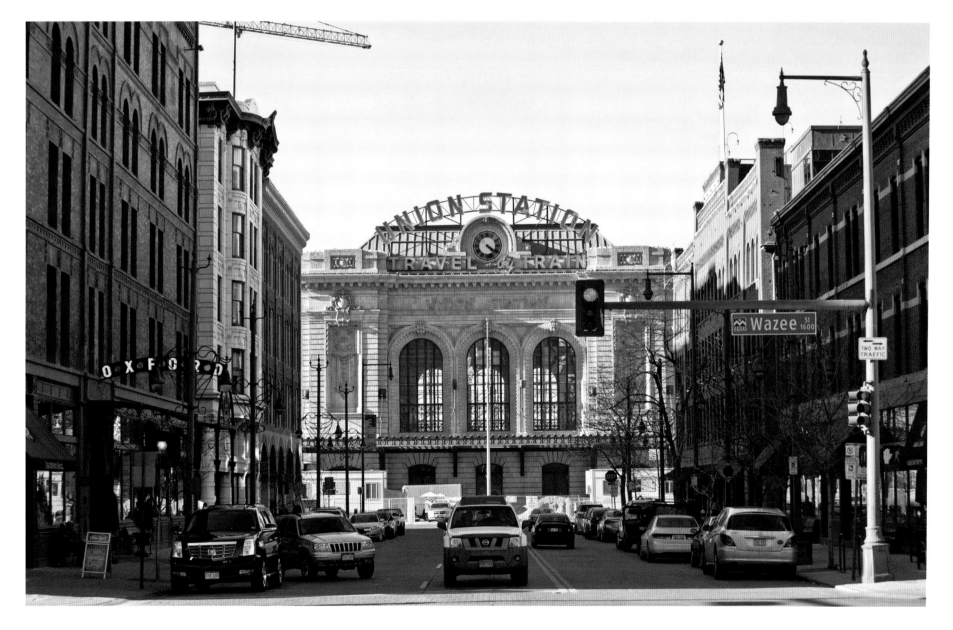

BELOW When it was built in 1881, Union Station was a symbol of Denver's coming of age, its initiation as "Queen City of the Plains." This shot, taken shortly after the main structure's second and final rebuilding in 1914, shows the simpler, more modern face of Denver's railway depot. Gone is the massive clock tower and Italianate architecture of the old building, replaced by the three mammoth arches that are seen today. Although simpler, the depot still offered travelers a marvel to behold: eight-foot chandeliers dangled from its lofty ceilings and bronze sconces dotted the walls. As a mark of the station's uniquely Colorado character, 2,300 Columbine flowers—the state's official flower—were carved into the walls. Trolleys, meanwhile, connected regional travelers coming through the station to the rest of the city by way of 17th Street. The Welcome Arch was deemed a traffic hazard and removed in 1931.

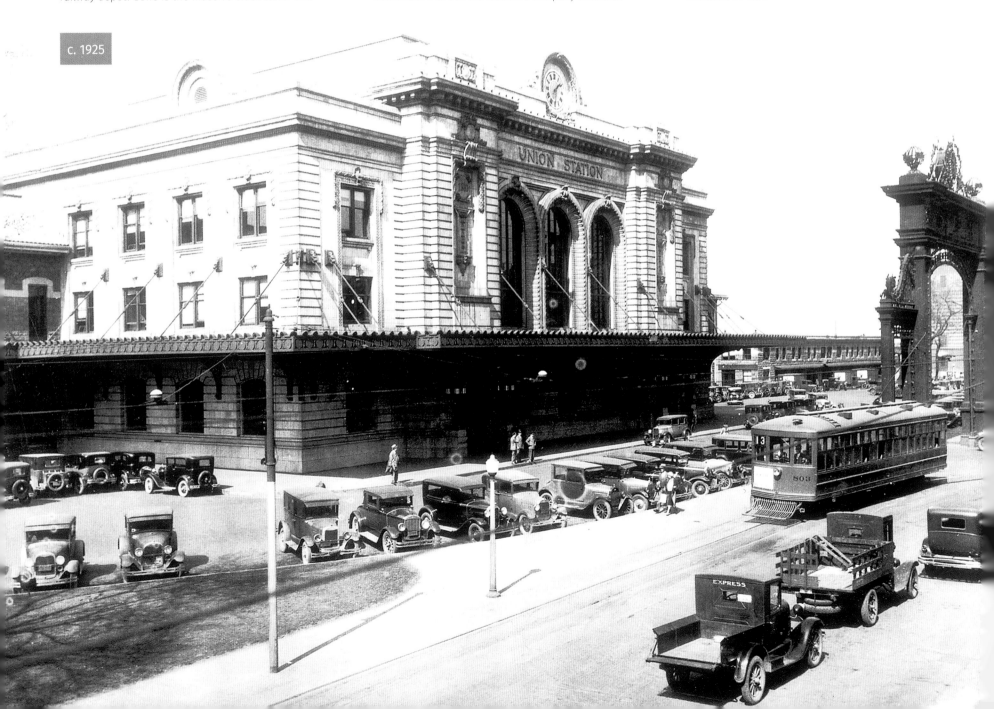

c. 1925

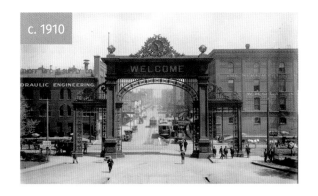

c. 1910

BELOW: Bustling Wynkoop Street is lined with restaurants today, and more appeared in 2014 with the slow completion of the Union Station redevelopment project. Architects and contractors have been careful to preserve the majesty of its great hall, however, with sunlight streaming in from its beautiful 30-foot-high arched windows. The Icehouse, just visible far right, was built in 1903 to flank the train station. It was once the home of Littleton Creamery and Beatrice Foods Cold Storage Warehouse. The building was used for cold storage and refrigeration for some 80 years, until it was converted for more modern usage. Today, the Icehouse is the home to residential lofts, restaurants, and popular bars, and is a prominent feature on the National Historic Register. In the space between the Icehouse and Union Station is a newly constructed staircase, crossing from bustling LoDo into the transportation hub of the expanded Union Station.

LEFT: The view looking through the Welcome Arch down 17th Street.

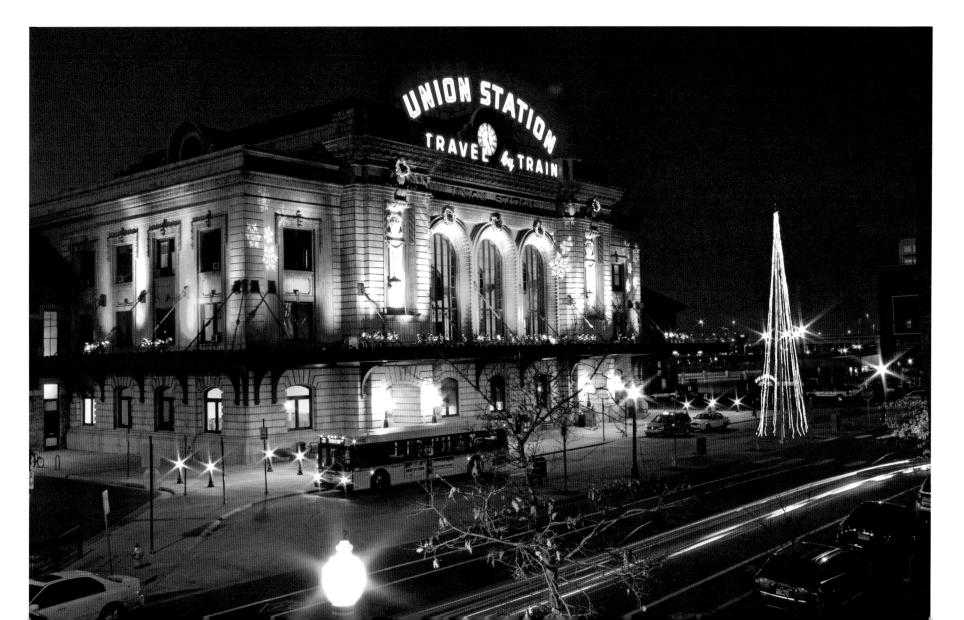

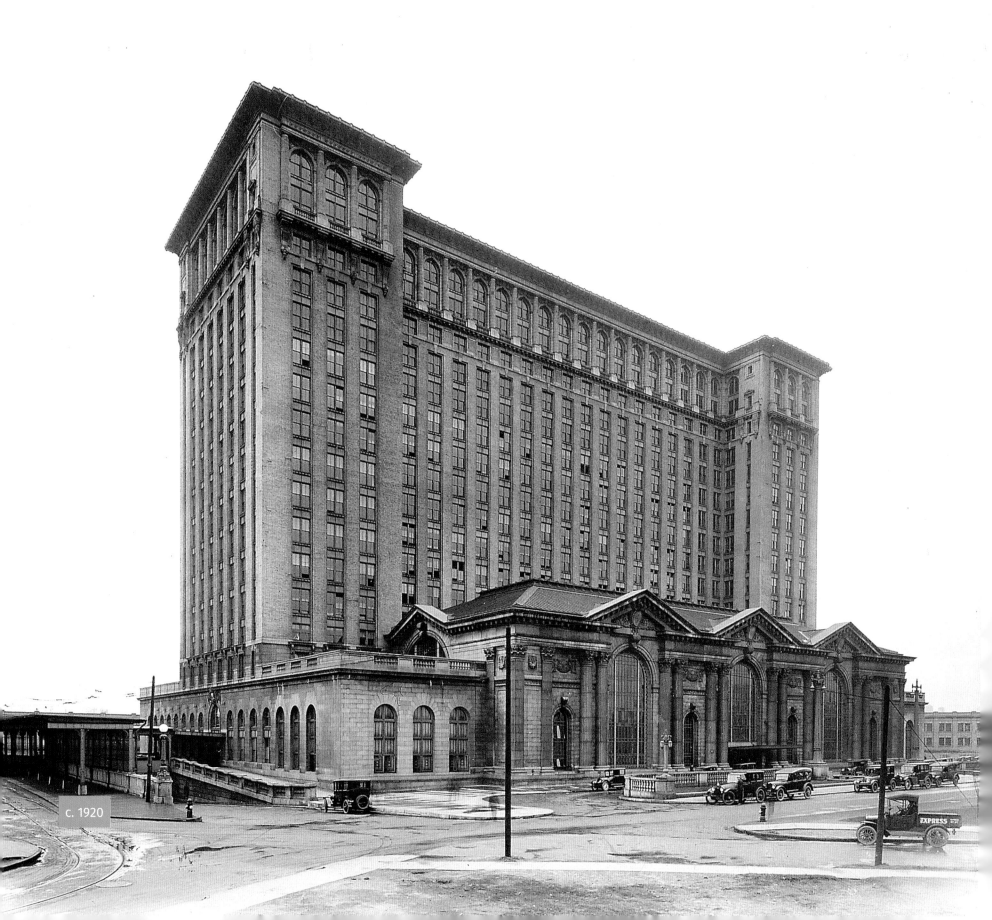

c. 1920

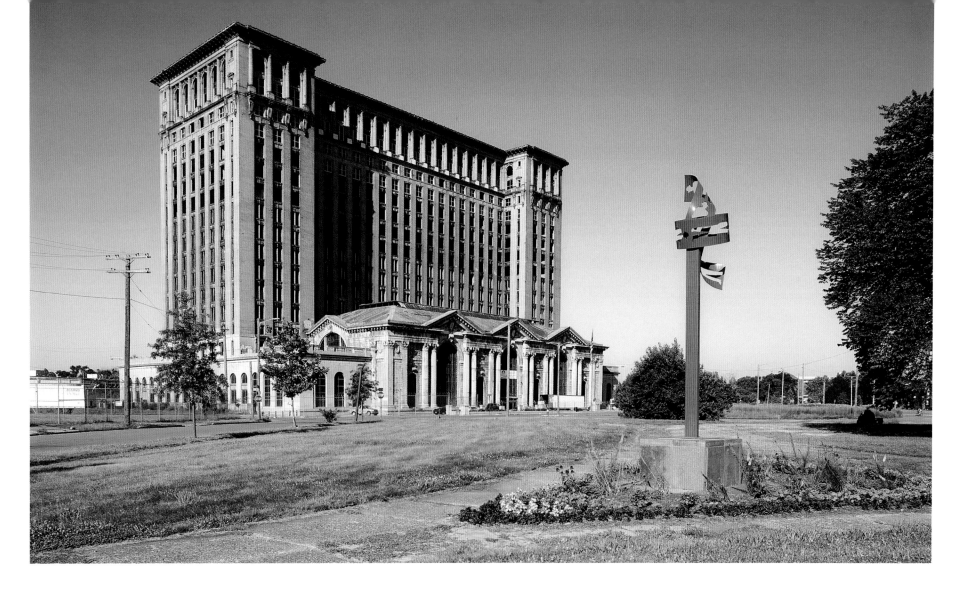

DETROIT | MICHIGAN CENTRAL STATION

Designed by the same architectural firm that built New York's Grand Central Station

LEFT: Opened on December 26, 1913, Michigan Central was designed by Whitney Warren and Charles D. Wetmore, the same architects who built New York's Grand Central Station. A Roman-style waiting room with marble columns and arches is connected to the 16-story office building. At one time, more than 43 trains passed through the depot daily. This photograph, taken around 1920, shows the station from the south side, overlooking what would become Roosevelt Park.

ABOVE: The now-vacant building has been left unprotected from the ravages of time, the elements, and the unscrupulous. Amtrak closed its offices in 1988 and since then various owners and developers have proposed uses for the building, including a casino, retail center, athletic club, and even as a headquarters for the Detroit Police Department. The mammoth structure with its gaping windows has become a symbol of Detroit's so-called decay. Now the Moroun family, whose company owns the train station as well as the Ambassador Bridge, has negotiated a land swap with the city in which they will exchange five acres of their property to be used for a riverside park and replace over 1,000 windows in the train station, in return for three acres of city-owned land for a proposed new bridge span. Even with new windows, there is still no planned use for what once was a jewel of Detroit.

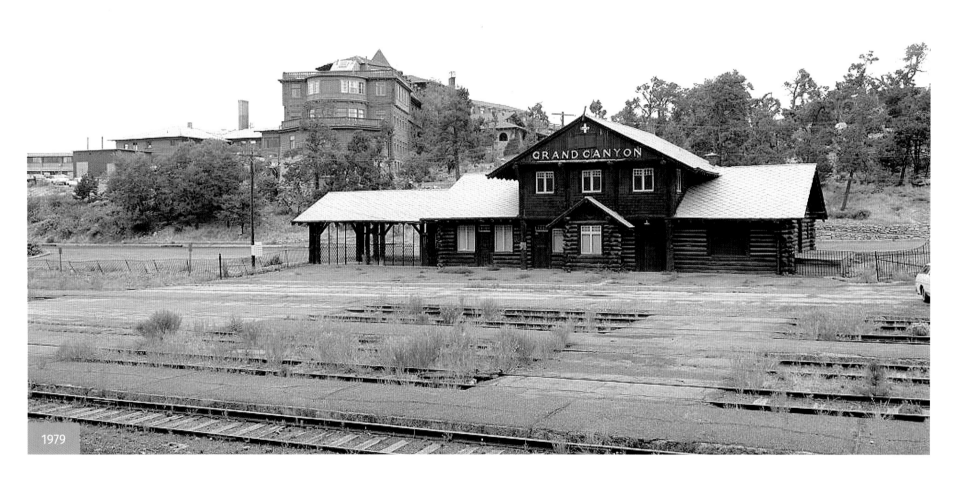

1979

GRAND CANYON STATION
The only passenger station in a National Park

ABOVE AND RIGHT: The original line to the Grand Canyon was built in 1897 to serve a copper mine, but it ran out of money eight miles short of its destination. The Grand Canyon Railway, a subsidiary of the Santa Fe, took over the line and reached the South Rim in 1901. The first depot was small and sited by the Bright Angel Hotel and the station was soon moved east, just below the El Tovar Hotel. Atchison, Topeka and Santa Fe's resident architect Francis W. Wilson designed what would be his only log structure, choosing a complementary style to the El Tovar, and his two-and-a-half-story building was opened in 1910. After passenger numbers dwindled in the 1960s the station was closed in 1968.

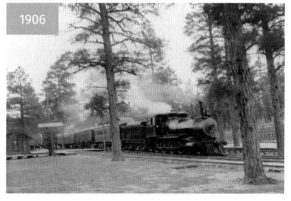

1906

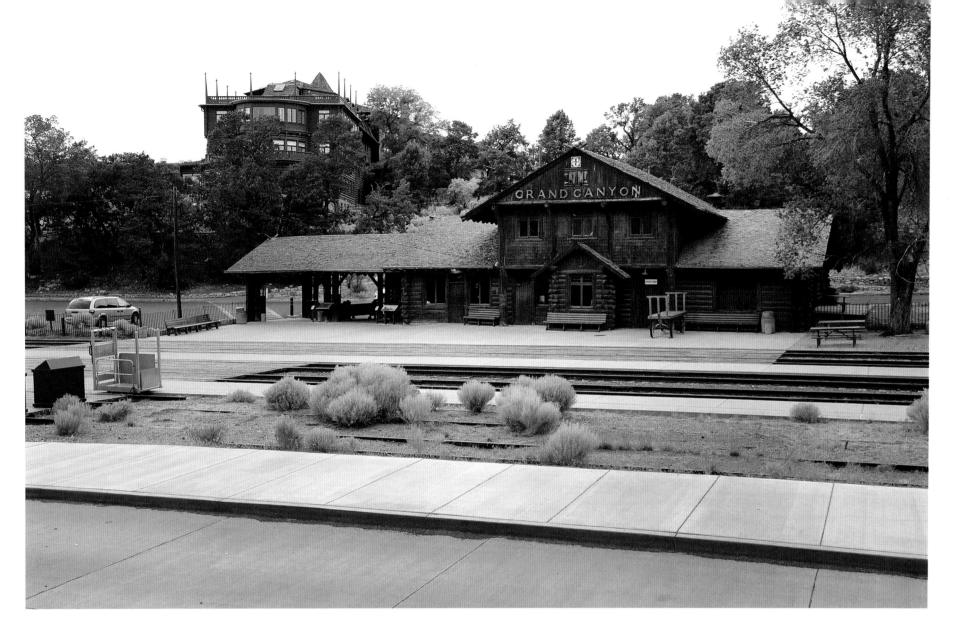

ABOVE AND LEFT: After the National Park Service acquired the redundant line in 1982, the Grand Canyon Railway was put back into service as a tourist line in 1989. Starting out from Williams, Arizona (about 30 miles west of Flagstaff), the journey of 65 miles up to the South Rim crosses 65 bridges, all built before 1900. The train leaves Williams at 9:30 a.m. and takes two hours and 15 minutes to reach the Grand Canyon—45 minutes quicker than in 1901. The train is conventionally pulled by one of six diesel-powered locomotives, but the railway has two working steam locos from 1906 and 1923 which are occasionally employed for the journey. Grand Canyon station has the distinction of being the only working log-built depot in the country and also the only one operating in a National Park.

HOUSTON | GRAND CENTRAL STATION
The tracks remain but a succession of railroad buildings are all gone

1915

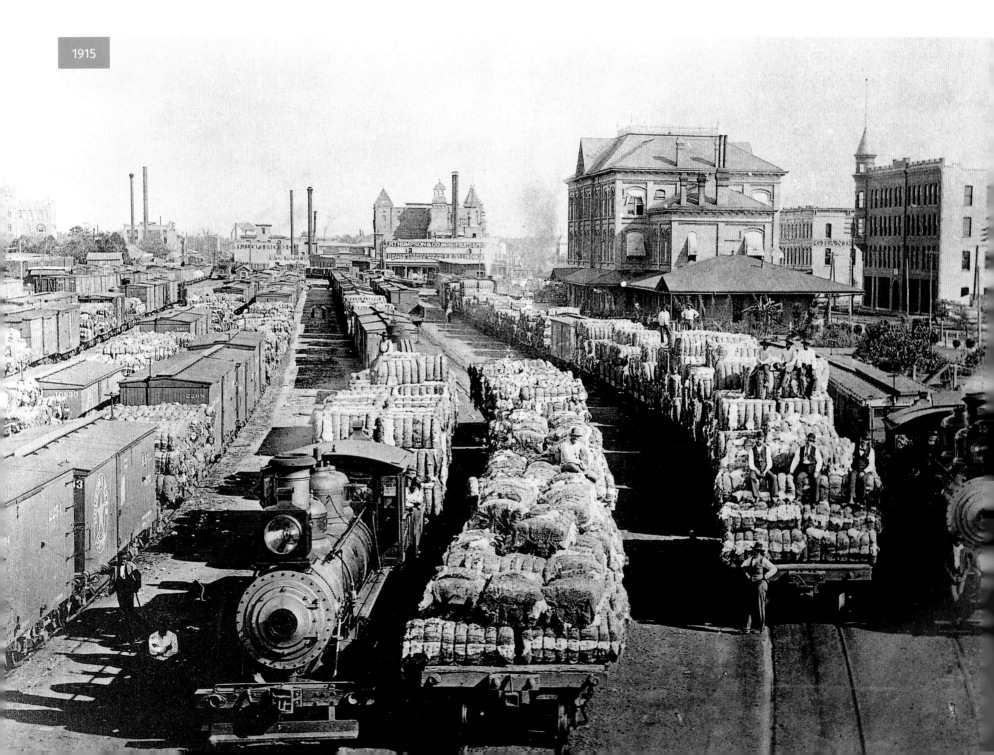

LEFT: Cotton and the railroad were still giants when these bales passed through Houston in the early twentieth century. This site saw more than one structure, and on the right is the old Grand Central Station that was built in 1887 to replace an earlier version. It cost $80,000 to build. Hotels sprang up nearby, and it was a good part of town in which to cater to business travelers. Cotton was big business back then. Rail shipments out of Houston peaked around 1917. The Old City Hall and Market Square can be seen in the background. Just to the right of the old depot building you can just make out the word "Grand." This was the old Grand Central Hotel that once stood at the corner of Washington Avenue and Seventh Street. Popular with business travelers, it offered a ten-course dinner for just 50 cents!

1880

ABOVE: This shot shows the first ever locomotive trip from Houston to New Orleans, Louisiana. The occasion was made possible by the expansion of the Morgan's Louisiana and Texas Railroad. This train set out for New Orleans on August 30, 1880. The trip between the two cities was known as the "Star and Crescent Route."

BELOW: The 1887 Grand Central Station was remodeled in 1906, and then again in 1914. But eventually it was razed and Grand Central's last iteration opened on September 1, 1934. It featured black walnut woodwork, intricate interior murals depicting Texas heroes, and beautiful marble flooring. The last Grand Central Station building was razed in 1961 and a central post office was built in its place. The tracks still follow the same path as the old rail station and the site now serves as an Amtrak terminal. The Gulf Freeway, Houston's first freeway, opened in 1948 and now passes over the site. In a wonderful flashback to the 1934 station's former glory, one of the station's interior murals—painted by artist John McQuarrie—resurfaced in 2012. It had been given to one of Sam Houston's relatives, who had kept it in their laundry room (it was recently sold at auction in Dallas).

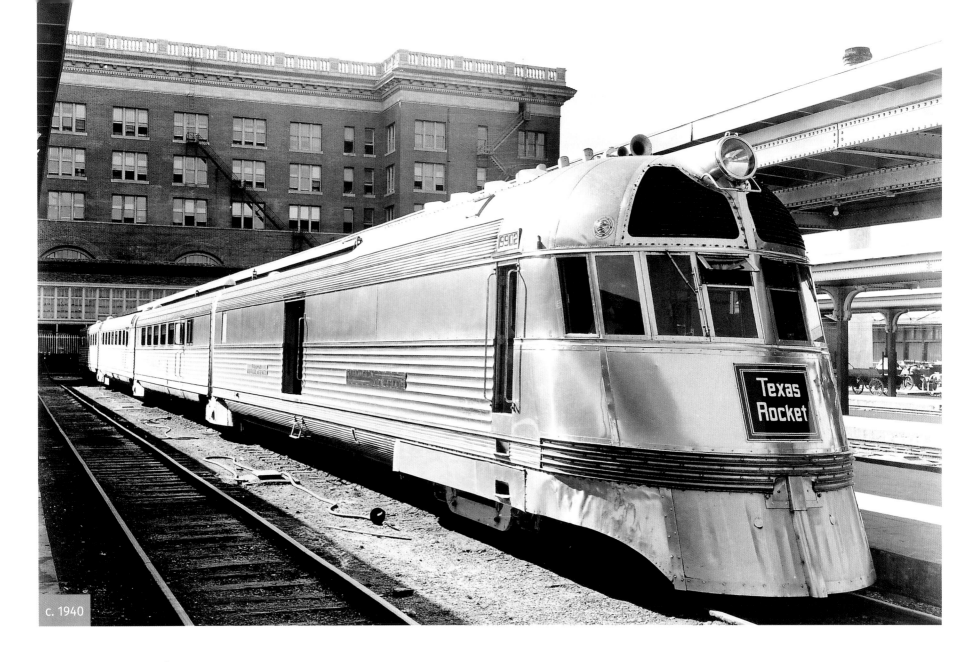

c. 1940

HOUSTON | UNION STATION

Houston's association with "space" travel dates back to the late 1930s

ABOVE: The original Union Station in Houston was built in 1880 and former president Ulysses S. Grant was in town for the station's opening. The more contemporary iteration of Union Station shown here was completed on March 2, 1911. The facility was designed by Warren and Wetmore, who were also the architects behind New York's Grand Central Station. At the corner of Crawford and Texas, the project cost $500,000 dollars and drew a crowd of around 10,000 people on the day it opened. The station had a number of amenities including a Harvey House restaurant, which opened in 1911 and closed in 1948. The Harvey House was a welcome sight for weary travelers in the Bayou City; it served its meals on fine china and a necktie was required of all gentlemen. The Texas Rocket, owned by the Burlington-Rock Island Railroad, ran between Dallas and Houston in the late 1930s. Its counterpart, the Sam Houston Zephyr, also shuttled passengers between the two cities.

RIGHT: Today the only rockets at Union Station come from the pitching mound. The last train left Union Station in 1974, a sad day for a building once so vital to so many Houstonians. In 1999, the facility was renovated into a new baseball park called Enron Field—the $100 million, 30-year name sponsorship being an obvious win-win for all parties. Following the corporate demise of Enron, the stadium came to be known as Minute Maid Park, home of the Houston Astros (you can see some of the new sponsors back in the outfield). The old terminal buildings are used for administration and the team store. Minute Maid Park seats over 40,000 under a retractable roof. Its first game was an exhibition between the Astros and the New York Yankees on March 30, 2000.

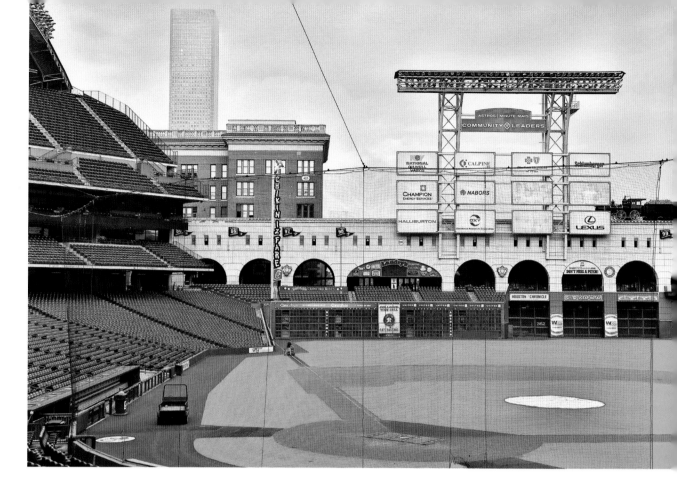

c. 1914

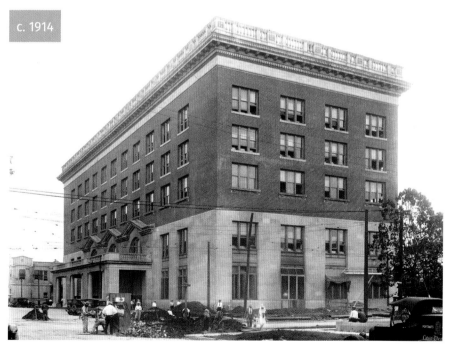

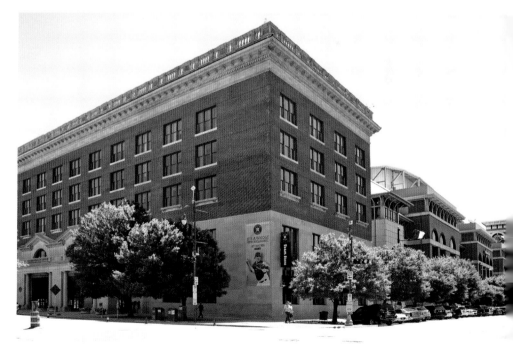

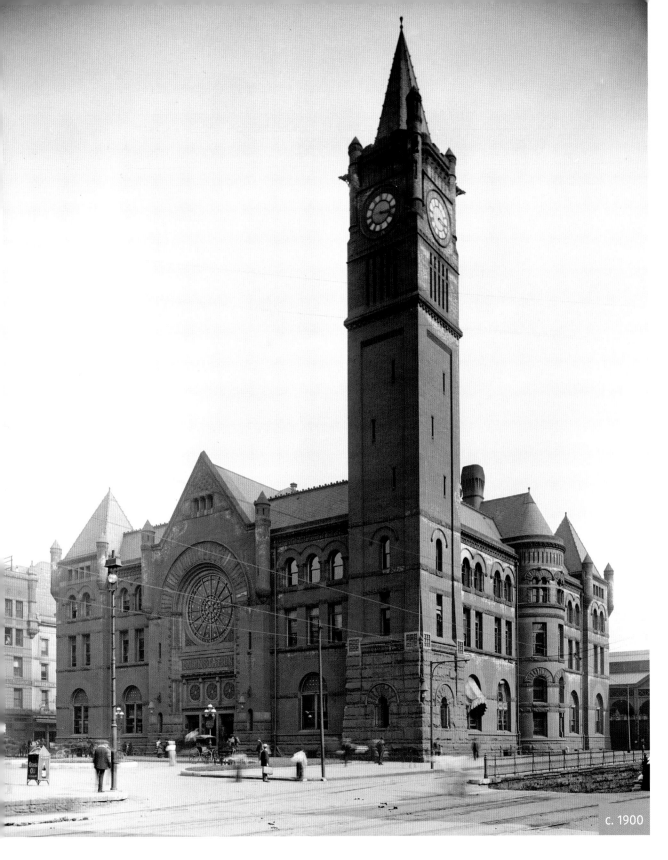

c. 1900

INDIANAPOLIS | UNION STATION
At the "Crossroads of America"

LEFT: In its heyday, thousands of passengers bustled daily through Union Station, at 39 Jackson Place, from soldiers (and their teary sweethearts) during World Wars I and II to college students and vacationers. Legendary trains such as the Spirit of St. Louis that roared through Union Station helped spur the "Crossroads of America" nickname for Indianapolis; at the station's peak, more than 200 trains came through each day. The snow-white Santa Claus in the photo from 1949 was a 51-foot-high "Santa Colossal" made of Styrofoam. He "spoke" recorded Christmas greetings to visitors at the Indianapolis Industrial Exposition; postcards with this image were handed to thousands of yuletide passengers at the terminal. When efforts to find a permanent home for Santa failed, he was chopped up to become insulation.

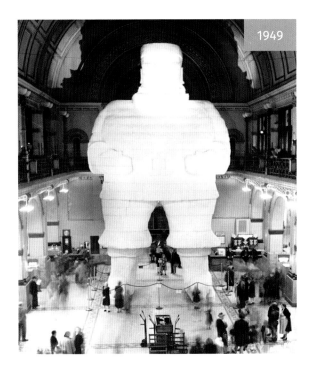

1949

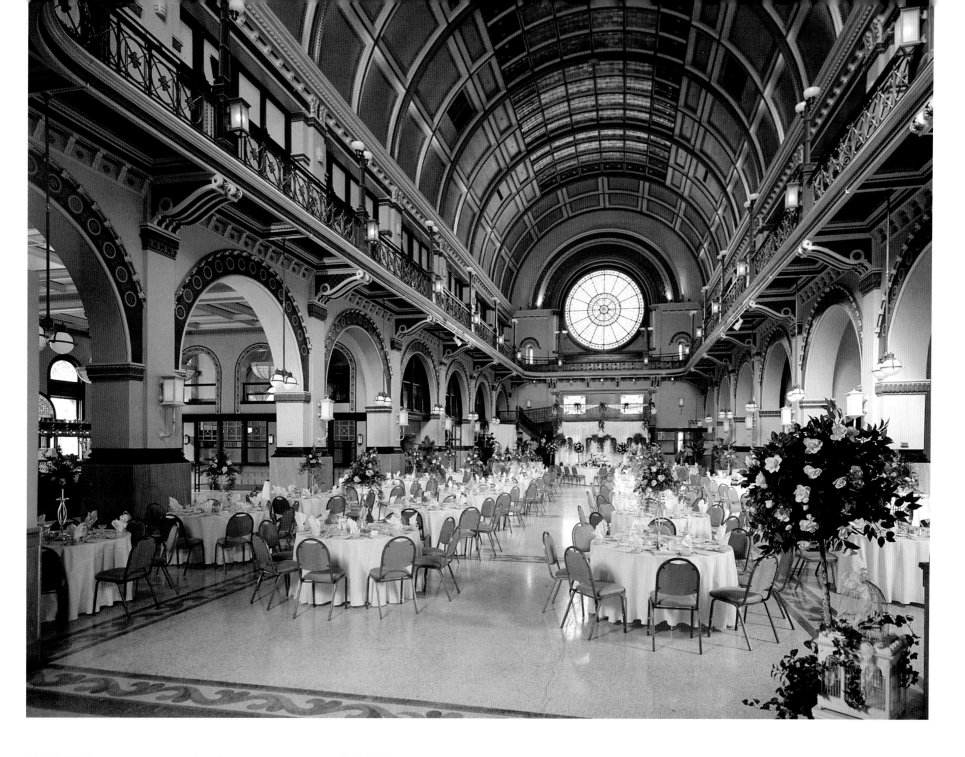

ABOVE: This former concourse, or headhouse, was nearly demolished, along with the rest of the train terminal, in the early 1970s. With the decline in passenger rail service, traffic at Union Station had nearly vanished and Penn Central, the station's owner, filed for bankruptcy. A New Year's Eve party in late 1971 was staged to raise money to save the station, which eventually was placed on the National Register of Historic Places. The bumpy path continued, though, even after a $30 million restoration in which Union Station reopened in 1986 as a "festival marketplace" of boutiques and restaurants. The concept fizzled and the city government searched for new buyers. In 1999 Crowne Plaza leased the facility for a banquet hall and conference center.

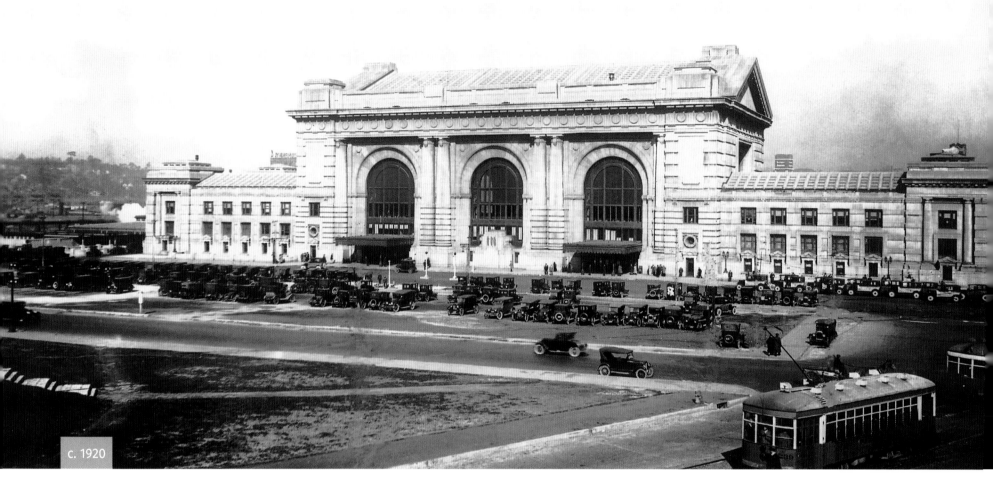

c. 1920

KANSAS CITY | UNION STATION

Kansas built a union station to rival that of Washington, D.C.

ABOVE AND RIGHT: After the Union Depot flooded in 1903, city leaders agreed that a new station was needed. The second station, on higher ground and accessible to downtown, was a massive structure in the Beaux-Arts style, designed by Chicago architect Jarvis Hunt. Parades and a 21-gun salute marked the grand opening on October 31, 1914. The enormous building, with its 352-foot waiting room, could accommodate over 10,000 people, while covered walkways protected passengers as they arrived and departed by train. The station's most notorious event occurred in 1933 when gangster Frank Nash was being escorted to Leavenworth Prison. His cronies shot and killed four officers—and Nash himself—in a bungled attempt to help him escape.

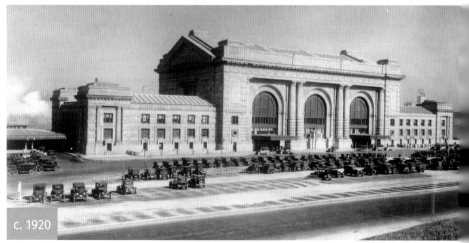

c. 1920

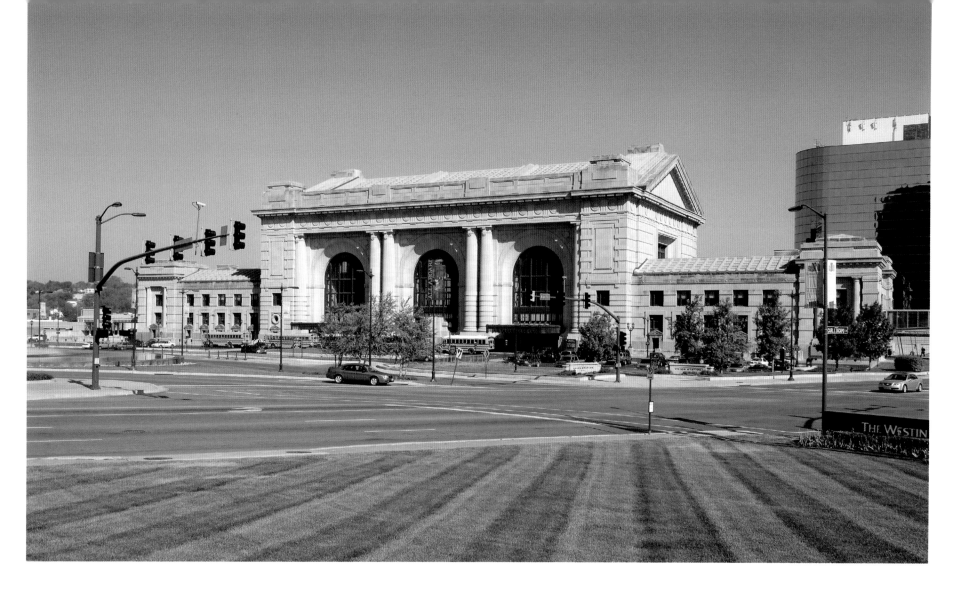

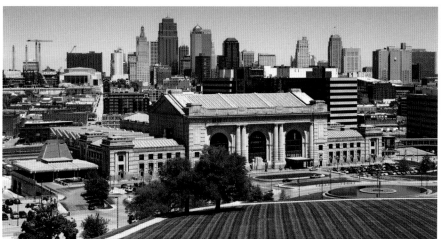

ABOVE AND LEFT: Union Station was abandoned in 1983 because of leaking roofs, reduced railroad traffic, and general neglect. But in 1996, a bistate tax in Missouri and Kansas raised the money to give Union Station a new lease on life and it reopened in 1999 with nearly as much hoopla as its first opening in 1914. Now the fountains on Pershing Road provide an elegant welcome as visitors enter through the heavy wooden doors to see the station's completely restored interior. Marble floors and beautiful ceilings and windows have turned the station into a center that includes movie theaters, restaurants, and Science City and its planetarium. The imposing clock, a popular meeting spot, has been painstakingly restored, and artworks by Thomas Hart Benton Gude (grandson of artist Thomas Hart Benton) are on display. The contemporary office building at the far right in the top photograph is called #2 Pershing Square.

1910

LAS VEGAS | RAILROAD DEPOT

The railroad depot was instrumental in driving the development of Las Vegas

ABOVE AND RIGHT: In 1902 Senator William Clark purchased the Las Vegas Rancho property on behalf of the San Pedro, Los Angeles and Salt Lake Railroad. On May 15, 1905, the land, now carved up into parcels, was auctioned off as Clark's Las Vegas town site. This view looking southwest from the top of the Arizona Club in 1910 shows how quickly the town took shape. The prominent Mission-style building is the railroad depot, constructed near Fremont and Main in December 1905. A contemporary newspaper article from the *Las Vegas Age* described the outer walls of the depot as buff-colored with contrasting terra-cotta tile roofing. The two-story building had telegraph rooms and dressing rooms for the train crews on the second floor, while most of the first floor was taken up with a large waiting room, ticket office, baggage room, and "a ladies waiting room of liberal proportions."

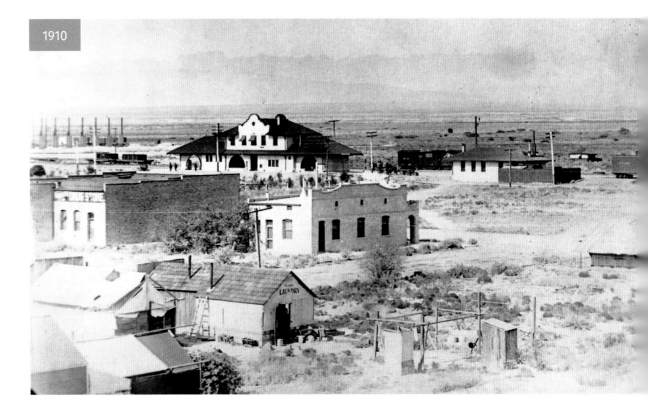

1910

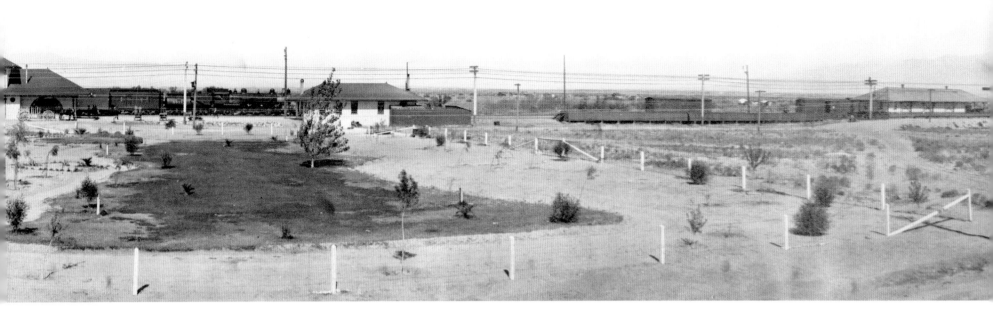

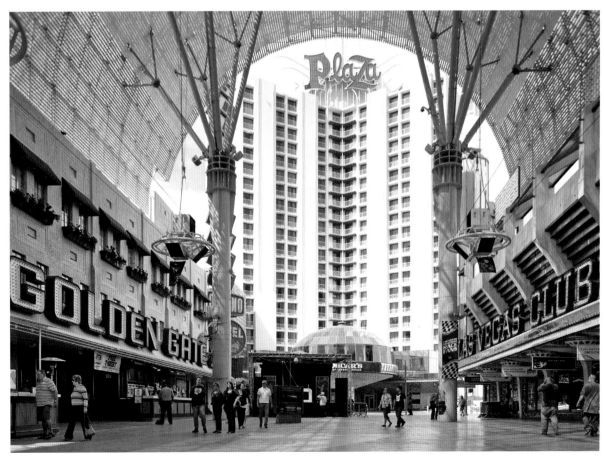

LEFT: More than a hundred years later, there are few reminders of the important role the railroad played in the development of downtown Las Vegas. Where once the residents were dwarfed by the vastness of the surrounding desert, today tourists are dwarfed by the hotel high-rises and canopy of the Fremont Street Experience. The recently renovated Plaza Hotel stands tall on the site of the original railroad depot, while its modernistic dome projects onto the porte cochere area of the hotel. The hotel itself was constructed on the park grounds of the former railroad depot, and the actual tracks still remain behind the hotel.

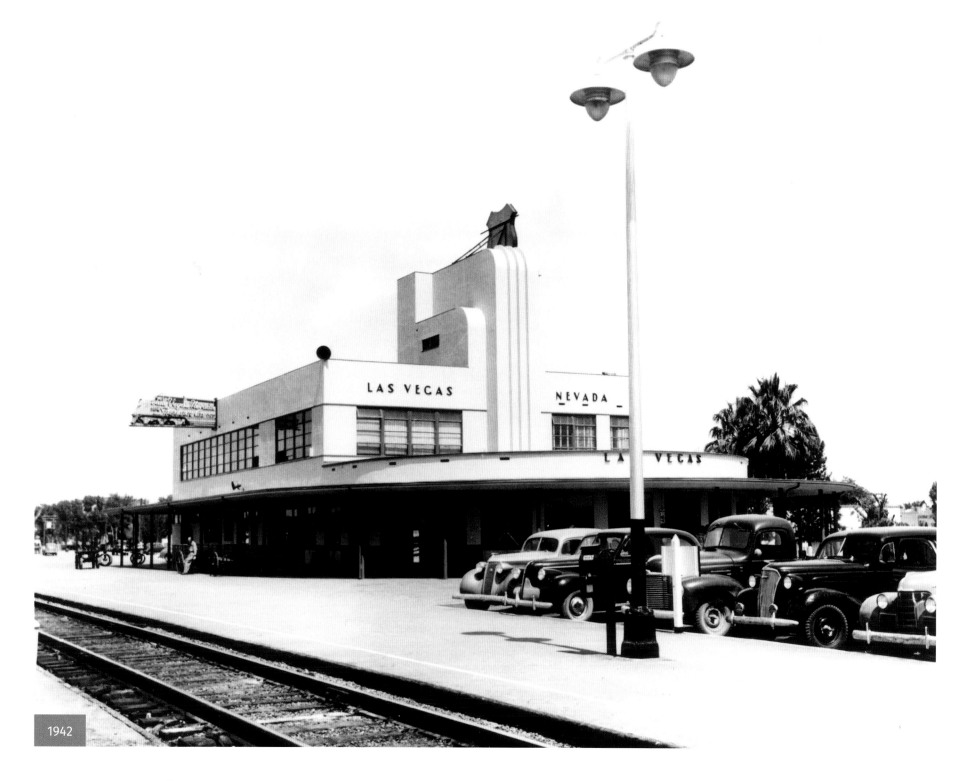

1942

LAS VEGAS | UNION PACIFIC STATION
The station was demolished in 1970 to make way for the Union Plaza Hotel

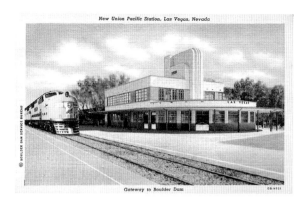

New Union Pacific Station, Las Vegas, Nevada

Gateway to Boulder Dam

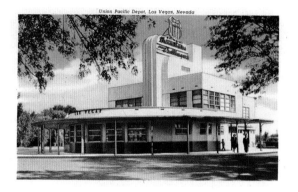

Union Pacific Depot, Las Vegas, Nevada

ABOVE: The City of Las Vegas was the passenger train operating between Las Vegas and Los Angeles in December 1956. In September 1961, the train was renamed the Las Vegas Holiday Special. The service was discontinued in June 1968.

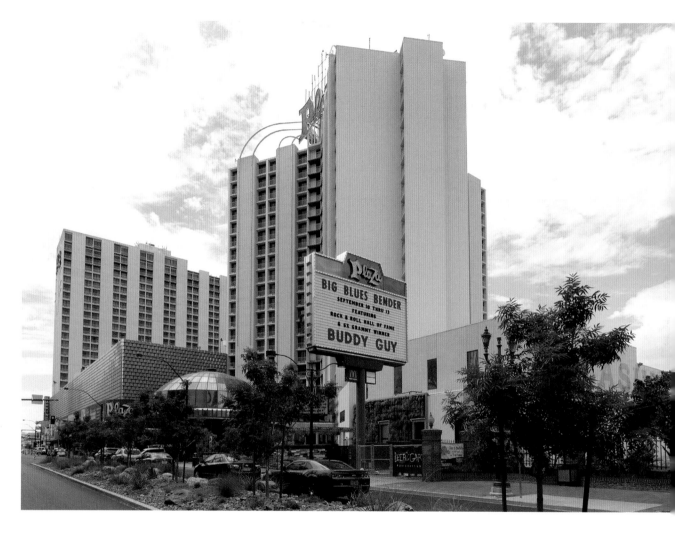

LEFT: In 1940, the gleaming new Union Pacific Station took the place of the original Mission-style Salt Lake Depot at Main and Fremont. Contemporary publicity described it as being in the "typical modernistic western motif" style and billed the Union Pacific Station as "the first streamlined, completely air-conditioned railroad passenger station anywhere." Over the years, the station became something of a downtown landmark. In the 1950s and 1960s, a typical Saturday night for Las Vegas teenagers would include "dragging" Fremont Street in their cars, and then driving around the circle in front of the station.

ABOVE: After passenger train service to Las Vegas was discontinued, the 26-story Union Plaza Hotel was constructed just in front of the original Union Pacific Station as a joint venture between the Union Pacific Railroad and a private corporation. The hotel opened on July 2, 1971, with what was then the world's largest casino. Downtown casino mogul Jackie Gaughan, one of the original partners in the Plaza's construction, became its main owner in 1993, and renamed the hotel Jackie Gaughan's Plaza Hotel and Casino. In March 2004, Gaughan sold most of his downtown properties, including the Plaza. It was closed briefly

in 2010 in order to carry out a number of renovations to the aging property. The $35 million renovation included extensive changes to the lobby, casino, guest rooms, and suites, bringing a sleek new look to the Plaza's decor with elegant furnishings, fixtures, and coverings purchased from the Strip's Fontainebleau Resort after it suspended construction. The renovated hotel opened in August 2011 and later that year, Oscar Goodman, the popular and gregarious former mayor of Las Vegas, opened Beef, Booze & Broads, an upscale steakhouse, in the elevated dome space located just in front of the hotel.

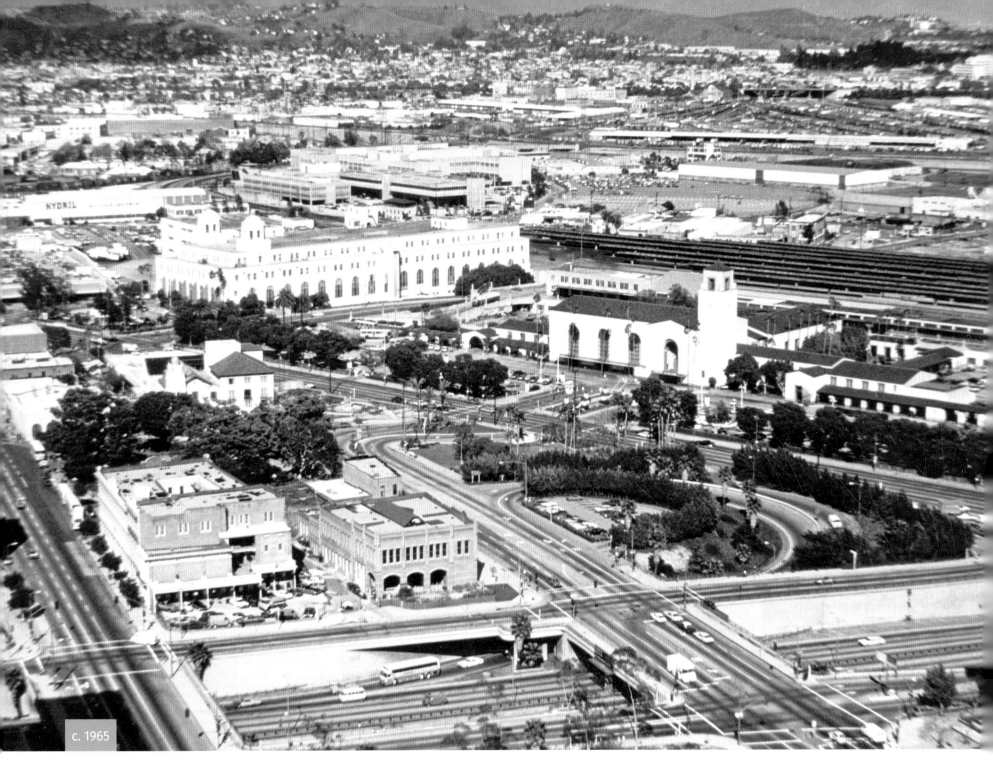

c. 1965

LOS ANGELES | UNION STATION

Back from the brink, Union Station bustles again in the new century

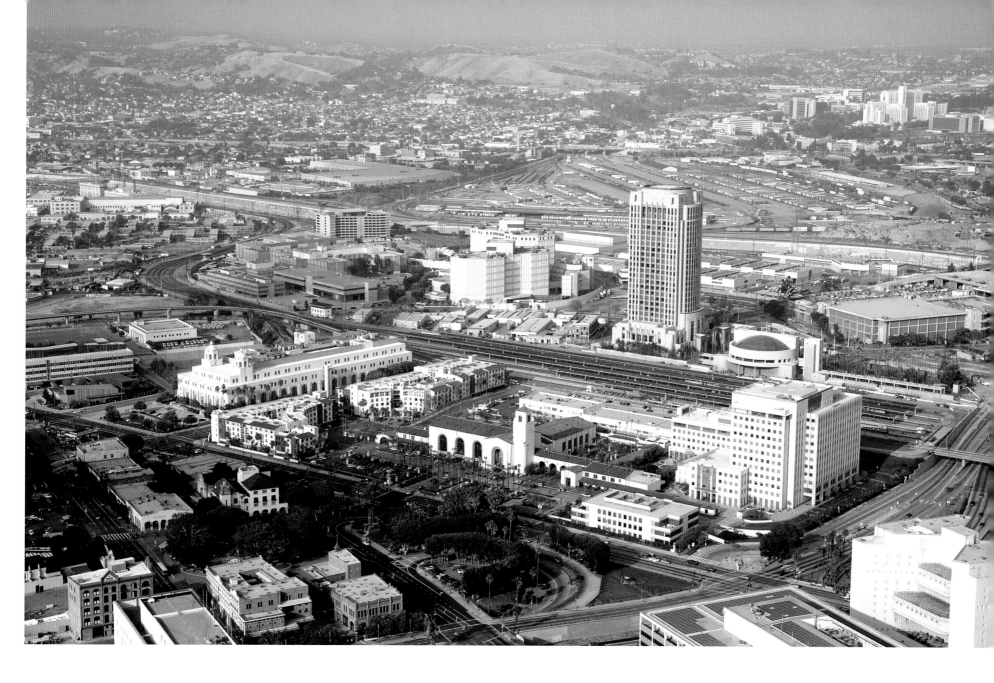

LEFT: A civic gala opened Union Station in 1939 on Alameda Street (the former site of Old Chinatown). It served the Southern Pacific, Santa Fe, and Union Pacific Railroads, and was designed by John and Donald Parkinson in a Spanish Mission style, with carved ceilings, marbled floor, and a 135-foot clock tower. Before air travel became popular, Union Station was the arrival and departure point for all Los Angelenos, including wartime GIs and movie stars such as Greta Garbo and Cary Grant.

ABOVE: Considered the last of America's great railway stations to be built, Union Station fell on hard times when air travel became widespread in the 1970s. The 1990s saw a resurgence at Union Station when the Metro Line Subway Terminal opened. Amtrak's Coastal Starlight and San Diegan emerged as the new favorite way to travel and the station's Traxx restaurant the place to eat. In 2011 the L.A. Metropolitan Transportation Authority bought Union Station for $75 million. They added several retail and dining businesses to the concourse and, in September 2013, opened the Metropolitan Lounge for business travelers. A popular location for film and television companies, with over 60 filming sessions a year, this distinctive setting can be seen in many films, including *The Way We Were*, *Blade Runner*, and *The Dark Knight Rises*.

LOS ANGELES | UNION STATION

The original tiling remains, but the passenger information has gone digital

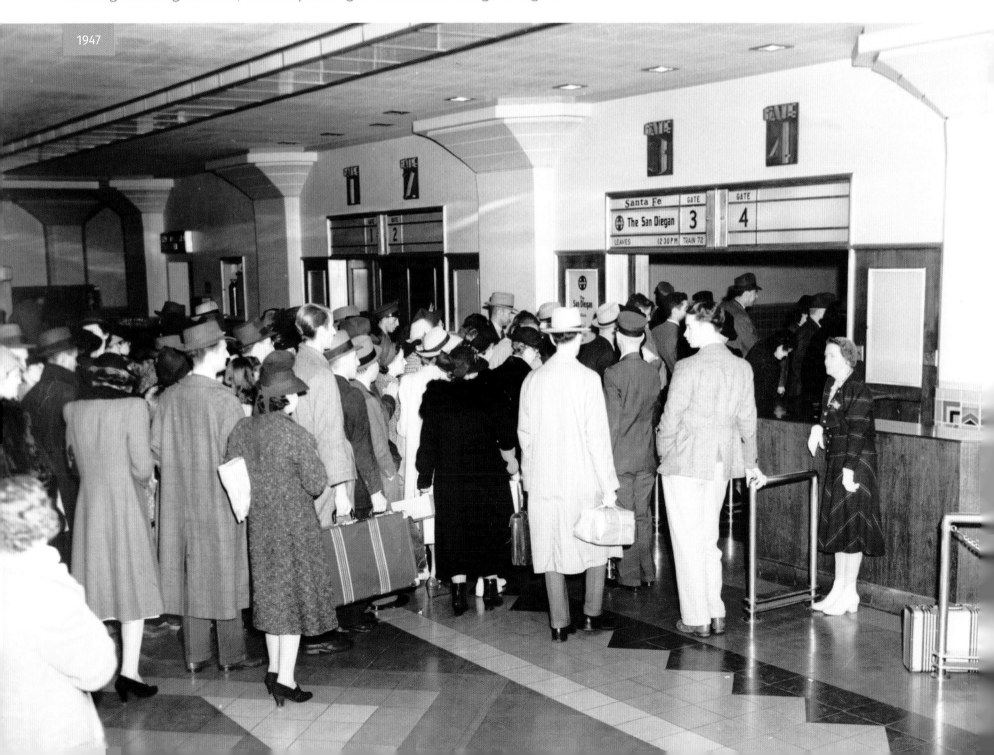

1947

1947

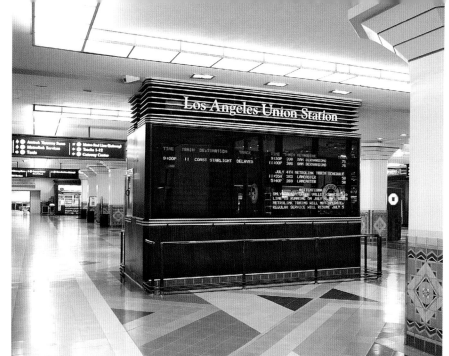

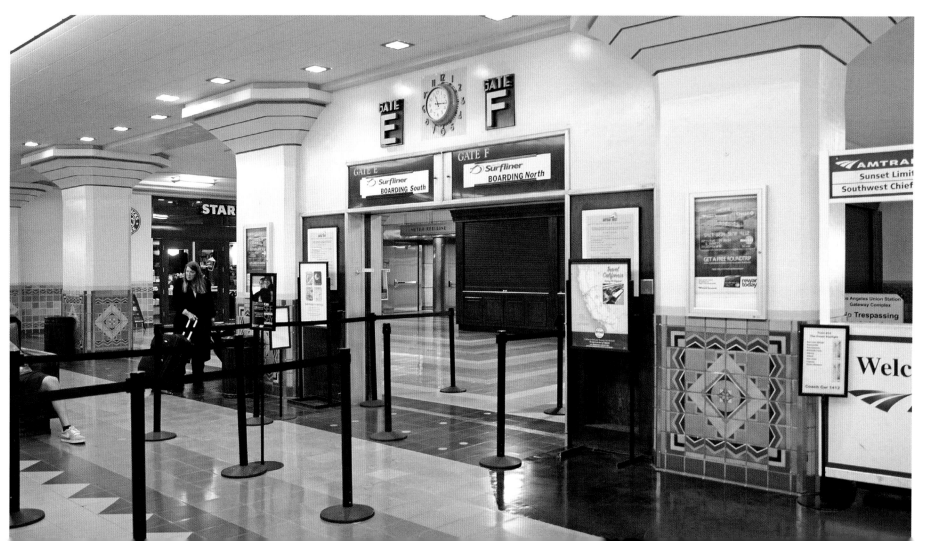

1906

LOUISVILLE | UNION STATION
Once the largest railroad station in the South

LEFT: It took nine years to construct but the Union Station in Louisville was built to last. It was the work of architect F. W. Mowbray, who was hired to design a station in the then-fashionable Richardsonian Romanesque style. It was formally opened in 1891 and it superseded a number of smaller stations in Louisville, including one at Tenth and Maple. The exterior of the station was mostly in Bowling Green limestone, cut in ashlar blocks where the adjoining faces were cut smooth, with the exterior face left rough with a quarried-stone look. The interior walls were made of Georgia marble and a wrought-iron balcony overlooked an impressive atrium with rose-colored windows on both sides. When it was opened it was said to be the largest station in the South and the second largest in the West after Chicago. In 1905 a fire put it out of use and when it re-opened the rose-colored windows had been replaced by a stained glass skylight made up of 84 panels.

ABOVE: Union Station served primarily the Louisville and Nashville (L&N) Railroad, along with the Pennsylvania Railroad, the Monon Railroad, and the Louisville, Henderson and St. Louis which was later absorbed by the L&N. The station's heyday was the 1920s, when 58 trains a day would pull in or out. This volume was increased during the annual Kentucky Derby at Lexington when an extra 20 trains a day were put on for racegoers. In 1937 the Ohio River flood caused extensive damage to the main floor and basement and resulted in the station's temporary closure. The Transit Authority of the River City (TARC) bought the grand edifice in 1978 and tore up the tracks and trainsheds to the southwest of the station. Between 1979 and 1980 they spent $2 million restoring it and converting it to their administration building.

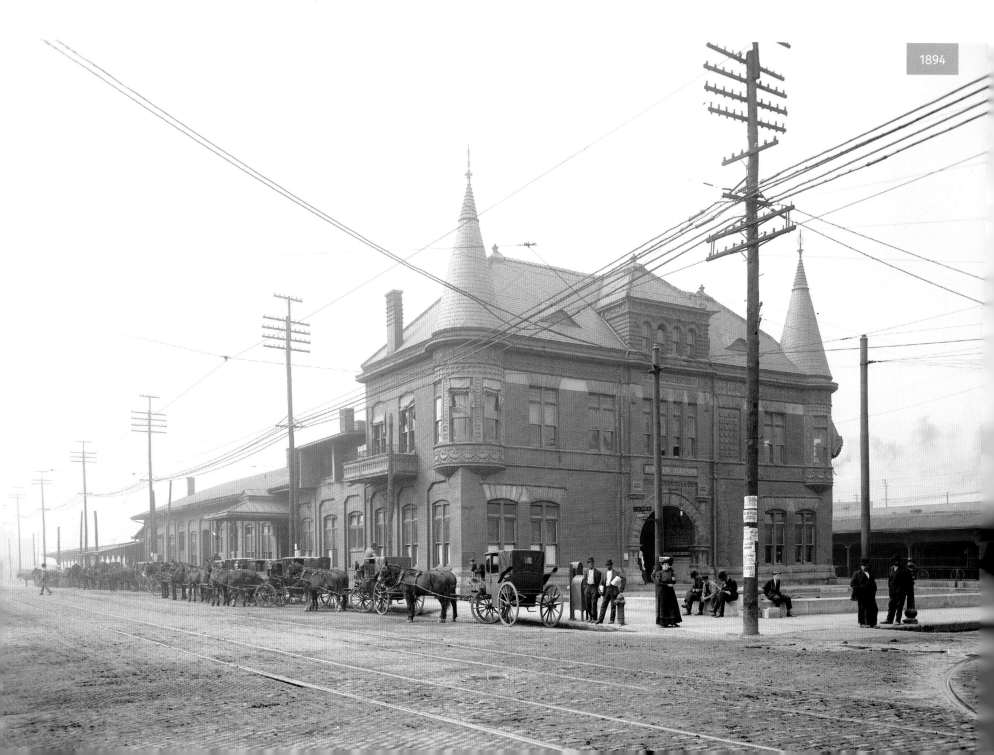

MEMPHIS | ILLINOIS CENTRAL STATION

The station from which Casey Jones departed on his final, fatal run

1894

LEFT: In 1893 Memphis trumped all river rivals by opening the Frisco Bridge across the Mississippi River. Even then, an Illinois Central train was present. Having for years been a railroad junction, the Memphis bid for a bridge was aided by the opening of the Illinois Central Station in the heart of the city. Built at the corner of Main and Calhoun in 1888, the Illinois Central Station was sometimes referred to as Union Station due to the many freight lines that converged there. Some years later, an official Union Station joined the Memphis lines. The photo shown here was taken in 1894. The station gained enduring fame in 1900 when it was the site of Casey Jones's last departure on his way to one of the most famous train wrecks in history.

BELOW: In 1914 Illinois Central completed a new station at the same location as the old. Known as Grand Central Station until the end of World War II, it has since been referred to as Central Station. Solely owned by Illinois Central, the station served a number of passenger lines, including the Frisco, the Rock Island and, much later, Amtrak. Amtrak now owns the station. It carries one line, the City of New Orleans, and also serves the Memphis Riverfront and Main Street trolley cars. The name of Calhoun Avenue has now been changed to G. E. Patterson Boulevard. The building's beautiful 1914 facade remains, but the once-grand station now services just a single platform.

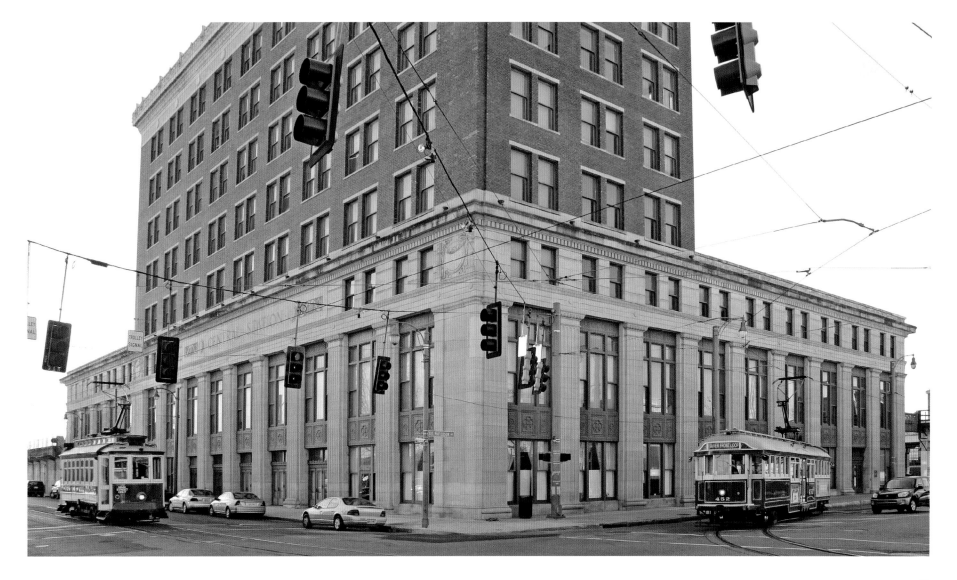

MILWAUKEE | CHICAGO AND NORTH WESTERN DEPOT

This imposing depot served Milwaukee for more than seventy years

1899

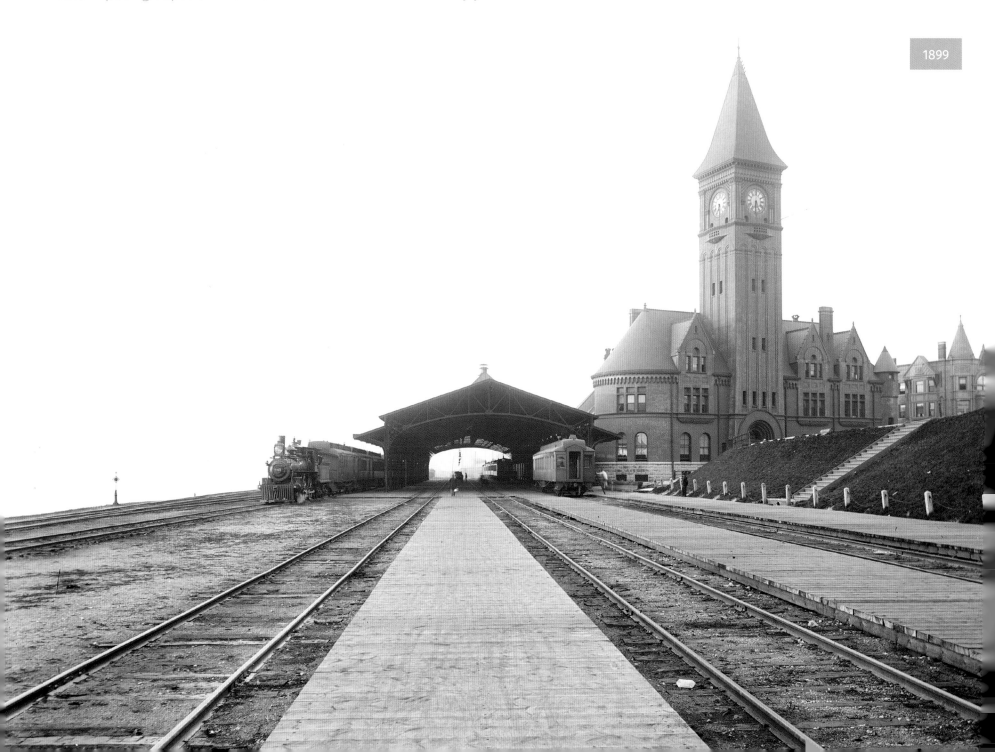

1928

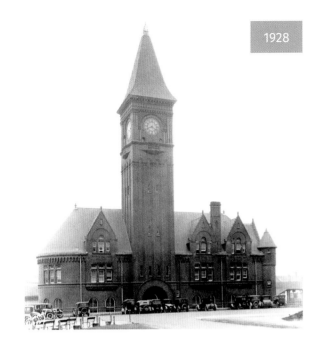

LEFT: The Chicago and North Western Railroad built this imposing depot in 1889 on the lake bluff at the end of Wisconsin Avenue, where its Romanesque tower stood for more than 75 years. The railroad was organized in 1859 and was a conglomeration of older railroad lines that suffered failure in the Panic of 1857—when a series of financial scares caused widespread economic depression. The North Western moved into Wisconsin from Chicago. Banker Alexander Mitchell became a railroad magnate and his Milwaukee Road line competed with the Chicago and North Western for regional dominance.

BELOW: In 1968, despite efforts to save the depot, the structure succumbed to the wrecker's ball. After the depot was razed it was replaced by a park, which at one time displayed a series of photo panels commemorating the Chicago and North Western Railway Station. In the early 1990s, construction began on the O'Donnell Park complex. In addition to a parking structure and large terraced area, there is the Miller Pavilion that houses a restaurant and the Betty Brinn Children's Museum. The clock on the pavilion's facade is from the old Union Station (Milwaukee Road Depot)—now on the site of the Chicago and North Western Road Depot. A bike and walking path now follows the route of the old train tracks just above Lincoln Memorial Drive.

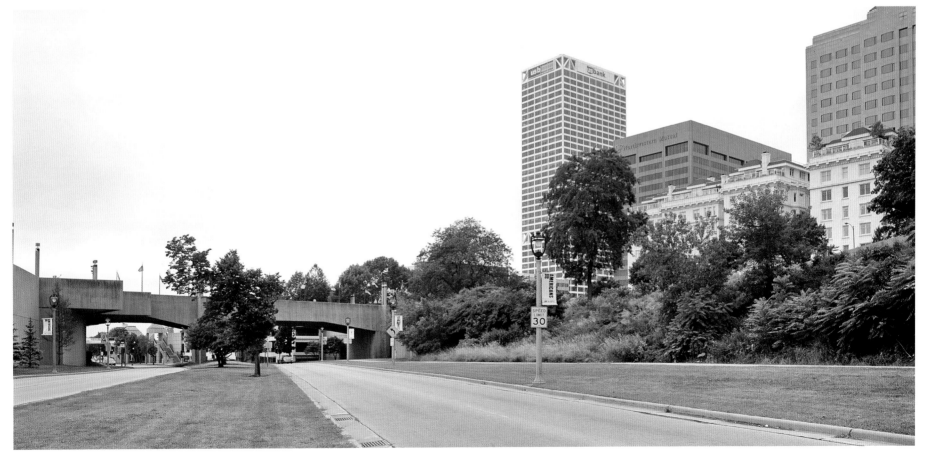

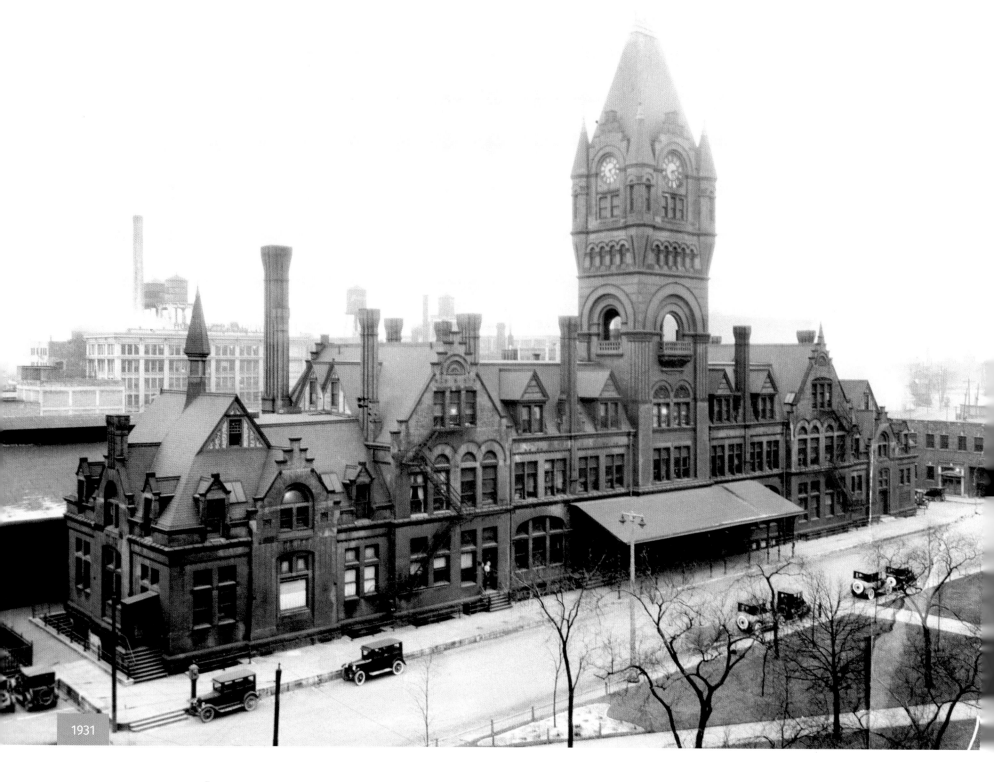

1931

MILWAUKEE | UNION STATION
Local architect Edward Townsend Mix designed the Gothic Revival depot

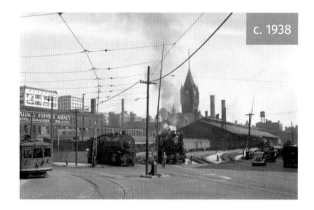

c. 1938

LEFT: Alexander Mitchell, a prominent banking figure in Milwaukee, led the way in railroad development of the area. Mitchell knew that a railroad network, along with the Great Lakes water route, was essential to the industrial and commercial growth of Milwaukee and the surrounding areas. Mitchell reorganized the bankrupt Milwaukee and St. Paul Railroad and served as its president. The general office was located in the Mitchell Building downtown. The main shops were located in the Menomonee River Valley and the station was located just south of Michigan and Third Street along the banks of the Menomonee River. The Milwaukee Union Station (also known as the Milwaukee Road Depot and the Everett Street Depot) was designed by Edward Townsend Mix and erected in 1884.

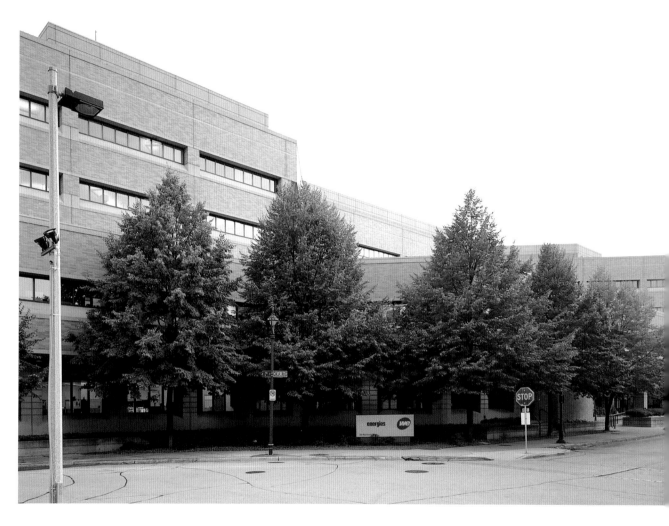

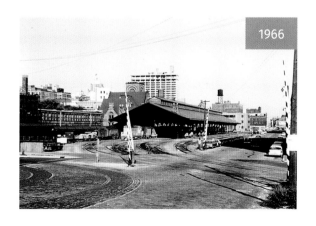

1966

ABOVE: In 1965 the Milwaukee Road Depot was closed and the building was razed in 1966. Wisconsin Electric Power Company, now called We Energies, added a five-story parking structure on the site in 1984 and a five-story annex that houses offices, laboratories, and computer facilities in 1986. Skywalks link the parking structure and annex to the restored headquarters building. Across from the annex is Zeidler Park, an early public square, which is named for Mayor Carl Zeidler and contains a Wisconsin Workers Memorial.

LEFT AND ABOVE LEFT: Two views of the depot taken from St. Paul Avenue: the lower one was taken by Ray Szopieray in 1966 just as the top of the Gothic clock tower had been removed.

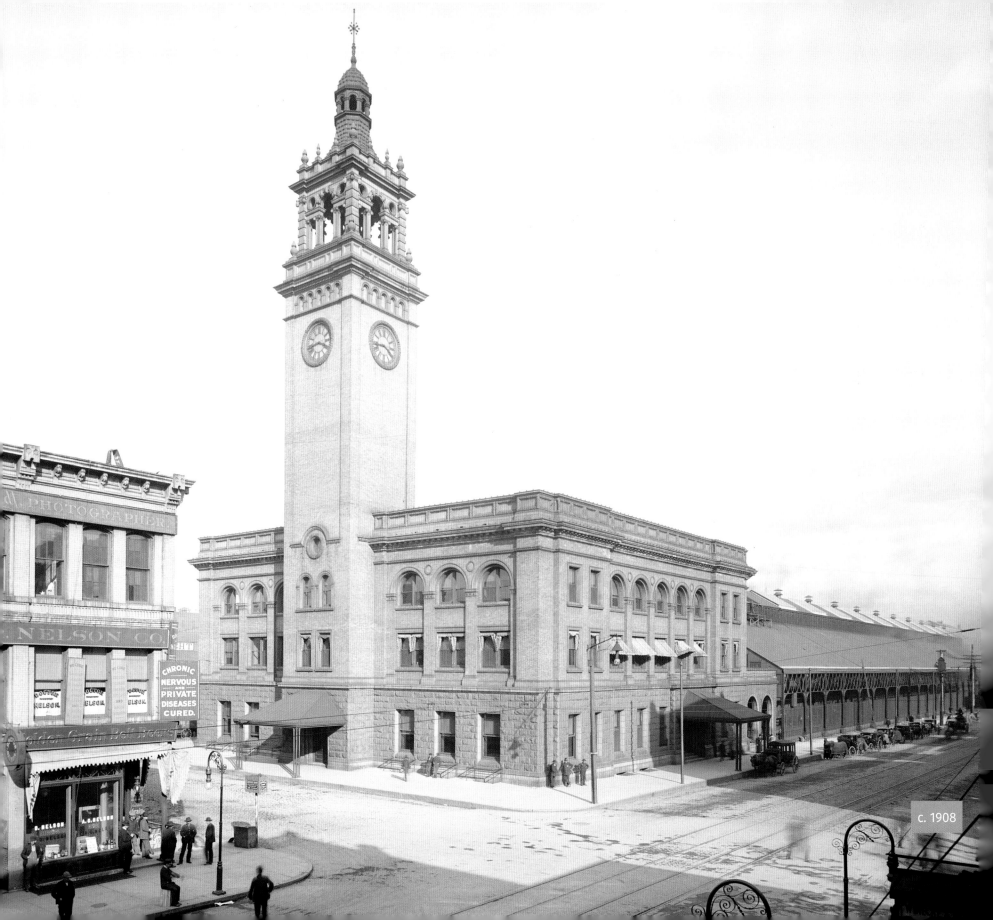

CHRONIC
NERVOUS
AND
PRIVATE
DISEASES
CURED.

c. 1908

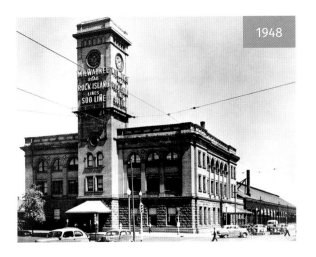

1948

MINNEAPOLIS | MILWAUKEE ROAD DEPOT
No longer a place to catch trains, the 1899 station is now a hotel

LEFT: The first major depot in Minneapolis was built in 1879 in Italianate style. It didn't last long. Twenty years later it was superseded by this grand Renaissance Revival structure at Washington and Third Avenues, with a clock tower modeled on the Giralda in Seville, Spain. In 1916 there were 15 passenger trains a day and by 1920 that had risen to 29. The station lost its distinctive peaked tower in stormforce winds in 1941 and continued with a flat-roofed tower after that.

BELOW: The station closed in 1971 and various reuse plans were put forward. To help preserve the structure it was placed on the National Register of Historic Places in 1978. Any lingering thoughts of using it as a rail hub were terminated when the Milwaukee Road abandoned its downtown track in 1980. Conversion to hotel accommodation began in 1998 and the development of a water park and a year-round ice skating rink transformed the former trainshed.

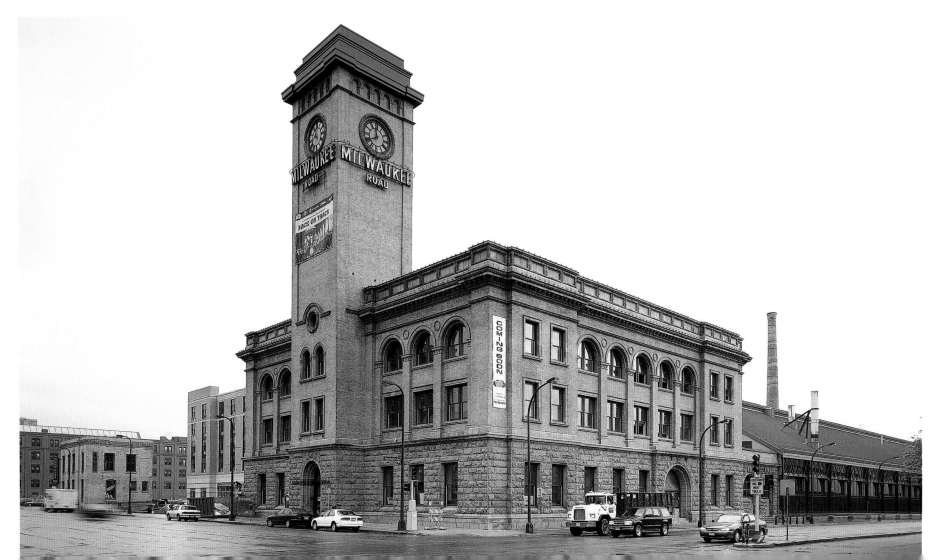

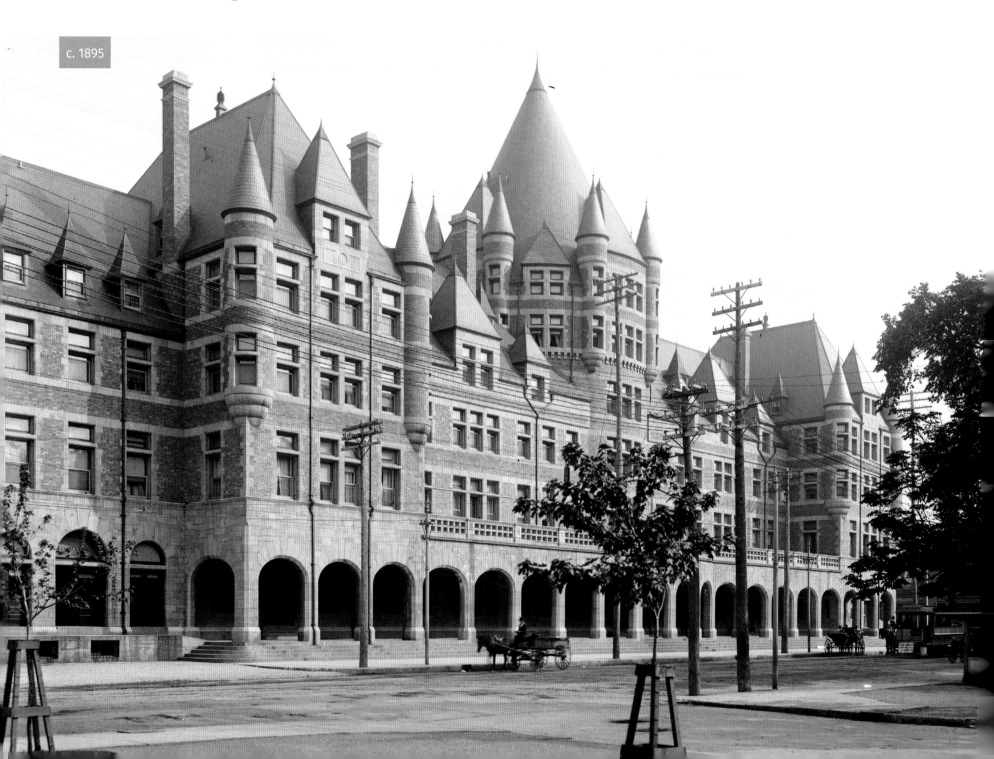

MONTREAL | PLACE VIGER

One of Canadian Pacific's grand station-hotels

c. 1895

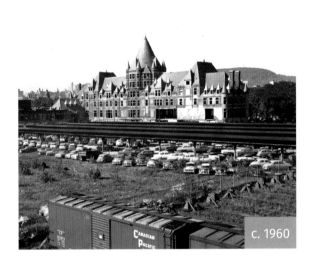

c. 1960

LEFT AND OPPOSITE: The Canadian Pacific railway adopted the British concept of combining their stations with grand hotels, such as London's St. Pancras Station. Place Viger was built in 1898 to a design by Bruce Price and featured a railway station on its lower level with a luxurious hotel above. Like all Canadian Pacific station-hotels it was designed in the Chateau style with medieval turrets. It was named for the first mayor of Montreal Jacques Viger and served lines from the north and east, particularly to the regional capital in Quebec. Mayor Raymond Préfontaine had encouraged its construction in an area at the heart of Francophone interest in the city, rivalling the Windsor Station to the west.

BELOW: Despite the attraction of the elegant Viger Gardens through which visitors could stroll at the front of the hotel, the station-hotel faced an uncomfortable shift in the city's business center. The commercial district moved to the northwest in the early twentieth century, taking trade away from the hotel, and the Great Depression of the 1930s sealed its fate. The hotel shut its doors in 1935 and the station closed in 1951. The City of Montreal stepped in to buy the building and renamed it Édifice Jacques-Viger. Interiors were gutted and replaced with standard municipal offices while the gardens were largely consumed in the 1970s by the new Ville-Marie highway, which further added to the isolation. The city sold the property in 2005 and it changed hands several times in its evolution into a mixed-use building of apartments and offices.

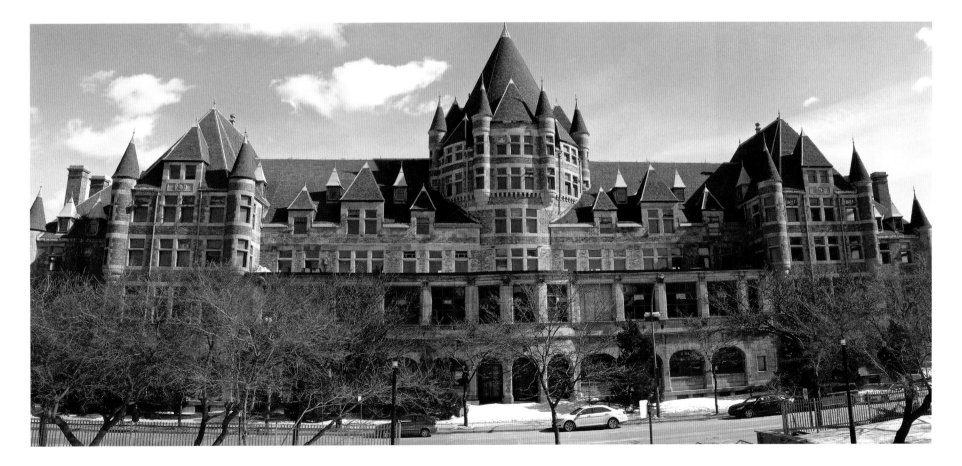

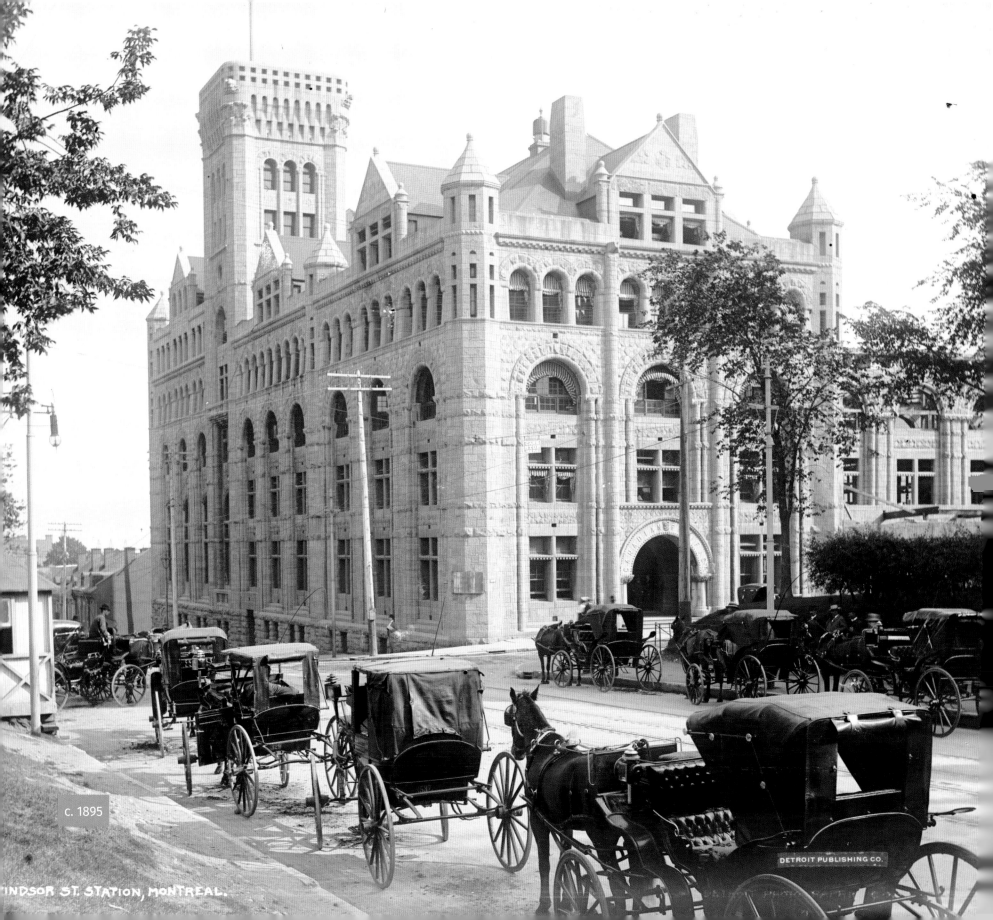

c. 1895

DETROIT PUBLISHING CO.

INDSOR ST. STATION, MONTREAL.

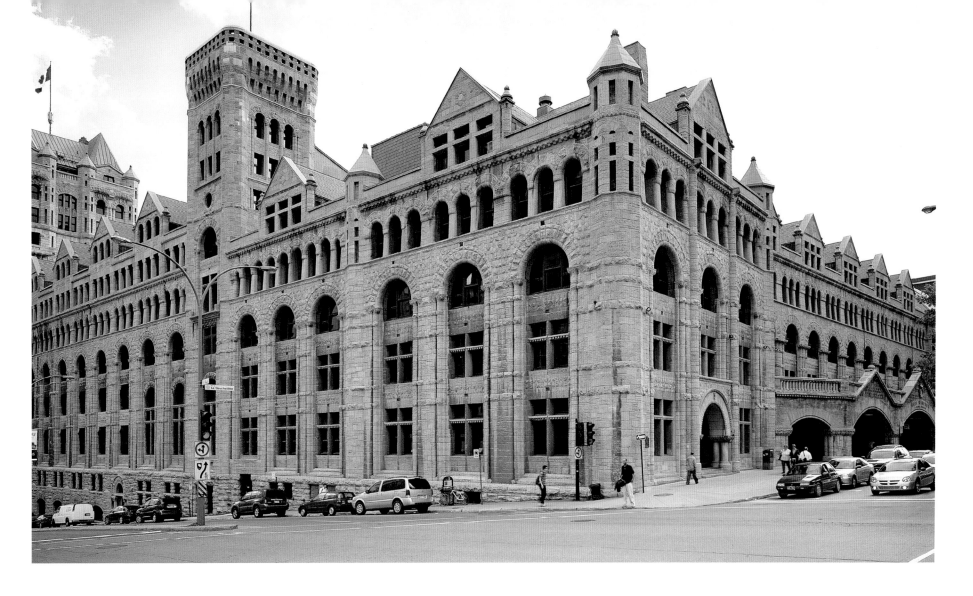

MONTREAL | WINDSOR STATION

An ice hockey arena was the final death knell to Windsor's rail service

LEFT: Canadian Pacific Railway (CPR) president Sir William Van Horne described Windsor Street Station as the "finest station in all creation," when it opened. Built for $300,000 in 1889 as CPR's corporate headquarters, the building was designed in Romanesque Revival style by New York architect Bruce Price. The station was developed over the next 25 years, including the addition of a 15-story tower in 1916. Although still in service, by 1970 CPR had developed plans to demolish the old station and replace it with a 60-story tower designed by the same architects responsible for New York's World Trade Center. Eventually these plans were abandoned.

ABOVE: In 1978 Via Rail was created and took over the intercity services of the Canadian National railway, CN, and the CPR. It consolidated the transcontinental services previously run out of Windsor at CN's Central Station. Amtrak continued to use Windsor for its daily Montreal to New York service, the Adirondack, which lasted until 1986. After that Windsor was a commuter station until 1993 when construction of the hockey arena, the Molson Centre (subsequently the Bell Centre) was begun. The replacement for Montreal's famous Forum venue was sited on the trackage to the west of the station and cut Windsor off from the rail network. Canadian Pacific moved its headquarters from Windsor Station to Calgary in 1996. The building stood empty for a while but has been redeveloped into an office and hotel complex.

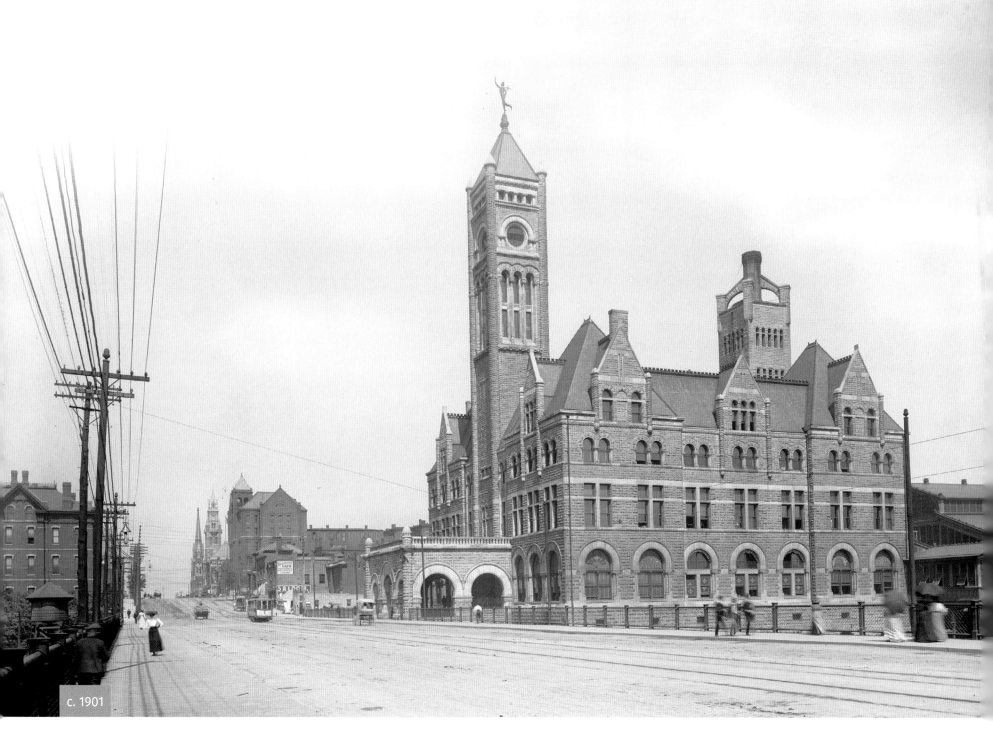

c. 1901

NASHVILLE | UNION STATION

A great example of late Richardsonian Romanesque architecture

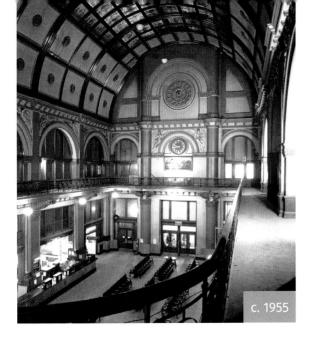

c. 1955

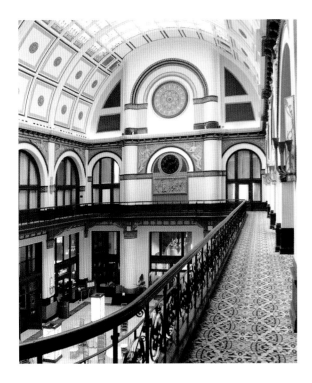

TOP: The interior of Union Station before it closed in 1960. The ticket counter and the ladies' lounge are on the left in this view, and a barber shop is in the center below the clock.

ABOVE: The waiting area of Union Station is now a grand lobby occupying the ground level of Union Station Hotel. The entrance to the restaurant, Prime 108, can be seen on the left.

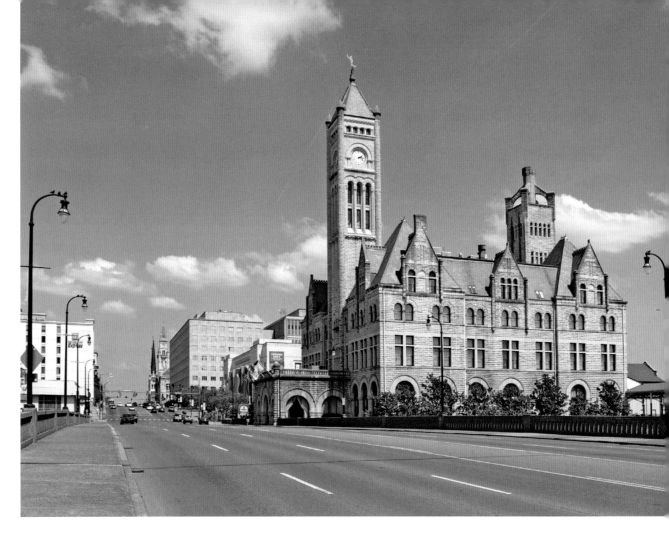

LEFT: Union Station was opened for business in 1900 by the Louisville and Nashville (L&N) and the Nashville, Chattanooga and St. Louis (NC&StL) railroads. The duty of designing the new station fell to Richard Montfort of the L&N. The architectural style he employed was Richardsonian Romanesque, which echoed that of the Louisville station opened in 1891. The entire building and tower were built of gray stone and Tennessee marble at a cost of $300,000. The interior of the station had a vaulted stained-glass skylight ceiling and marble floors. A bronze statue of Mercury, the mythical Roman god of travelers, topped the clock tower, which housed an early version of a digital clock. The statue was blown off in the 1950s by a tornado. This photograph was taken before the clock was installed.

ABOVE: Union Station was used less and less in the 1960s. When Amtrak took over in 1971 service was reduced to the southbound and northbound Floridian train each day and eventually stopped running in 1979. There were preliminary plans to convert the building to a federal office complex. Instead, it was purchased by hotelier Leon Moore of Gallatin, Tennessee, who converted it into a hotel. Careful attention to detail kept the building faithful to its original design. Moore eventually sold the hotel. The fate of the vast train shed posed more of a problem for preservationists eager to see an alternative use. It deteriorated until it was unsafe and was razed in 2000. Today Union Station is part of Marriott International's Autograph Collection Hotels. The statue of Mercury has been replaced with a somewhat smaller silhouette of the original design, painted to appear three-dimensional.

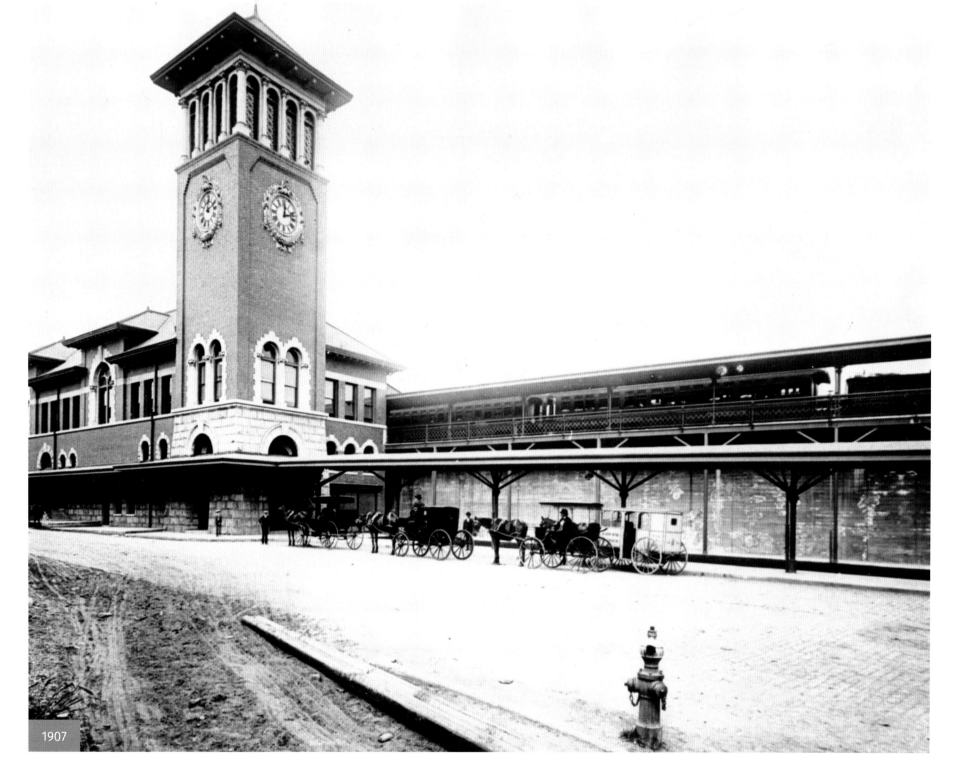

1907

NEWARK, NJ | BROAD STREET STATION
This DL&W station served both commuters and long-distance rail travelers

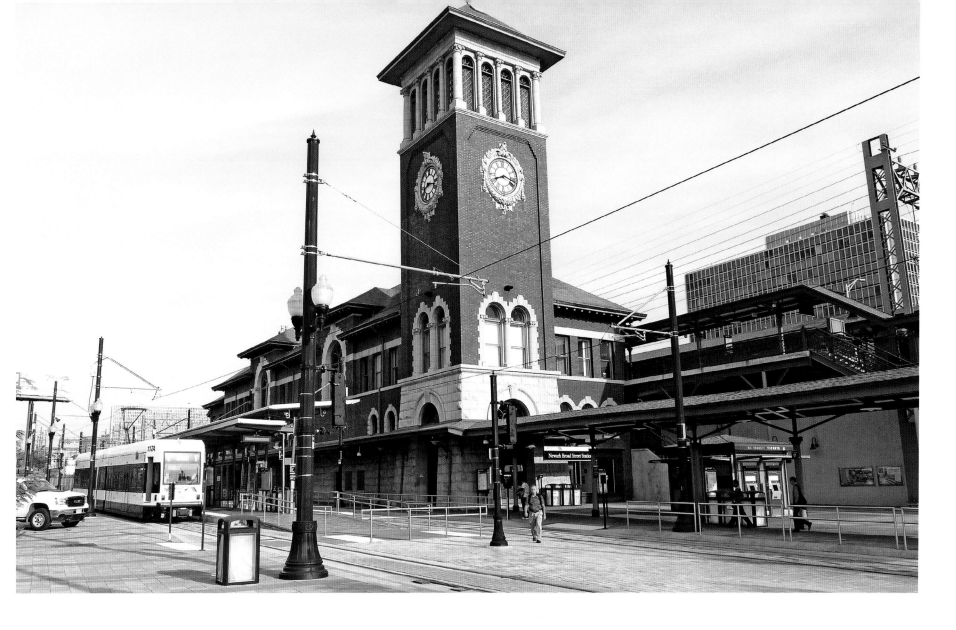

LEFT: Newark's Broad Street Station was one of several attractive stations the Delaware Lackawanna & Western Railroad (DL&W) put up in the early 1900s to serve its growing number of commuter train passengers. The station was designed by the railroad's architect, Frank Nies, in a Renaissance Revival style using elegant brick and stone. The 80-foot clock tower on the eastbound side of the station faces Broad Street as a beacon to Newark travelers. The station was built in 1903, replacing the Morris and Essex Station one block east. Commuter rail service started in 1837 between Morristown and Newark, but it wasn't until 1907, following construction of the DL&W Hoboken Terminal, that fast commuter trains were inaugurated, making it practical for the first time to live in New Jersey and work in New York City. The Hoboken station was a transportation hub with streetcars and ferryboats. Broad Street Station also served long-distance travelers, as it was an important stop on the railroad's service to Buffalo, New York.

ABOVE: The former DL&W railroad station was spruced up from 2004 to 2008; years of grime were removed from its facade and interior spaces, along with major infrastructure upgrades. The station is served by Newark's light railway system. Broad Street Station has changed hands a number of times. It was owned by the DL&W from 1903 to 1960. Because of declining coal revenues and mounting commuter rail costs, the DL&W merged with its arch rival—the Erie Railroad—in 1960, becoming the Erie-Lackawanna. That combined railroad went bankrupt, as did a number of Eastern railroads, which led to the creation of Conrail in 1976 as a U.S. government–sponsored corporation to own the ailing railroads. New Jersey Transit took over commuter rail operations and most of its stations in 1983. The station, with the tallest campanile-style clock tower in Newark, was placed on the National Register of Historic Places in 1984. The overhead electrical wires running through the station have been there since 1930 when the Morris and Essex branch was electrified from Hoboken to Dover.

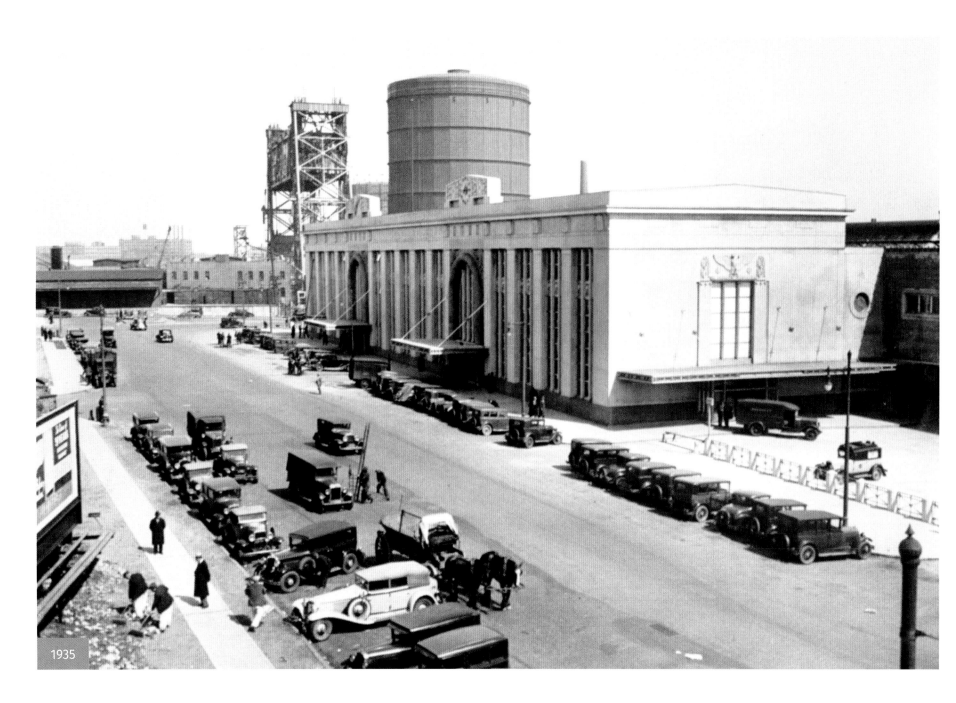

1935

NEWARK, NJ | PENNSYLVANIA STATION
One of the grand Penn stations that wasn't demolished

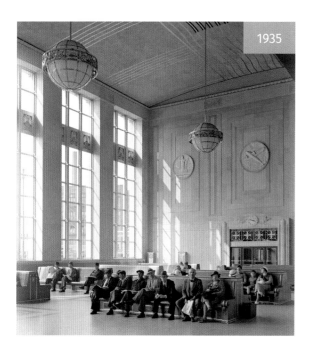

1935

ABOVE: The waiting room of the Pennsylvania Railroad Station features medallions illustrating the history of transportation, from wagons to steamships to cars and airplanes.

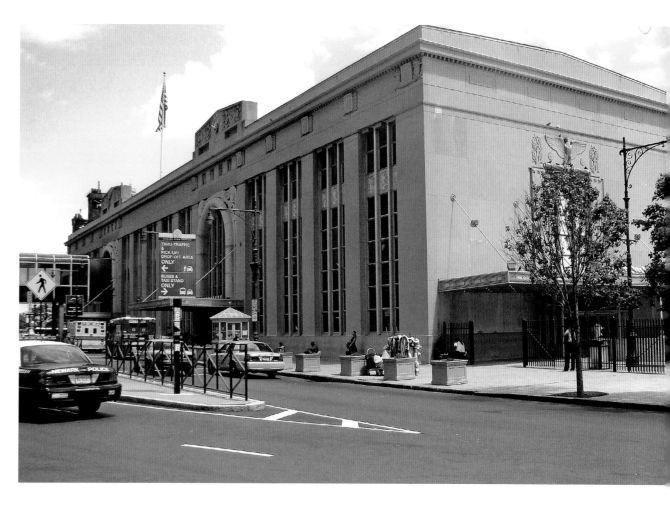

LEFT: Pennsylvania Station at Raymond Plaza and Market streets, Newark, was dedicated in 1935. It is a Beaux-Arts-style station designed by the well-known architectural firm of McKim, Mead, and White, whose other notable buildings include Brooklyn Museum, the James Farley Post Office, and the original Penn Station in New York City. The station has an impressive waiting room with marble walls featuring emblems tracing the history of transportation from a Viking ship to an airplane. The station was erected while the Pennsylvania Railroad was the dominant passenger railroad, as witnessed by the number of stations the company built by itself or with other rail lines, beginning with Pennsylvania Station in New York City, Newark's Penn Station, Philadelphia's Broad Street and Thirtieth Street Stations, Baltimore's Penn Station, Pittsburgh's Penn Station, Union Station in Washington, D.C., and Union Station in Chicago.

ABOVE: In 1968 the Pennsylvania Railroad merged with its long-time rival, the New York Central Railroad, forming Penn-Central Railroad. A variety of factors led to the Penn-Central Railroad filing for bankruptcy in 1971. Most of Penn-Central's freight operations were placed in Conrail, the government-sponsored rail corporation for the northeast. Passenger operations were taken over by state agencies, such as New Jersey Transit and MARC in Maryland, with long-distance passenger service going to Amtrak. In 1999 Norfolk

Southern Railroad bought the half of Conrail containing the former Pennsylvania Railroad. The Pennsylvania Railroad is long gone but its spirit lives on in the architecturally distinguished railroad stations it left behind, including Newark's masterpiece. Pennsylvania Station was renovated in 2007 and now looks very much like it did in 1935. It is still a major transportation hub for PATH (Port Authority Trans-Hudson), the City Subway, buses, and railroad trains.

NEW ORLEANS | SOUTHERN RAILWAY STATION

The city's stations were designed by two of the greatest American architects

1910

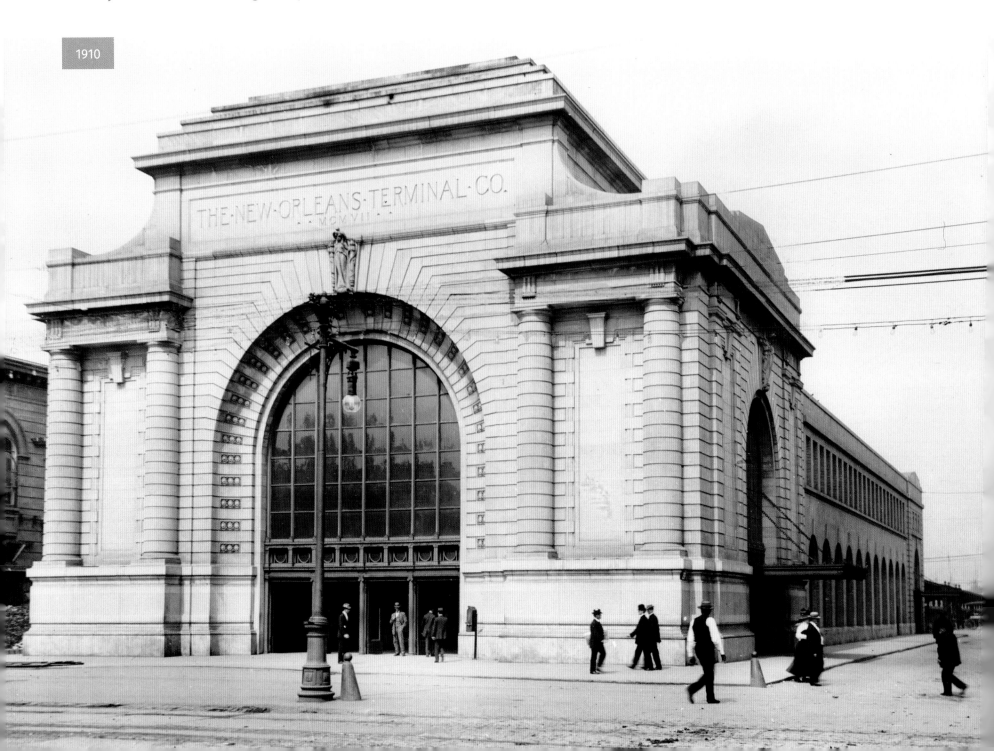

LEFT: The Southern Railway Passenger Station was designed by the great architect Daniel Burnham, responsible for the Union Stations in Washington, D.C., Chicago, Columbus, Pittsburgh, and also those in Keokuk, Iowa, and El Paso, Texas. It was constructed in 1908. This photo shows the station as it looked in 1910 on the corner of Basin and Canal streets. At the time it was at the cultural crossroads of New Orleans. To the left was the Krauss Department Store, which opened in 1903. It was also adjacent to Storyville, home to legalized prostitution, dance halls, and great music venues featuring entertainers like Jelly Roll Morton and Louis Armstrong.

BELOW: Storyville is gone, and so is the original railroad station, demolished in 1956. Rail service was consolidated at the Union Station, another New Orleans terminal with a Chicago connection. While Daniel Burnham had been the driving force behind the 1893 Chicago Exposition, the 1892 Union Station in New Orleans was the work of Louis H. Sullivan with contributions from his draftsman Frank Lloyd Wright. This was razed in 1954 and replaced by the current New Orleans Passenger Terminal. Storyville was closed down by the U.S. military in the 1920s, and the dance halls and jazz joints that filled the area are also gone. The removal of the station has revealed a lot more of the Krauss store, which survived in business until 1997. The building remained vacant for 11 years but became the first luxury condominium development in the post-Katrina era.

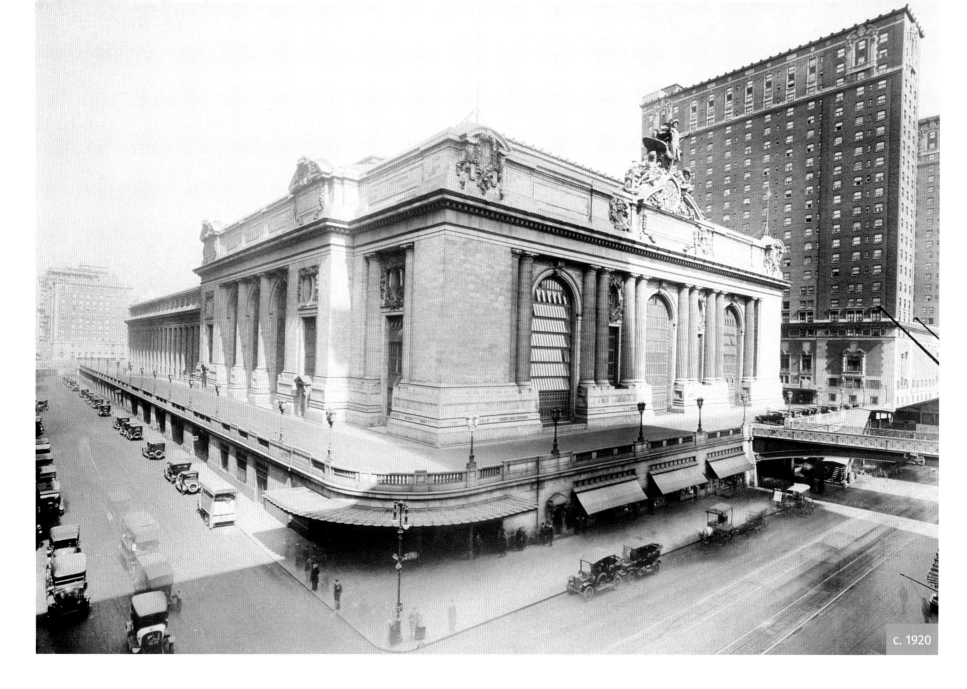

c. 1920

NEW YORK | GRAND CENTRAL STATION
Built as a grand gateway to the city, the terminal led to New York's expansion

ABOVE: Elevated on a platform above Park Avenue, with a triple-arched facade, Grand Central Terminal was built as a gateway to New York City. Completed in 1913, it replaced the first Grand Central Depot built here at Forty-second Street in 1871, when that street was at the northern end of the city. The new terminal, the crowning glory of Cornelius Vanderbilt's New York Central Railroad, brought several railroad lines together under one roof and spearheaded the city's expansion beyond Forty-second Street. The taller building on the right is the Commodore Hotel, built in 1919 by Vanderbilt who was known as the "Commodore" for his first career in shipping lines. The hotel was part of Terminal City, a complex of hotels and office buildings developed by the railroad and connected by underground passageways to Grand Central.

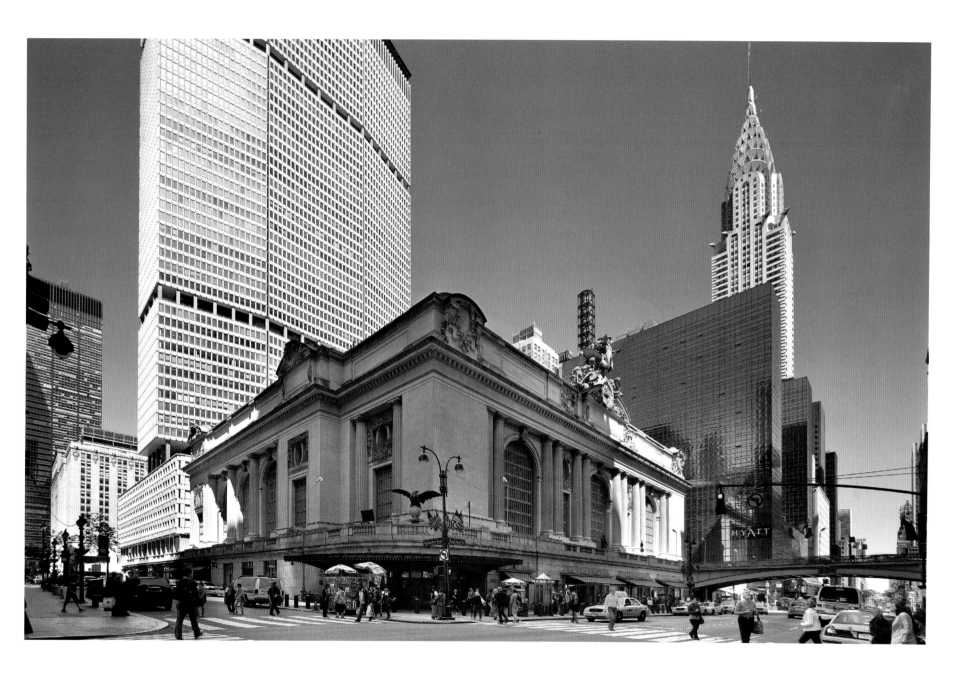

ABOVE: Over the years, Grand Central Terminal was surrounded by much taller buildings. Behind it is the 59-story slab built in the 1960s as the Pan Am Building, now the MetLife Building. Critics called it "a monstrous bland blanket." In the late 1970s, the railroad and the Commodore Hotel were on the brink of bankruptcy. Donald Trump bought the hotel and reopened it as the glass-sheathed Grand Hyatt in 1980.

Ever since the 1950s, the financially strapped railroad had been trying to demolish or drastically alter the building. Preservationists fought to save it and, after a long court battle, finally prevailed in 1978. The eagle perched above the corner entrance was salvaged from the less fortunate Penn Station. The sleek Chrysler Building stands like a sentinel on the far right.

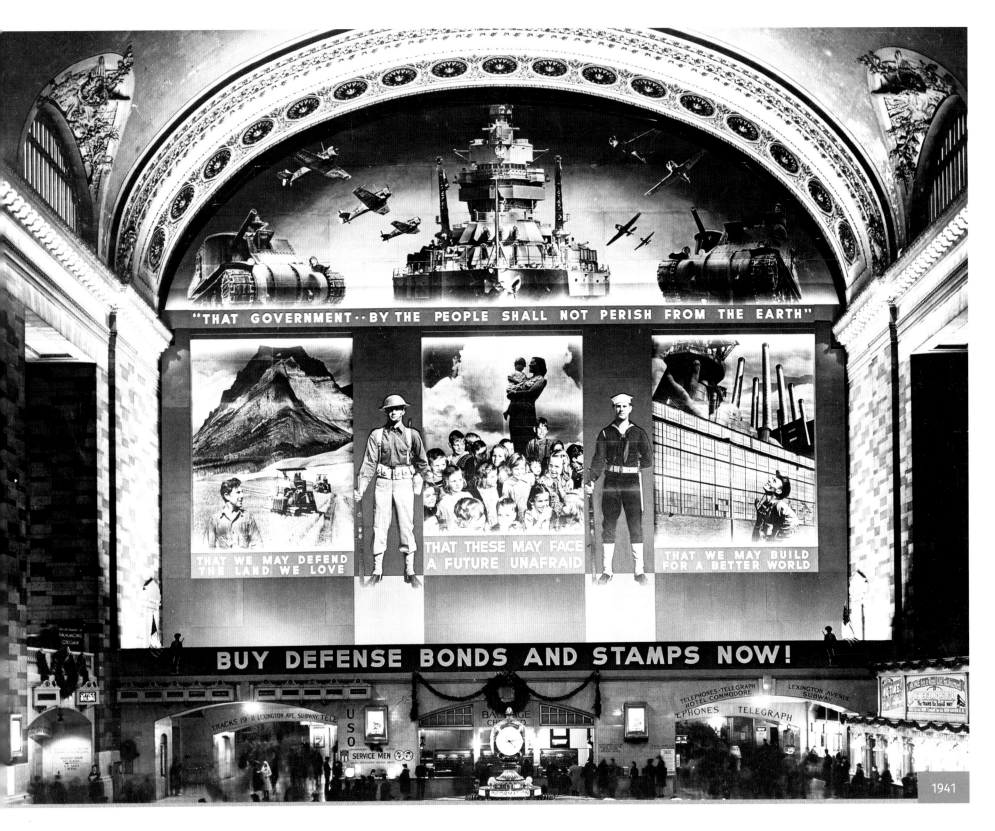

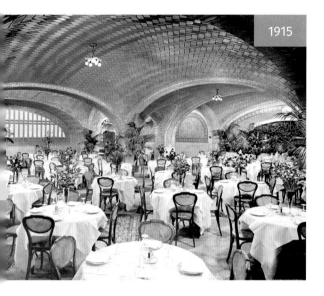

1915

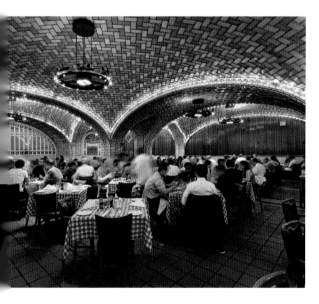

ABOVE: Grand Central's Oyster Bar and Restaurant, with its distinctive ceiling embellished with Guastavino tiles, opened in 1913 at the same time as the terminal.

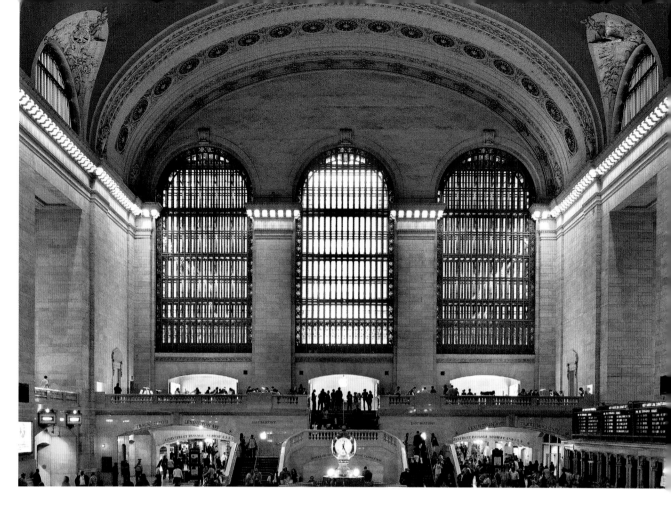

OPPOSITE: During World War II, this huge mural covered one wall of Grand Central's towering windows, urging the thousands who passed through the main concourse to focus on the prodigious war effort, not the building's masterful architecture. The splendid interior had been designed as a superb embodiment of the terminal's monumental character. Towering columns rose to a vaulted ceiling painted with a mural of the constellations. Spotlights behind the ceiling illuminated the stars. Two quarreling teams of architects worked on the project: Reed & Stem and Warren & Wetmore. Whitney Warren got the job through the influence of his cousin, the railroad's chairman, William Vanderbilt. While the rival architects competed in court over credit for their work, the result was universally recognized as the nation's premier public space.

ABOVE: The main concourse is a glorious space today, thanks to a decades-long preservation battle that saved the terminal from destruction. With train service declining in the 1950s, the ceiling lights of the zodiac went out, grime stained the stone columns, and a giant screen advertising Kodak film covered the wall of grand windows. At first, the railroad tried to demolish the terminal and when that failed tried to build a skyscraper on top of it that would have pierced this room with steel columns. In 1978, after years of lawsuits, the U.S. Supreme Court upheld the terminal's landmark protection. Twenty years later, the Kodak screen finally came down, a marble staircase went up in its place, the cerulean blue ceiling was cleaned and its stars were lit once again. Filled with bustling shops and restaurants, the concourse is now a vibrant place for tens of thousands of commuters.

NEW YORK | PENN STATION

A monument of civic architecture, its loss prompted New York's first landmark protection law in 1965

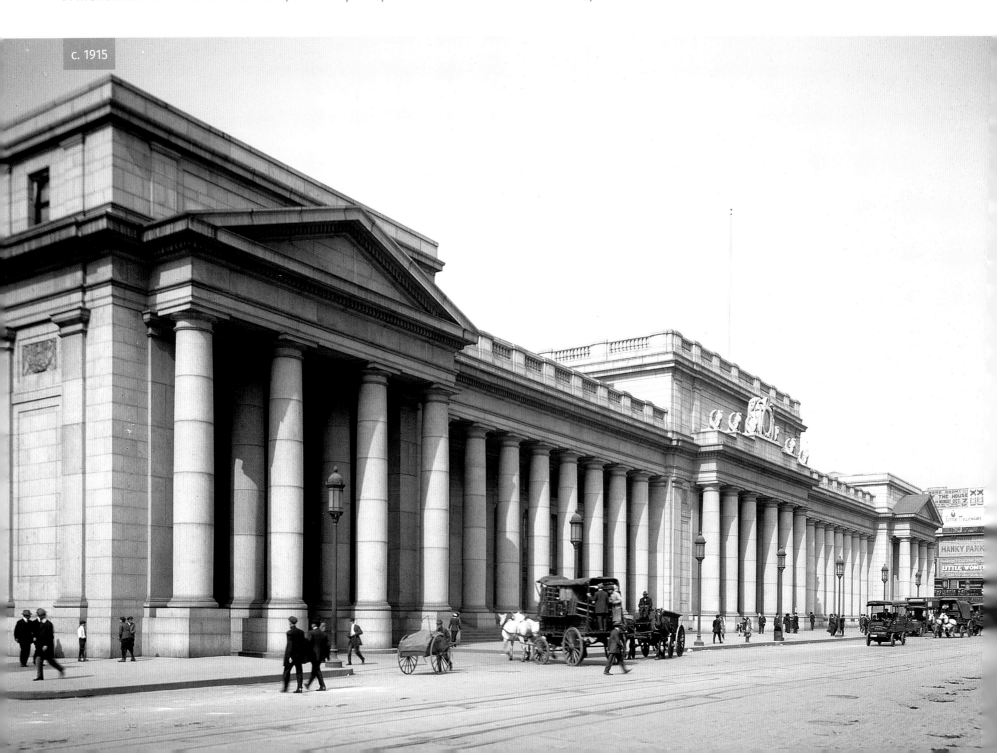

c. 1915

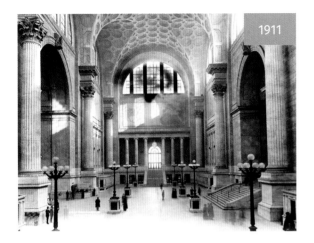

1911

ABOVE: The main waiting room, seen here in 1911, a year after the station's completion, was an awe-inspiring space.

OPPOSITE AND LEFT: This monumental, two-block-long classical temple was built between 1904 and 1910, a time when railroad stations became as expansive as their operations throughout the nation. To build its first station in New York City, the Pennsylvania Railroad cut a tunnel under the Hudson River in 1904, connecting the island of Manhattan to the rest of the country. Like Grand Central, the city's other great train station in construction at this time, Penn Station was an engineering and architectural marvel. Designed by McKim, Mead, and White, it not only moved a complex transportation network through the city, but also celebrated it with a sense of civic grandeur. Construction of the station cleared blocks of tenements in Hell's Kitchen and was heralded as the dawning of a new era for West Midtown.

BELOW: Like the tenements it replaced, Penn Station fell victim to changing times and new property values. As automobiles outpaced train service in the 1960s, the railroad sacrificed its grand station to higher real estate revenues. Demolition began in 1963, replacing the station in 1968 with an office tower and the new Madison Square Garden, a giant doughnut of a building dropped on the site of the grand waiting room. To sports and rock-concert fans, the Garden is the ultimate venue. To those who remember the original Penn Station, however, the modern building is a sad reminder of the loss of a magnificent space. Although the station still operates beneath the Garden, the monumental building and its vast waiting room are only a memory. Their loss led to a public outcry and the creation of the city's first landmark protection law in 1965.

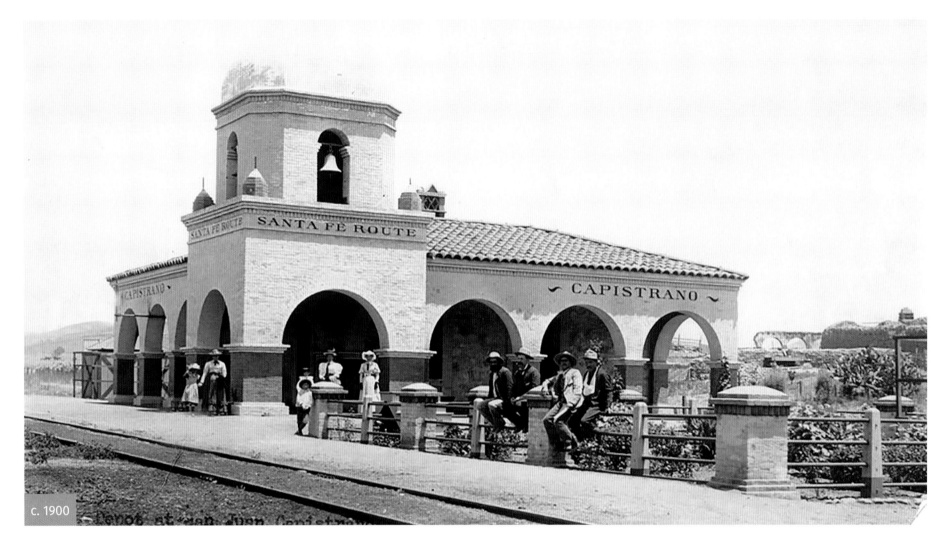

c. 1900

ORANGE COUNTY, CA | CAPISTRANO DEPOT

An inspiring example of Mission Revival architecture

ABOVE: In 1894, the Santa Fe Railway constructed what would become known as one of the most outstanding examples of Mission Revival architecture in the West—a landmark rail depot on the California frontier. Tiny, isolated San Juan Capistrano, at the midpoint between Los Angeles and San Diego, had awaited the 1888 rail connection with excitement. Even before the depot was built, groups of residents gathered to view each smoky steam engine that stopped or passed through town. A race had developed between the Southern Pacific and the Santa Fe to connect Southern California's two biggest cities. The north-south challenge was the need to cross the vast private Irvine Ranch in Orange County to make the connection. The Santa Fe Railway finally won the right to construct its line, and Capistrano became an important stop.

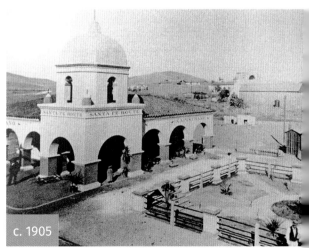

c. 1905

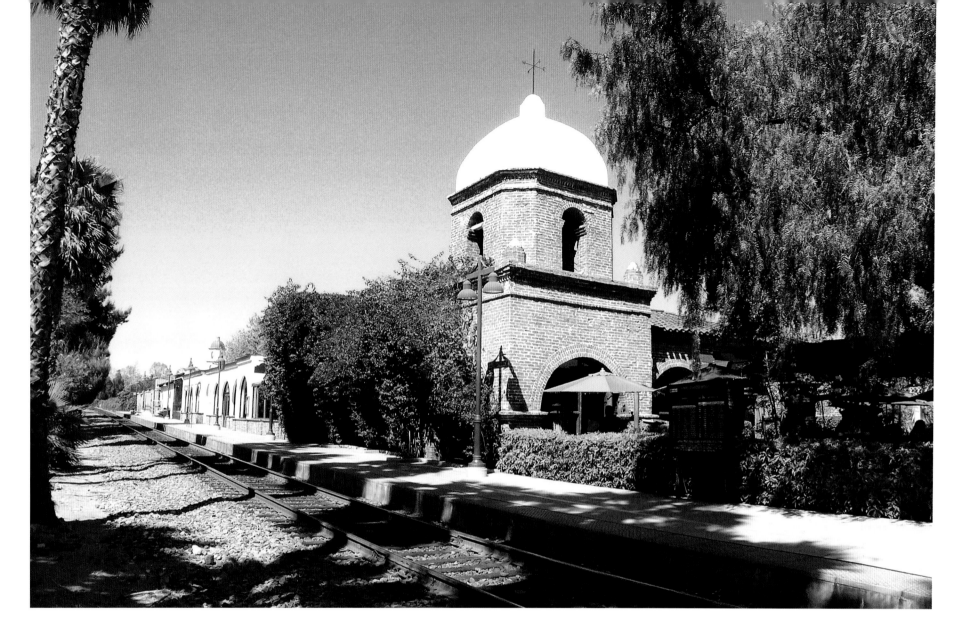

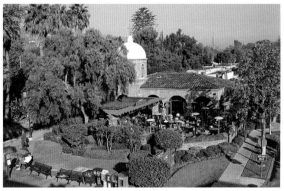

ABOVE: The historic domed Capistrano Depot has lost its white stucco exterior, revealing the original red bricks beneath it. It has been called "the finest depot on the Santa Fe system." The Capistrano Depot restaurant offered dining areas inside the station, outside on the patio, and in a vintage passenger caboose parked behind it. For many years it was known as Sarducci's Capistrano Depot, but under a change of ownership in 2016 it has become Trevor's at the Tracks. The original garden square is now an outdoor train waiting area beside a multistory parking garage for commuters. A garden of native California plants forms a dramatic transition across the tracks—from modern Amtrak Surf Line and Metrolink commuter trains to Los Rios Street. Some of the nearby homes date back to the eighteenth century: almost as old as the Spanish mission that was founded here in 1776. Some were made of adobe bricks, some of board-and-batten construction. These homes form the oldest residential community in California, Los Rios National Historic Neighborhood.

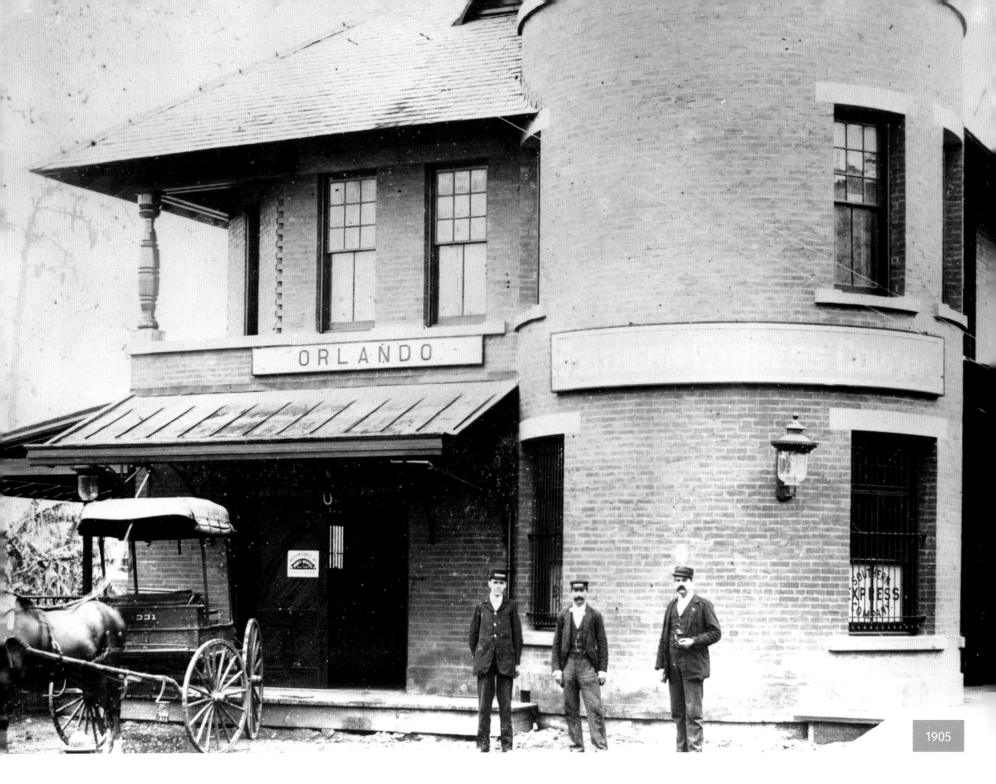

1905

ORLANDO | CHURCH STREET DEPOT
SunRail has given the old station a new lease on life

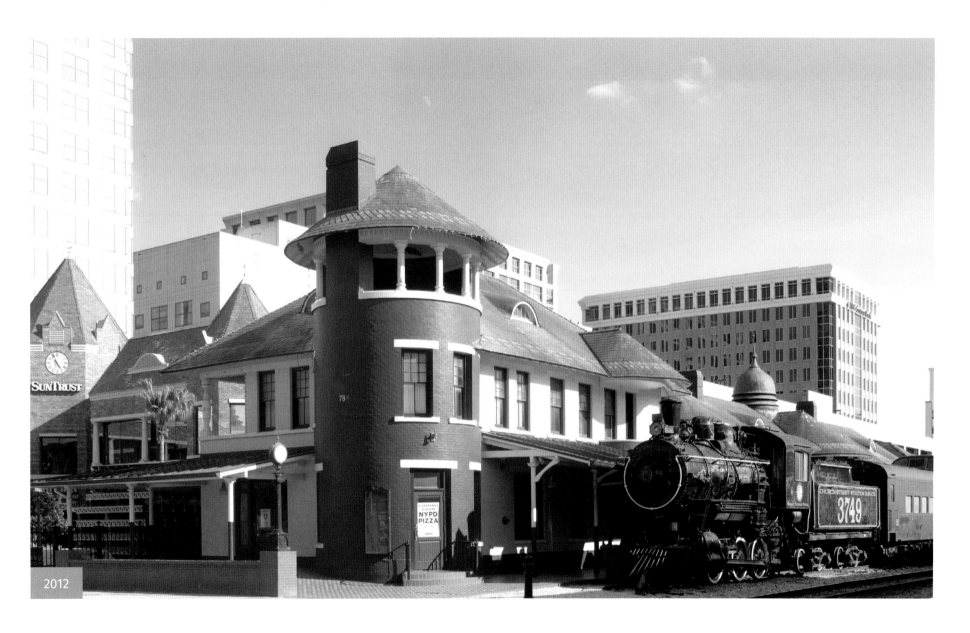

2012

LEFT: Until regular, scheduled service on the South Florida Railroad arrived on November 15, 1880, Orlando was a small scattering of buildings halfway between the ports of Sanford and Kissimmee. Four stores, a hotel, a blacksmith and wagon shop, and a livery stable surrounded the county's adopted log courthouse on Church Street, less than one block east of the tracks. In the next few years, the area had expanded a block to the north along Orange Avenue and nearly three blocks to the east along Pine Street. By the time the third depot (shown here in 1905) was dedicated in January 1890, the city's population had reached 2,856.

ABOVE: The railroad continued to influence the growth of Orlando. By 1886, the rails reached Tampa and traffic increased. The Church Street Depot continued to serve rail passengers until 1927. In 1976, the building became one of Orlando's first listings on the National Register of Historic Places and for many years the RR FRISCO 0-6-0 Switcher Locomotive #3749 was on display at the station. The 140-ton locomotive was acquired by the City of Orlando and later donated to the Florida Rail Museum in Parrish in 2012. The SunRail commuter rail service now uses the historic depot as one of its three downtown stops.

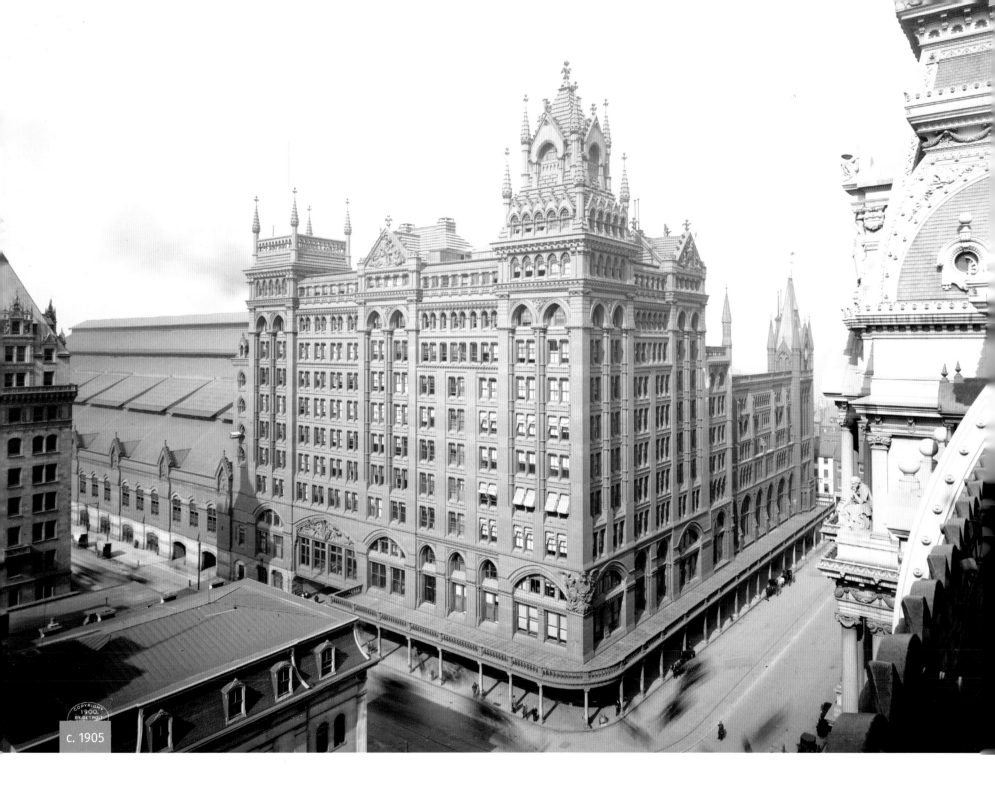

c. 1905

PHILADELPHIA | BROAD STREET STATION
The loss of the Pennsylvania Railroad terminal had a profound effect on the development of the city

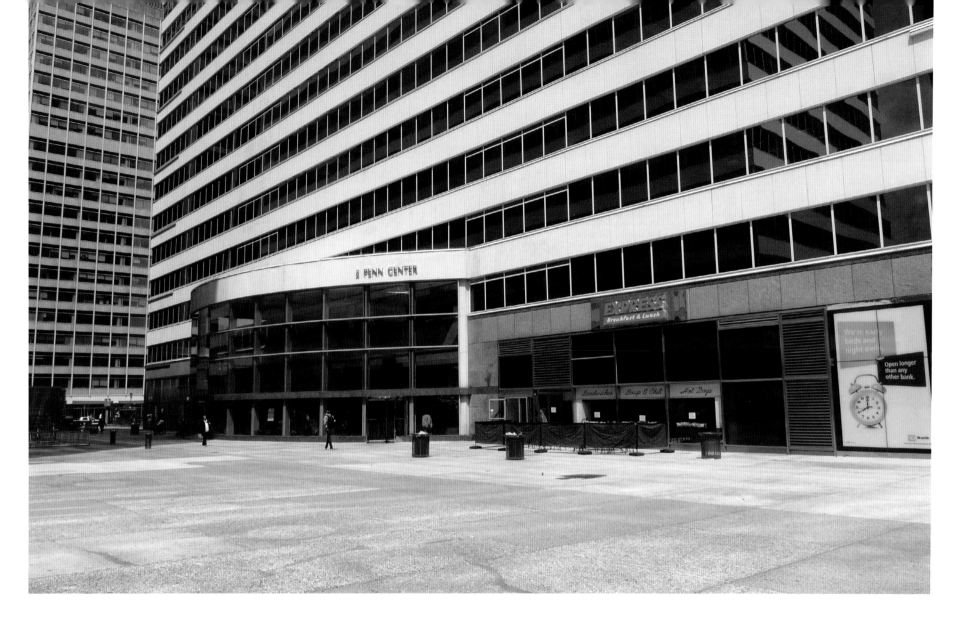

LEFT: Throughout most of the nineteenth century, railroad terminals dotted the periphery of Philadelphia's downtown. When the Pennsylvania Railroad opened the behemoth Broad Street Station across from City Hall in December of 1881, it brought shoppers, theatergoers and businessmen right into the heart of the commercial district. By 1886, the number of passengers using the station averaged a million a month. In 1892, architect Frank Furness added an office annex with soaring spires and Gothic arched windows. The whole complex, with its genteel waiting rooms, restaurants and shops created a space where middle class Philadelphians would feel welcome and safe. The smaller train sheds were then replaced with one enormous one—the largest in the world. There were problems. The elevated tracks that ran west were supported by huge granite blocks that created an eight-block-long "Chinese Wall," that effectively cut the city west of Broad Street in two.

ABOVE: In the late 1920s, plans were drawn up for Thirtieth Street Station in West Philadelphia and in 1930, Suburban Station rose next door. Outdated Broad Street Station finally gave way to mid-century urban rehab when it was demolished in 1952. Under City Planning Commission Director Ed Bacon, the area west of City Hall changed dramatically. Between 1953 and 1970 six new buildings went up on the site as part of the new complex called Penn Center. Today, Penn Center includes eleven office buildings and is connected to Suburban Station's busy underground pedestrian retail concourse. The success of Bacon's vision for Penn Center has led to the redevelopment of the Center City area west of City Hall as the new business district, replacing the small, seedy storefronts and industrial warehouses with rows of gleaming new office towers.

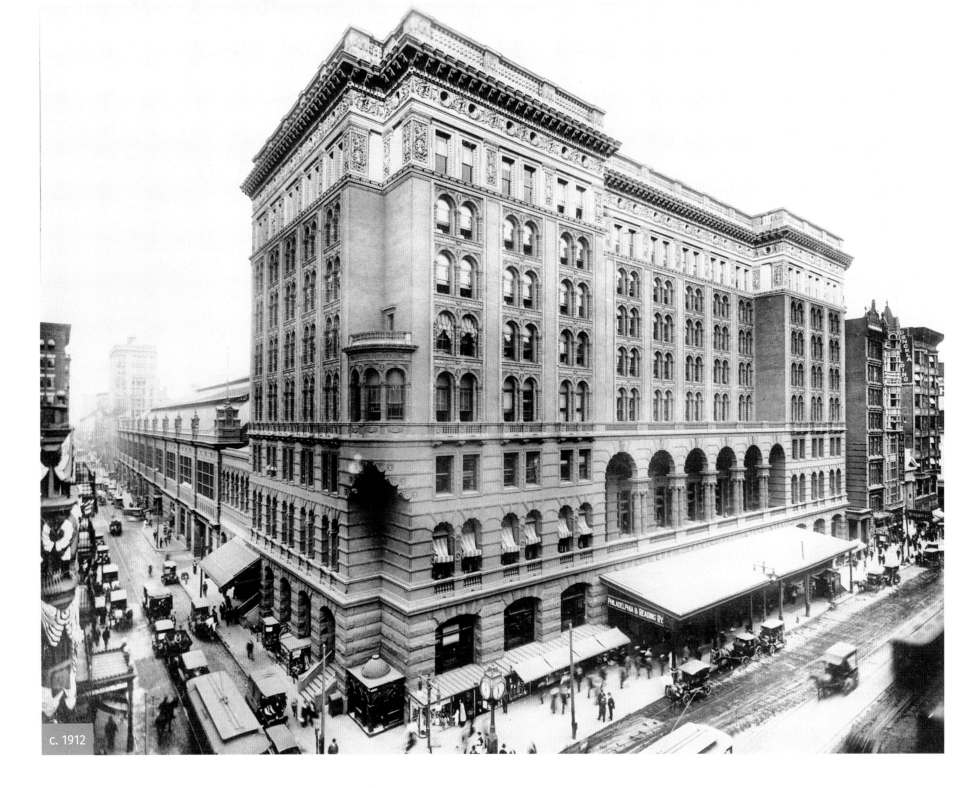

c. 1912

PHILADELPHIA | READING TERMINAL

A grand Italianate building that has survived the passing of the railroad

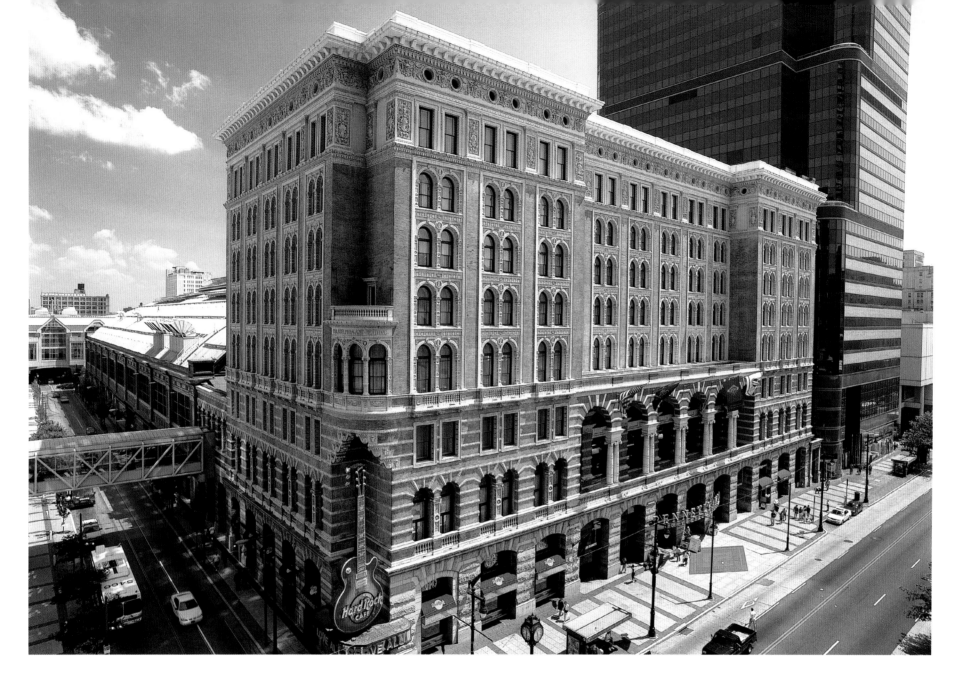

LEFT: When the Reading Railroad Terminal was opened in 1893, it brought train passengers right into the heart of downtown Philadelphia. Previously, travelers disembarked at one of the terminals that dotted the city's periphery and took a horse-drawn trolley to their final destination. When the building was completed, it replaced the farmers' and butchers' markets with the indoor Reading Terminal Market. These two previous buildings themselves had been replacements for the original colonial market. That market was an open air pavilion that extended up the street from the Delaware River past Washington's executive mansion at Sixth Street. Moving the market indoors improved sanitation and opened up the street for trolley tracks.

ABOVE: The headhouse of the Reading Terminal at Twelfth and Market Streets was designed by Francis H. Kimball. The graceful Italian Renaissance Revival building, with brick walls and cast-iron columns, housed offices and a passenger station until 1984, when the use of electric powered commuter trains decreased ridership. The building complex was incorporated into the design of the Convention Center in 1993. The train shed, which spreads behind it for two city blocks, features the world's largest steel span arch. After 1997 renovations the landmark train shed has been preserved for a grand entrance and exhibition hall.

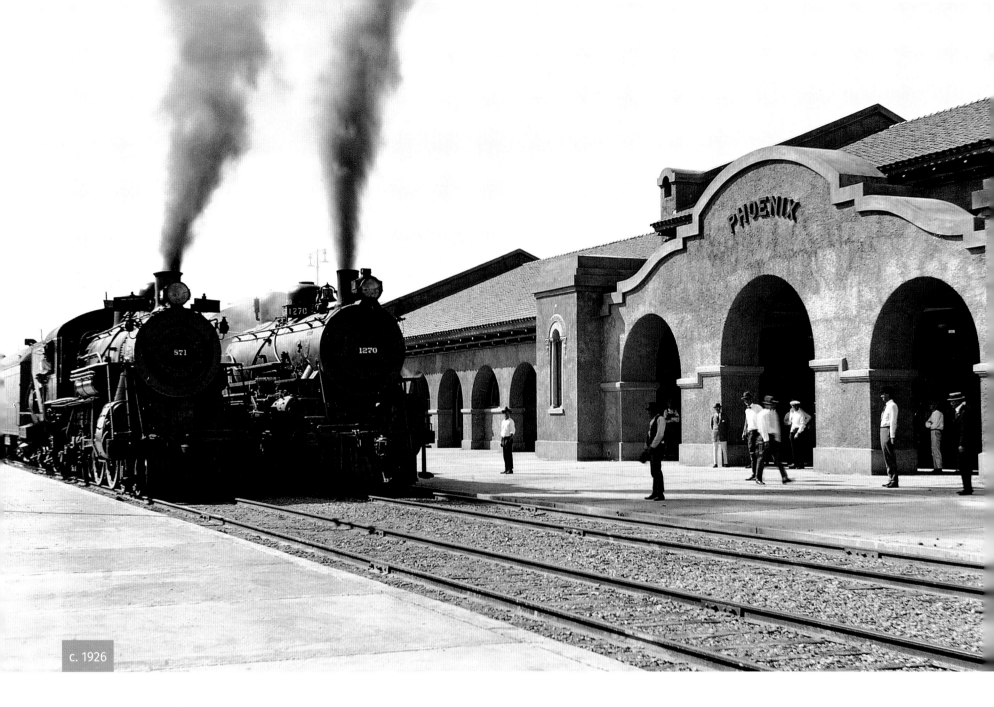

c. 1926

PHOENIX | UNION STATION

When the Union depot closed in 1996, America's sixth largest city had no railroad station

LEFT: Phoenix Union Station was just a few years old when the photographer took this photograph in about 1926. These two trains belong to the Santa Fe Railroad, but it would have been possible to see a Southern Pacific train here as well—both lines used Union Station. In 1926 Southern Pacific decided to make Phoenix part of the main

line and trains went directly to or from California. Opened in 1923, this Mission Revival station provided the look that tourists from the East expected, and many did come through as Phoenix's tourism industry took off in the 1920s.

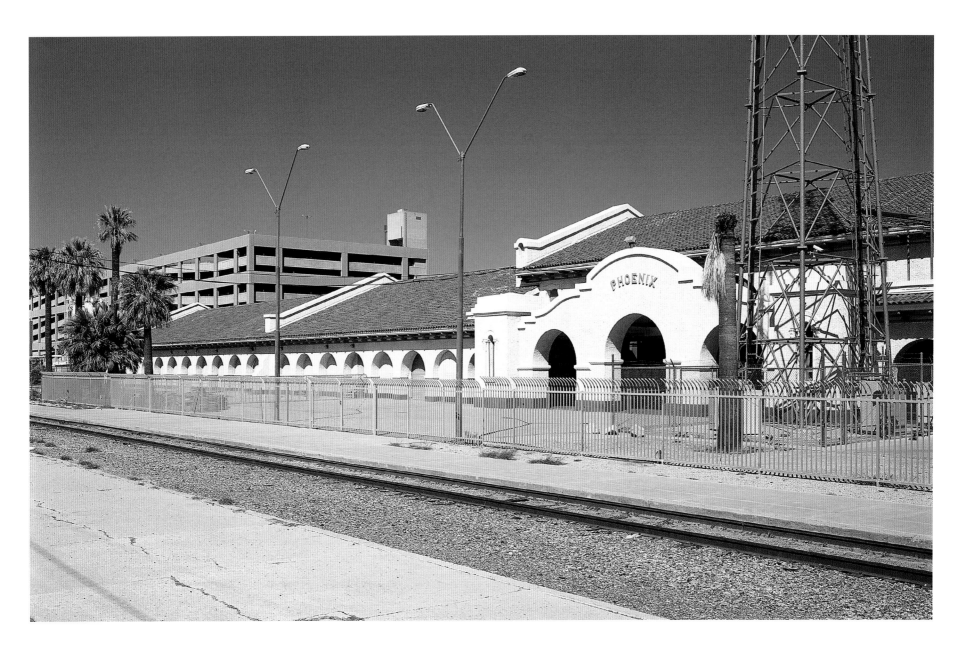

ABOVE: Amtrak stopped serving the station and Phoenix on June 2, 1996. Trains leave from Tucson or Flagstaff instead. The private railroad companies now move freight and still pass by Union Station, but their names have changed since the 1920s. Union Pacific took over the Southern Pacific in the 1990s. Santa Fe merged with Burlington Northern. Union Station is redundant as a transport stop, but it has not been forgotten by a vocal group of local railroad enthusiasts. They rallied in 1999 when they thought that Maricopa County was planning to tear it down (the County has since promised not to, despite its listing on the National Register of Historic Places from 1985). The rail pressure group also wants to return passenger rail service to Phoenix and new life to Union Station. It is currently used by the Sprint Corporation to house telecommunication equipment.

PITTSBURGH | UNION STATION
Still bearing evidence of the city's "Pittsburg" spelling

BELOW: As chartered in 1846, the Pennsylvania Railroad ran only from Philadelphia to Pittsburgh, but it extended itself northward and westward by leasing five other lines, and thus called its Pittsburgh terminal Union Station. A handsome station of 1865 was destroyed in the railroad strike of 1877, and the railroad eventually ended the city's consequent "architectural penance" with this grand new station of 1903, the work of Daniel Burnham–who had been responsible for the architecture of the World's Columbian Exposition in Chicago in 1893. Its ocher terra-cotta and brick exterior soon showed evidence to its regular bathing in smoke by passing and idling steam locomotives. The balloon trainshed lasted until 1946.

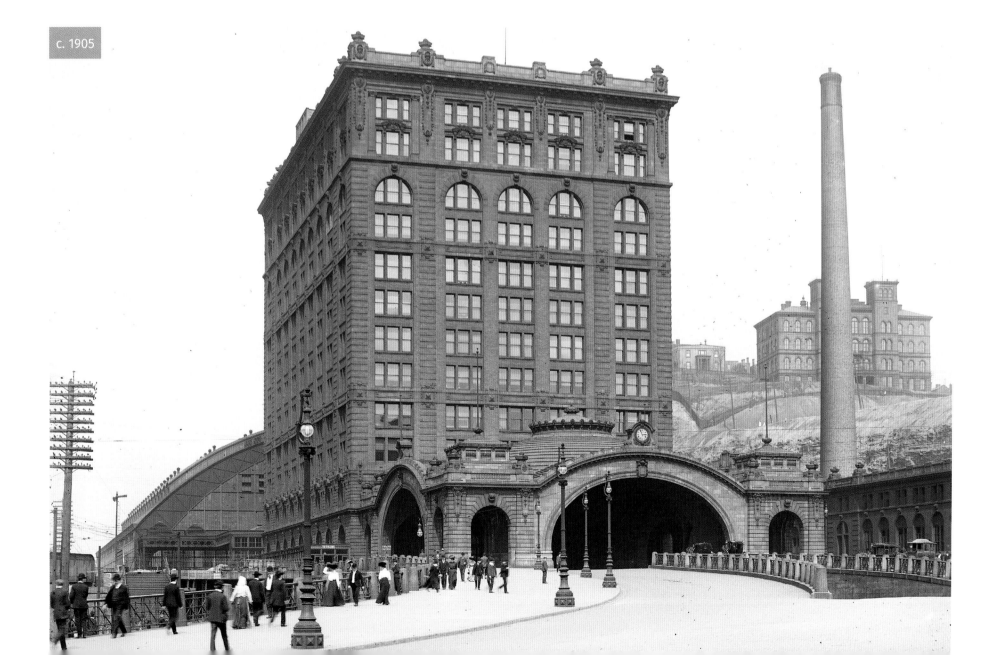

c. 1905

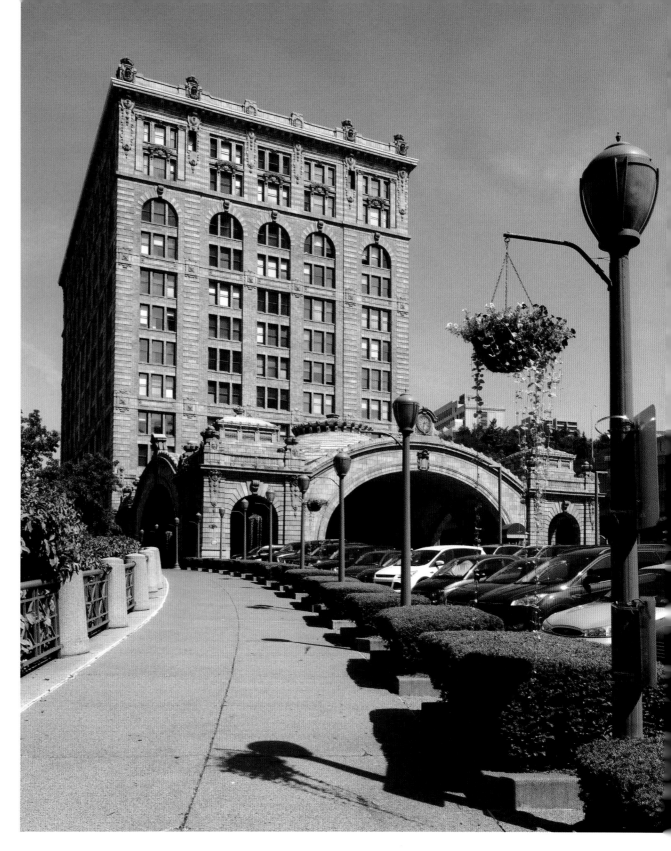

ABOVE AND RIGHT: A landmark at the northeastern corner of the Triangle, the carriage shelter of the former Union Station is the city's most flamboyant architectural gesture, with its play of arches and its top-lit dome. The building is now The Pennsylvanian, an apartment house, and offices are located on the main floor. Amtrak runs a passenger service, but is camped out in a minor space behind the station building. A pendentive from the Union Station entrance (above) shows the name "Pittsburg." In 1891, the U.S. Board on Geographic Names determined that the name "Pittsburgh" (a name given by a Scottish general, John Forbes) should be changed to "Pittsburg." It was only in 1911, after organized protest, that the "h" was officially restored.

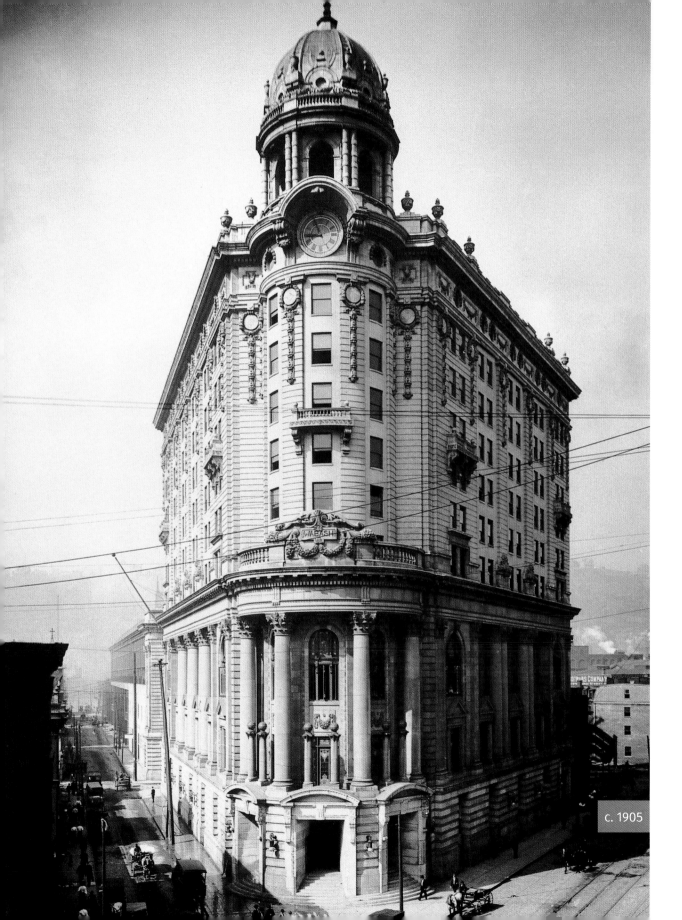

c. 1905

PITTSBURGH |
WABASH-PITTSBURGH
TERMINAL

A grandiose Beaux-Arts terminal built to
rival the Pennsylvania Railroad

LEFT: The Wabash-Pittsburgh Terminal Railway was a
vainglorious attempt to gain the sort of access to the
Triangle, the downtown business district of Pittsburgh,
that the Pennsylvania Railroad and the Baltimore &
Ohio had previously been enjoying. This was the last
important railroad built in the Pittsburgh area. All the
other major railroads had got to Pittsburgh first and
so the route laid out by Joseph Ramsey for the Wabash
Pittsburgh Terminal Railway followed tricky terrain,
along the tops of the ridges, which generated many
engineering hurdles. The line cost a million dollars a
mile to build with six percent of the mileage on bridges
and two percent in tunnels. This grandiose structure
in the Beaux-Arts style, with an entrance on Liberty
Avenue was designed by Theodore Link of St. Louis and
opened in 1904.

c. 1950

RIGHT: In trying to build a transcontinental railroad George Jay Gould had overextended himself and the financial panic of 1907 didn't help his cause. The Wabash-Pittsburgh Terminal Railway went into receivership in 1908 and the receivers ran the railroad until it was sold at foreclosure in 1916. The Pittsburgh and West Virginia Railway took over the line and managed to turn a profit. Freight haulage was important and one advantage of the high route was that the frequent flooding endured by the lower level routes didn't interrupt service. Due to dwindling numbers, the station was closed to passengers in 1931. Freight continued to be handled until 1946 when two separate fires destroyed the Wabash Terminal. This brought an end to the Pittsburgh and West Virginia Railroad in downtown Pittsburgh. The building was razed in 1955 and replaced between 1958 and 1960 with Four Gateway Center.

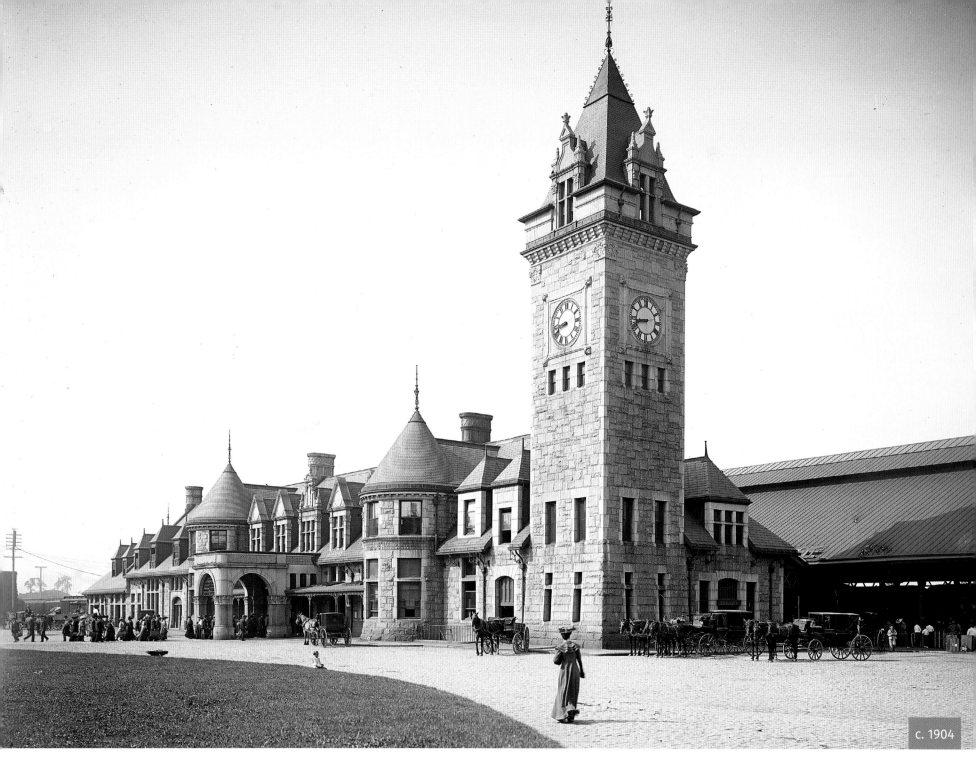

c. 1904

PORTLAND, ME | UNION STATION

The loss of this city landmark sparked a preservation movement

LEFT: The Union Station in Portland, Maine, was designed by Boston architects Bradlee, Winslow, and Witherell and constructed in 1888. It was built with pink granite from Maine and New Hampshire; inside, the waiting room had two grand fireplaces carved out of red sandstone and a checkerboard floor, alternating gray slate with white marble. It was built to connect the Boston and Maine Railroad with the Maine Central, giving trains from Boston access to areas north of Portland. The dominating feature, though, was the 138-foot clock tower, with one of New England's most accurate timepieces, as befitting an efficient rail service. The mechanism featured the same device installed in Westminster's Elizabeth Tower (Big Ben), a double three-legged gravity escapement originally designed by Sir Edward Denison.

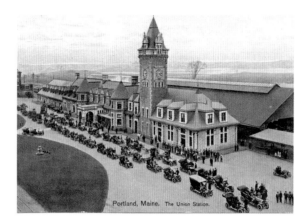

Portland, Maine. The Union Station.

BELOW: The largest construction project in State history put the future of Union Station in grave doubt. Once the Maine Turnpike opened in 1947 traffic on the railroad dwindled. Maine Central discontinued passenger service in September 1960 and the station closed. The magnificent clock tower was brought to earth on August 31, 1961, although despite the station's demolition the clock face was salvaged and now resides in Congress Square. In its place was built an anonymous strip mall, Union Station Plaza. As with other grand station demolitions, the demise of the Union stirred the preservation movement in the city and Greater Portland Landmarks was incorporated in 1964 to save important buildings and the city's unique identity.

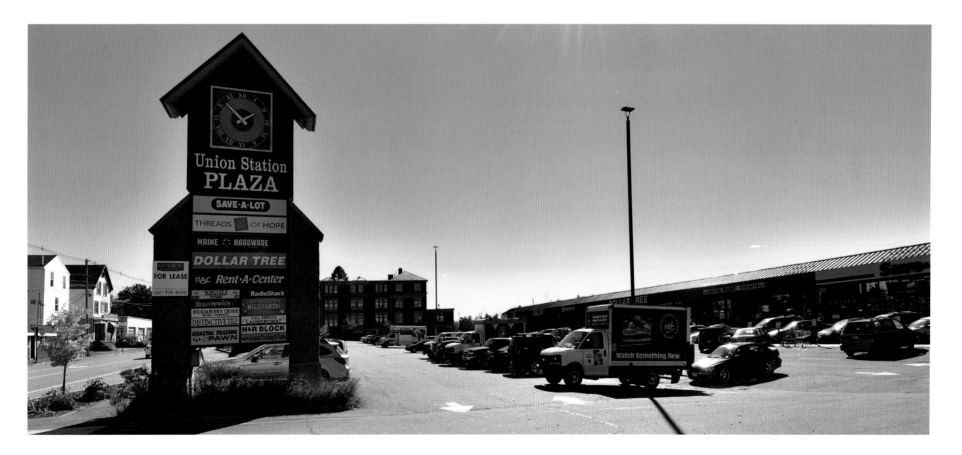

1910

SALT LAKE CITY | DENVER AND RIO GRANDE DEPOT
A grand station built to lure traffic away from George Gould's railroad rivals

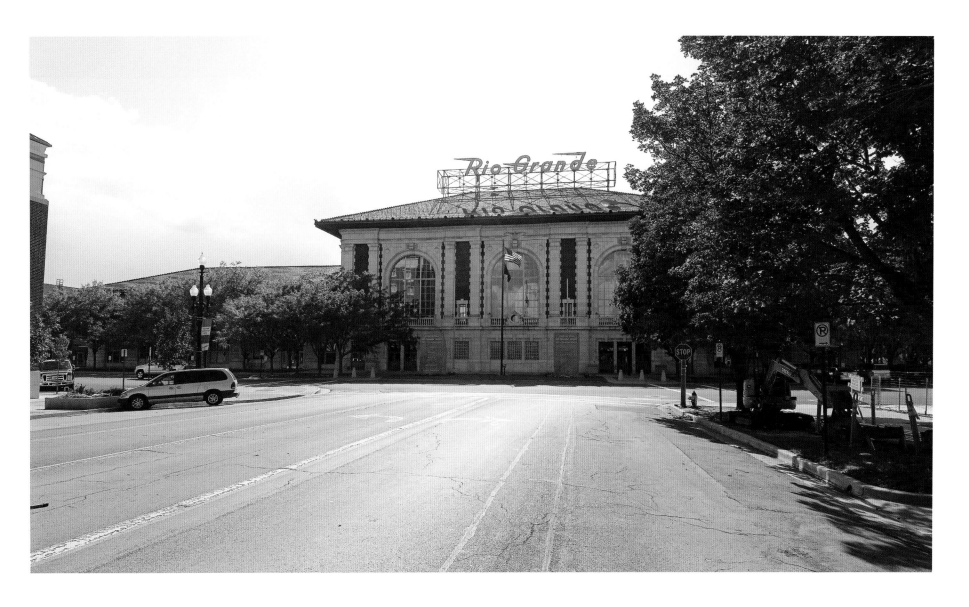

LEFT: This station was Denver and Rio Grande Railroad owner George Gould's attempt to lure passengers away from Union Pacific with an impressive structure. Designed by Henry Schlacks with elements of Renaissance Revival and Beaux-Arts style it cost $750,000. Gould had been developing a transcontinental system to compete with Union Pacific ever since the golden spike was driven in at Promontory Summit in 1869, and he believed this ultramodern station with a grand public space and rich ornamentation would deliver the message that the Denver and Rio Grande was the better option. Due to fierce competition, Gould went broke shortly after the depot's completion and lost his railroad empire.

ABOVE: The Denver and Rio Grande had the choice to demolish the building in the early 1970s. Maintenance of the depot had been neglected as costs skyrocketed. Instead, the building was sold to the State of Utah in 1977. The State chose to renovate the depot as the new home for the Utah State Historical Society and a new restaurant, the Rio Grande Cafe. The Utah Arts Council joined the Historical Society as a tenant in 2005, using the Rio Gallery (the former passenger lobby) to promote Utah artists. The California Zephyr, the Rio Grande line's last luxury passenger train, serves as thematic decor in the Rio Grande Cafe, which has been housed in the north wing since the building reopened.

SAN ANTONIO | INTERNATIONAL AND GREAT NORTHERN DEPOT

Built by the International & Great Northern Railroad with an architectural nod to the Taj Mahal

c. 1908

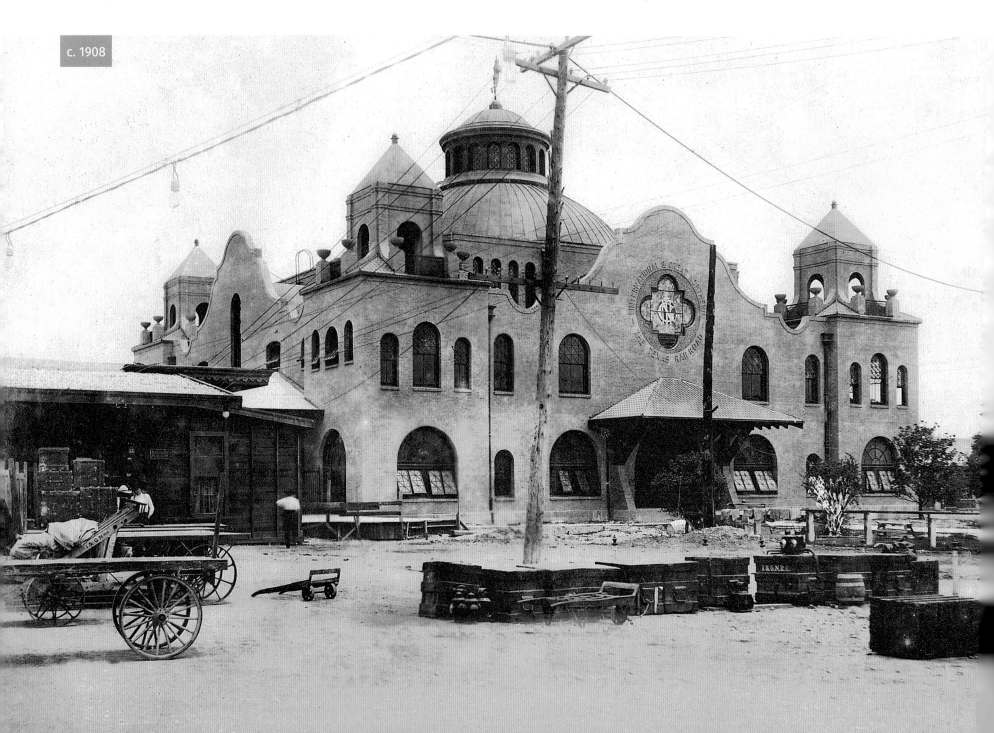

LEFT: Having served San Antonio since 1881, the International and Great Northern Railroad (IG&N) built this "cathedral of commerce" to replace its modest frame depot. Architect Harvey L. Page called it his "Taj Mahal," and it was completed in 1908 for about $142,000. Once owned by railroad robber baron Jay Gould, the IG&N had an eventful history marked by foreclosures and ownership changes. Its relationship with the Missouri Pacific (MoPac) extended its San Antonio service with connections to Dallas, Fort Worth, St. Louis, Memphis, and Chicago. The depot was down to a single passenger train a day in 1965, and MoPac closed the station in 1970. Amtrak briefly stopped at the boarded-up depot, but passengers had to buy tickets at the Southern Pacific station.

BELOW: After the Missouri Pacific sold its former depot in 1972, the building stood empty while private owners considered redevelopment plans. Meanwhile, vandals shattered its original IG&N stained-glass windows, and thieves stripped protective copper from the dome. Squatters left trash inside and may have started a 1982 fire that did further damage. The building was nearly unsalvageable by the time San Antonio City Employees Credit Union (now Generations Federal Credit Union) bought it in 1988 and committed to a $3.1 million restoration. The award-winning project restored the windows, replaced the dome's Indian statue (stolen in 1982 and recovered in a vacant lot), and built a compatible addition. After the credit union moved out, the building was chosen as the location for the Westside Multimodal Transit Center, a phased project of San Antonio's VIA transit authority.

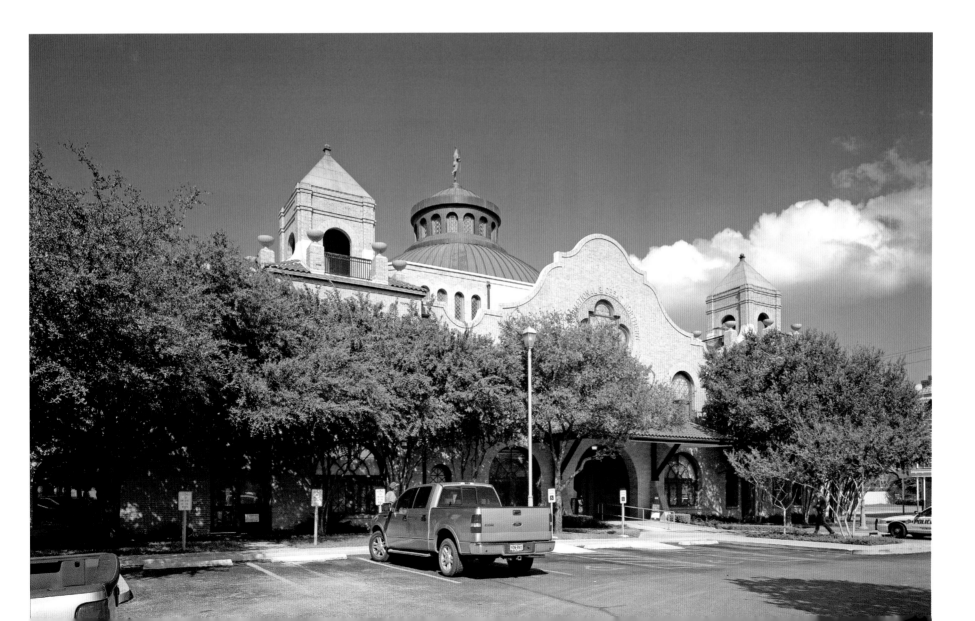

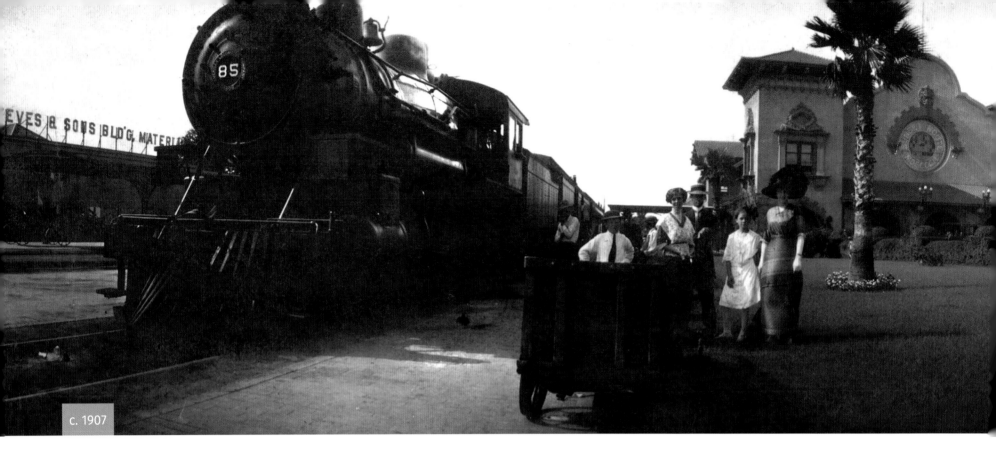

c. 1907

SAN ANTONIO | THE SUNSET DEPOT
An important stop on the New Orleans to Los Angeles "Sunset"route

ABOVE AND RIGHT: San Antonians were proud of the 1903 Sunset Depot, named by the Southern Pacific Railroad for its Sunset Route that stopped here between New Orleans and Los Angeles. Described by the railroad architect as an "adaptation of the Mission style . . . to modern requirements," the two-story station references the Alamo with its rounded gable and other mission churches with its twin towers. The Beaux-Arts interior held separate waiting rooms for men, women, and "colored" passengers, as well as a ticket counter, newsstand, "dining room," and depot offices. Built of stucco-clad brick (exposed in archways), the exterior was painted ocher. Details such as a grand staircase, stained-glass rose windows, and a gold-leafed barrel ceiling lent dignity to the business of travel. The station was nicknamed "the building of 1000 lights" thanks to the installation of many electric lights during its construction. Although these same lights helped cause an electrical fire in the roof in 1907.

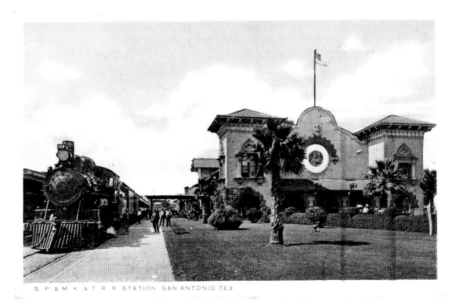

S P & M K & T R R STATION SAN ANTONIO TEX

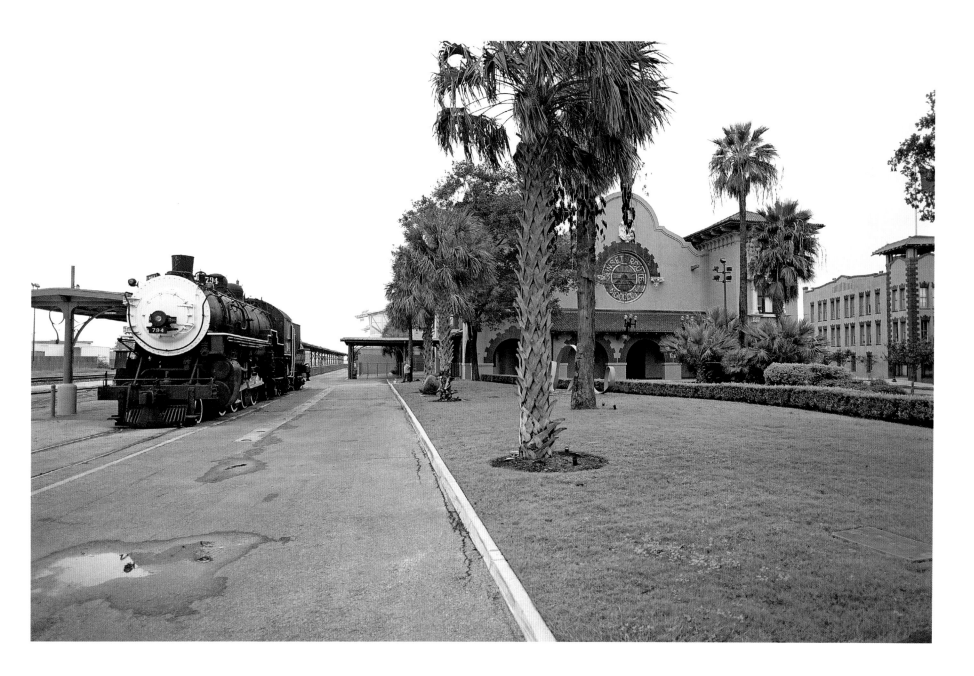

ABOVE: After the depot survived a 1907 fire, freight buildings were added. Passenger facilities were enlarged in 1942, and the building was painted pink around 1950. As railway use dwindled, Southern Pacific became the last independent railroad to run passenger trains to San Antonio before Amtrak's 1971 takeover. To cut costs, Amtrak moved in 1996 to an adjacent, smaller station, and today both the Sunset Limited and Texas Eagle serve the city. The old depot's owner VIA Metropolitan Transit, accepted a private proposal to rebuild the depot as an entertainment complex. After restoration of its decorative features and reconfiguration into restaurant and nightclub spaces, the depot reopened as Sunset Station, a popular venue for music and special events.

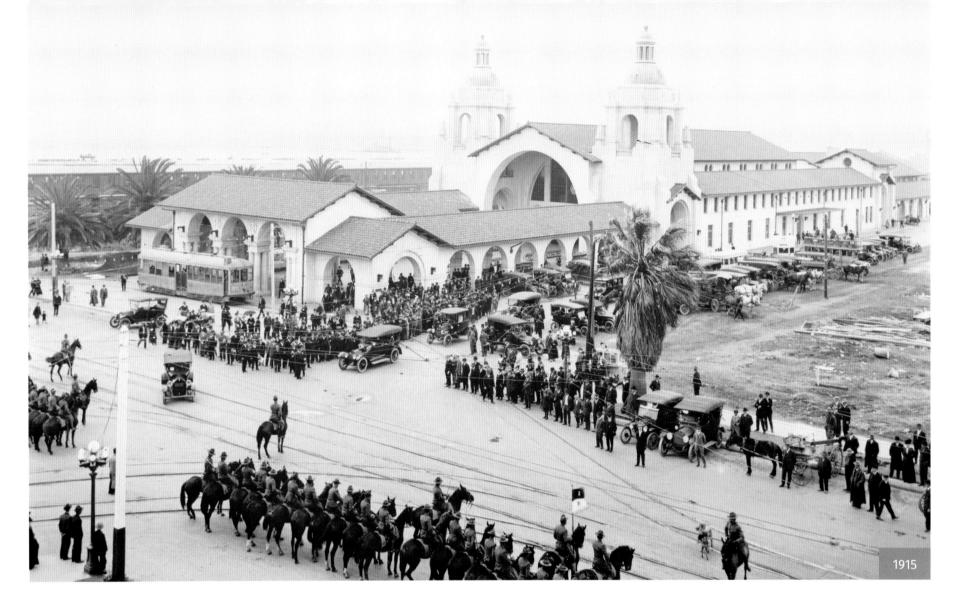

1915

SAN DIEGO | SANTE FE DEPOT
Opened just in time for the 1915 California Exposition

ABOVE AND RIGHT: The original train depot, shown in the process of demolition in March 1915 (right) was built in 1887 for the California Southern Railway. Early on it was thought that San Diego would become a major rail destination, with its harbor and port facilities delivering freight and passengers for the network and acting as a major conduit for trade with the Far East. It never became a terminus of the Atlantic, Pacific, and Santa Fe Railroads, as had been envisioned, though it was an important center in West Coast commerce. It was designed in the style of early Santa Fe stations and sported dark red paint with dark green trim. In 1914, plans were made to build a new station that would combine a Spanish Colonial appearance with the requirements of a modern train station (above). The goal was to design the new depot to blend with the buildings in Balboa Park that were being constructed for the 1915 Panama-California Exposition.

1915

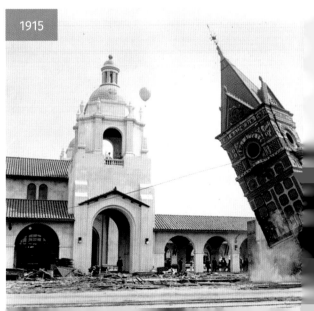

ABOVE: Construction of the new depot was begun in 1914 and it officially opened on March 8, 1915. To ease the disruption on passengers, the new depot was built in what had been the 1887 station's forecourt. Oliver Stough, San Diego's last surviving veteran of the Mexican War, purchased the first ticket. The new depot could have opened earlier, but was delayed because of a disagreement between the city council and the railroad over the closing of part of B Street. A 1971 attempt by Santa Fe to tear it down was opposed by local residents, and in 1972 the depot was placed on the National Register of Historic Places. The Museum of Contemporary Art San Diego, located across the street, is planning to turn the historic baggage building into an additional exhibition space, with the help of various charitable donations.

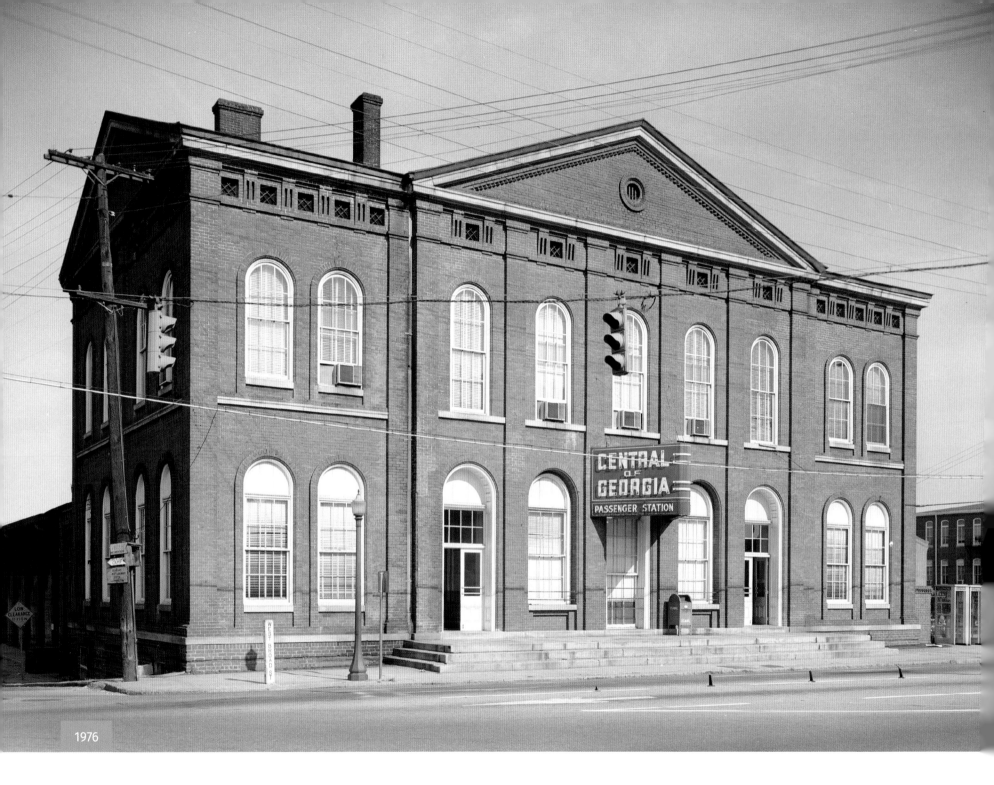

1976

SAVANNAH | CENTRAL OF GEORGIA PASSENGER DEPOT
Part of Savannah's rich railroad heritage

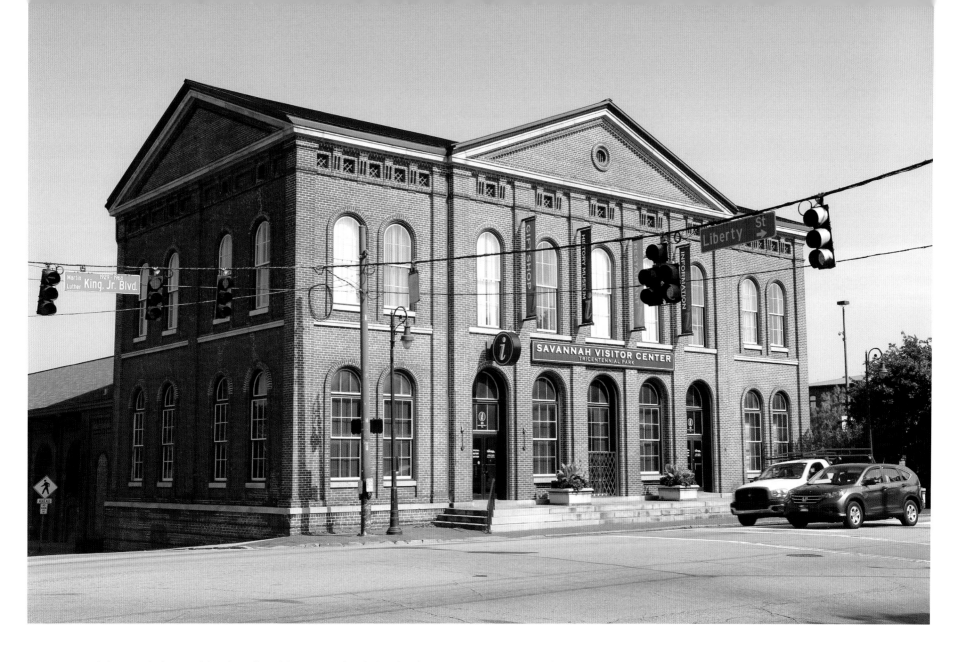

LEFT: Savannah in Georgia is grateful to its railroad investors. The city's Atlantic coast rival, Charleston, got its first railway line in the early 1830s, and threatened to take the lucrative Georgia and South Carolina cotton trade away from the Savannah River. William Washington Gordon supervised the construction of what would become the Central of Georgia railroad, dying in 1842 just before the nearly 200-mile track between Savannah and Macon was completed. For his efforts in preserving Savannah's port pre-eminence he was given a magnificent monument in Wright Square— that is, after the city fathers had first removed the remains of Indian chief Tomichichi. The result of all the railroad building boosted the port and ultimately helped create a significant complex of railroad buildings including the Central of Georgia passenger station constructed in 1860.

ABOVE: Today Savannah boasts the largest collection of antebellum railroad buildings in the country. After the demise of the nearby Union Station in 1963, the famous Nancy Hanks II train (named after the racehorse) continued to run into the city from Atlanta and Macon until 1971. The Atlanta service left Savannah at 7 a.m. each day for the six-hour run to Atlanta. Out of service in the 1970s, the station and trainshed were declared National Historic Landmarks in 1976 and today host the Savannah Visitor Center and the Savannah History Museum. The nearby preserved roundhouse, working turntable and railroad workshops have been lovingly preserved by the Georgia State Railroad Museum, while two large administration buildings have been put to good use by the Savannah College of Art and Design (SCAD).

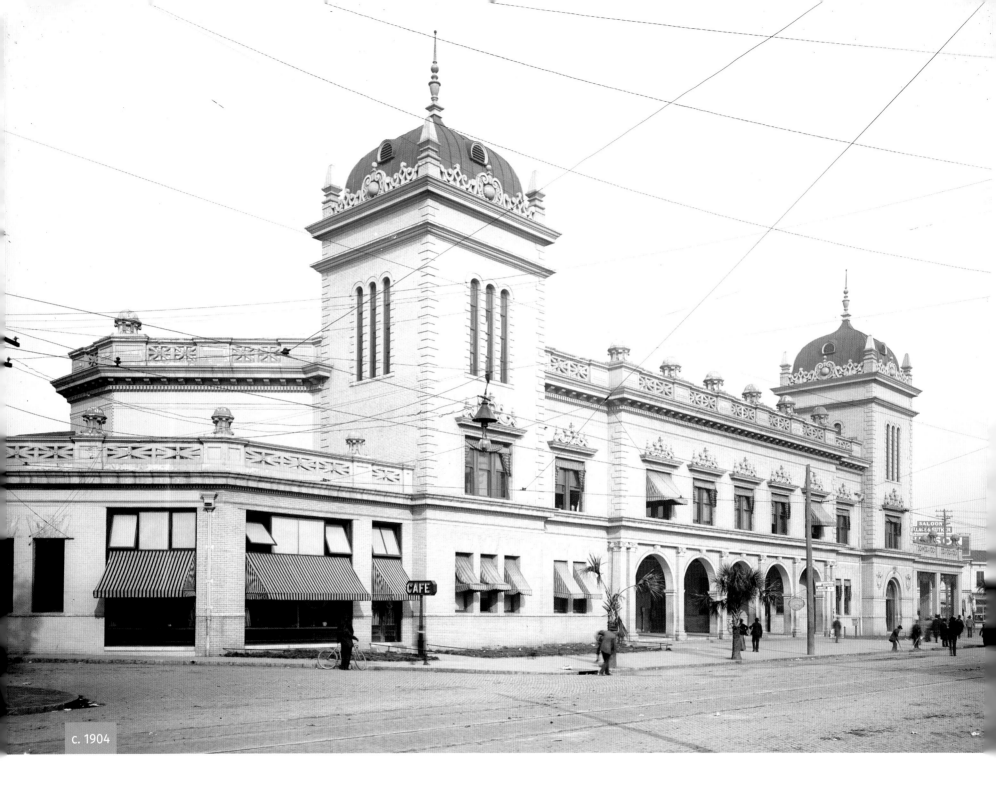

c. 1904

SAVANNAH | UNION STATION
City planners decided to remove the "relic of a bygone era" in 1963

LEFT: A combination of Spanish Renaissance and Elizabethan styles graced Savannah's Union Station. The Savannah Union Station was designed with opulence in mind by Frank Pierce Milburn and cost $150,000 to build in 1902. The unforgettable feature of the interior was the general waiting room, an octagonal room measuring 80 feet in diameter with two tiers of windows high above the marble floor. Exterior walls were made of pressed brick with granite and terra cotta trimmings. However as travel by train waned, the station was viewed as a dinosaur, an unappreciated relic of a slower, simpler, more genteel era. Union Station was demolished in 1963 to make way for an interstate highway interchange.

ABOVE: Although the Central of Georgia passenger station was still in service further down West Broad Street (subsequently renamed Martin Luther King Boulevard), the removal of the station between 419 and 435 hastened the economic decline of the area. As part of the deal to demolish Union Station, the Atlantic Coast Line Railroad built a new depot to the west of town, off the Telfair Road. Typical of its time—1962—it is a soulless modernist structure requiring onward transport to get anywhere near Savannah's famous Historic District. With the closure of the Central of Georgia passenger station it became Savannah's only rail link.

SEATTLE | KING STREET STATION

The station was modeled on Venice's Campanile di San Marco

c. 1881

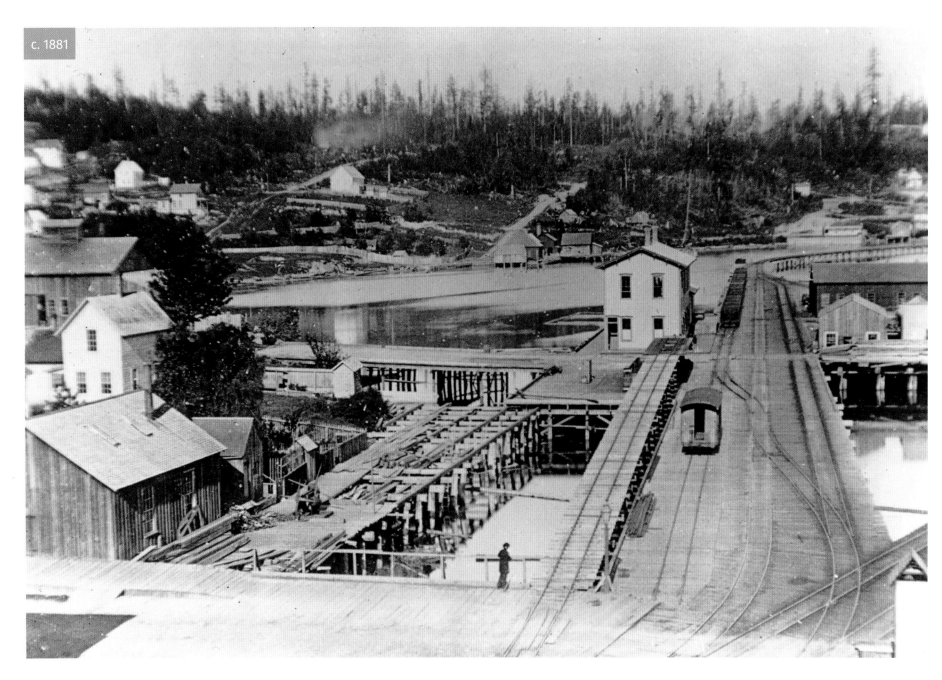

LEFT: Seattle's first railroad was the Seattle and Walla Walla, started in 1874 in response to the Northern Pacific's having chosen Tacoma as its western terminus the year before. It only ever made it as far as Newcastle, a coal-mining town northeast of Renton. In 1880 Henry Villard of the Oregon Improvement Company bought the railroad and mines for $750,000, renaming the former the Columbia and Puget Sound Railroad (CPSRR). This photo, taken sometime between 1880 and 1882, shows the city's first true rail depot. It was built by the CPSRR in 1880 over what were then still the tidal flats of Elliott Bay at Piner's Point. This site was historically a winter camp of the local Duwamish tribe, and was marked as such on a map drawn by Lieutenant T. S. Phelps of the U.S. Navy during the 1856 Battle of Seattle.

BELOW: In 1881 Villard took over the Northern Pacific, and later connected Seattle to the transcontinental railroad. A local alliance between the Northern Pacific and the Great Northern Railway was discussed as early as 1893, but did not come to fruition until the end of the decade, when the two lines agreed to build a passenger station in Pioneer Square. King Street Station opened in May 1906, a year after the completion of a mile-long tunnel under downtown that helped alleviate traffic on Railroad Avenue. The building, with a clock tower inspired by Venice's Campanile di San Marco, was the tallest in Seattle until the 1914 completion of the Smith Tower. It was placed on the National Register of Historic Places in 1973. The city bought King Street Station from the BNSF Railway in 2008 for $10.

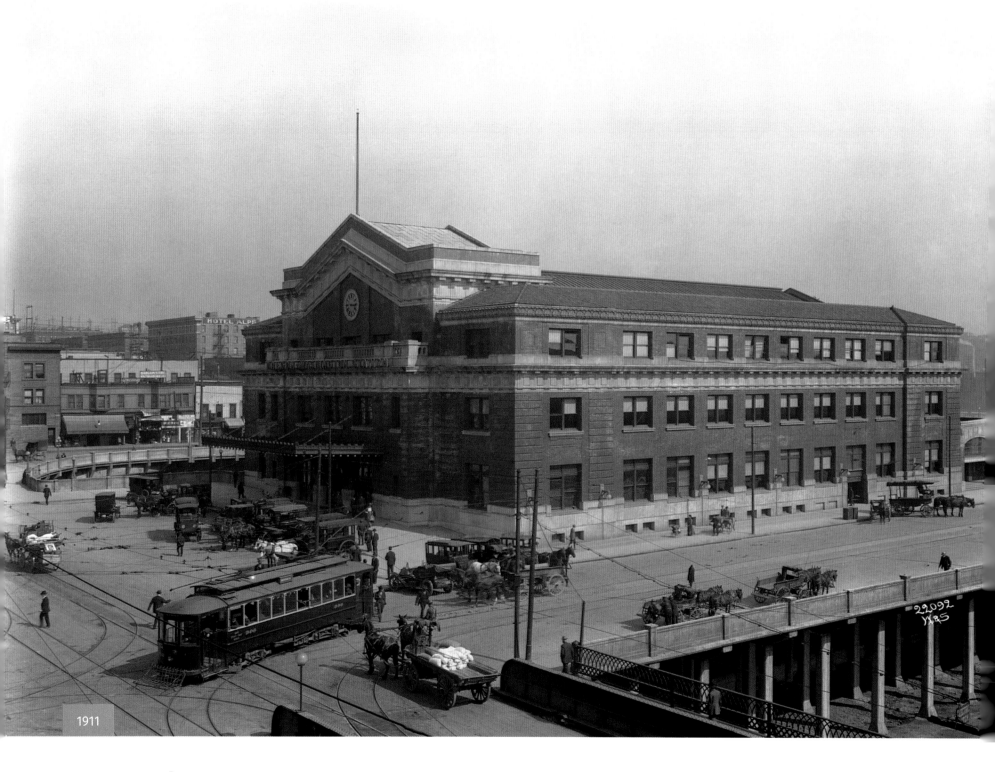

1911

SEATTLE | UNION STATION
Once the "handsomest" station on the Union Pacific Railroad

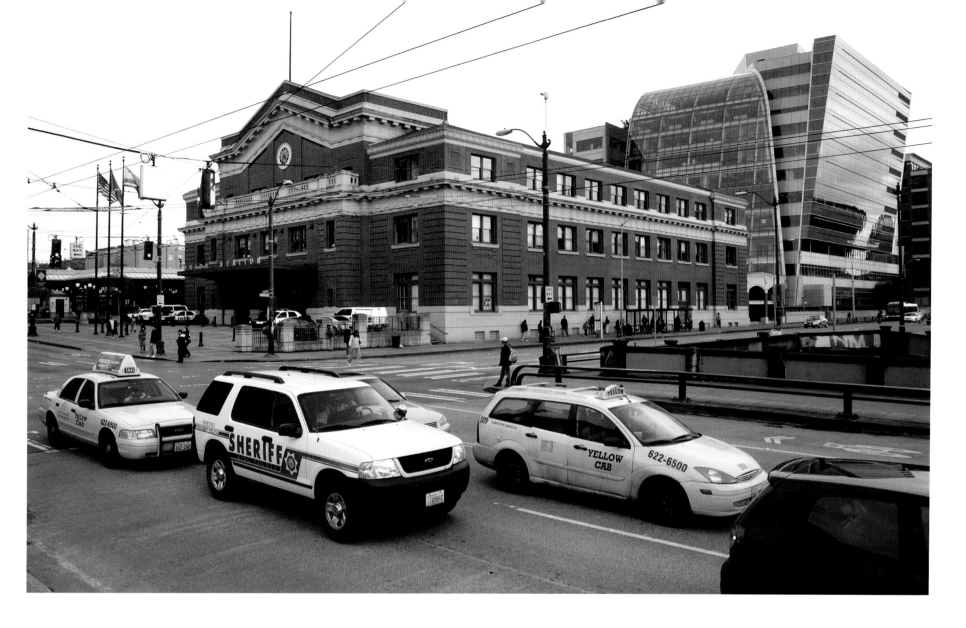

LEFT: The Union Pacific Railroad (UPRR) began construction on the Oregon and Washington Station in January 1910. Designed by Daniel J. Patterson, who also worked on a number of stations for the Southern Pacific, it was named for the Oregon and Washington Railroad, the local subsidiary of the UPRR. The Beaux-Arts building at the corner of South Jackson Street and Fourth Avenue South opened on May 20, 1911. As it also served the Milwaukee Road, it came to be known as Union Station. Union Pacific president Robert S. Lovett called it "the handsomest on Harriman's lines," a reference to E. H. Harriman, UPRR President from 1903 to his death in 1909. In the foreground of this 1911 photo are the shared tracks of the Great Northern and Northern Pacific railways, as well as one of Seattle's then-ubiquitous streetcars. Chinatown and the newly built Alps Hotel are visible in the distance.

ABOVE: Union Station served the Milwaukee Road until 1961, when it discontinued the Olympian Hiawatha. Union Pacific ceased all passenger operations on May 1, 1971, the day Amtrak was founded; subsequent passenger rail service out of Seattle was from the adjacent King Street Station only. Union Station, which was placed on the National Register of Historic Places in 1974, stood vacant for many years. In the late 1990s, the developers Nitze-Stagen and Microsoft cofounder Paul Allen's investment vehicle, Vulcan Inc., purchased the station and railyards from the UPRR, and began renovation and construction. The 505 and 605 Union Station buildings can be seen behind the original structure; the latter for many years housed the offices of Amazon.com. The station itself had originally been considered as a central transit hub for Seattle's new bus tunnel and light rail line. In 1999 it was sold to Sound Transit, the regional transportation authority, and now serves as its headquarters.

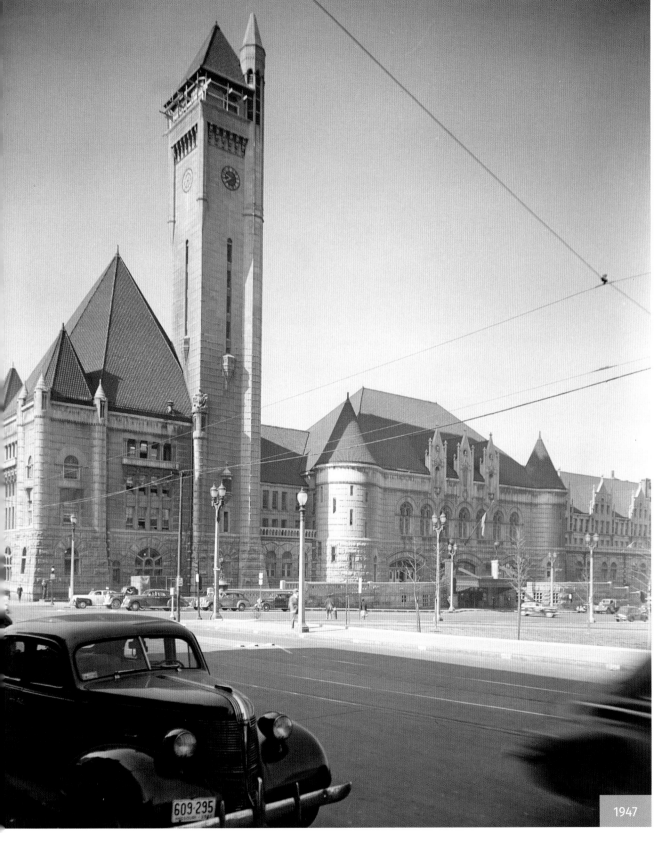

1947

ST. LOUIS | UNION STATION

A Richardsonian Romanesque survivor

LEFT: When completed in 1904 the St. Louis Union Station at Market and Eighteenth Streets was the nation's largest single-level passenger rail station. By the turn of the century it was also one of the busiest. Twenty-one railroads converged at St.Louis, more than at any other point in the United States. Theodore Link, the architect responsible for the Wabash-Pittsburgh terminal, designed the main hall in Richardsonian Romanesque style, with sturdy stonework and massive arches. Behind this Romantic exterior lay a thoroughly modern terminal that could accommodate 260 trains on 41 tracks and handle over 100,000 passengers a day. The yard was covered by George Pegram's elegant metallic train shed, which maximized natural light.

c. 1904

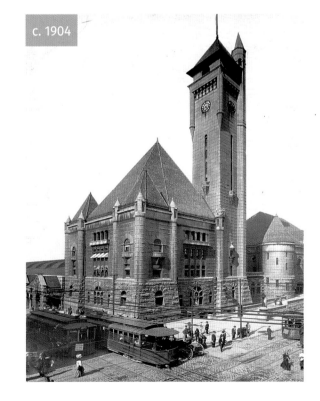

RIGHT: Along with the Eads Bridge over the Mississippi, the Union Station was a signature St. Louis landmark until surpassed by the construction of the Jefferson National Expansion Memorial Arch. Like all railroads, the station suffered in the automobile age. The last train left the station in 1979 and the terminal lay dormant for seven years until the $150 million restoration project by Hellmuth, Obata, and Kassabaum completed in 1985. Today, Union Station bustles once again, a tourist destination and a successful example of adaptive reuse as a "festival marketplace." The luxury station hotel was completely renovated and the terminal converted into shops and eateries.

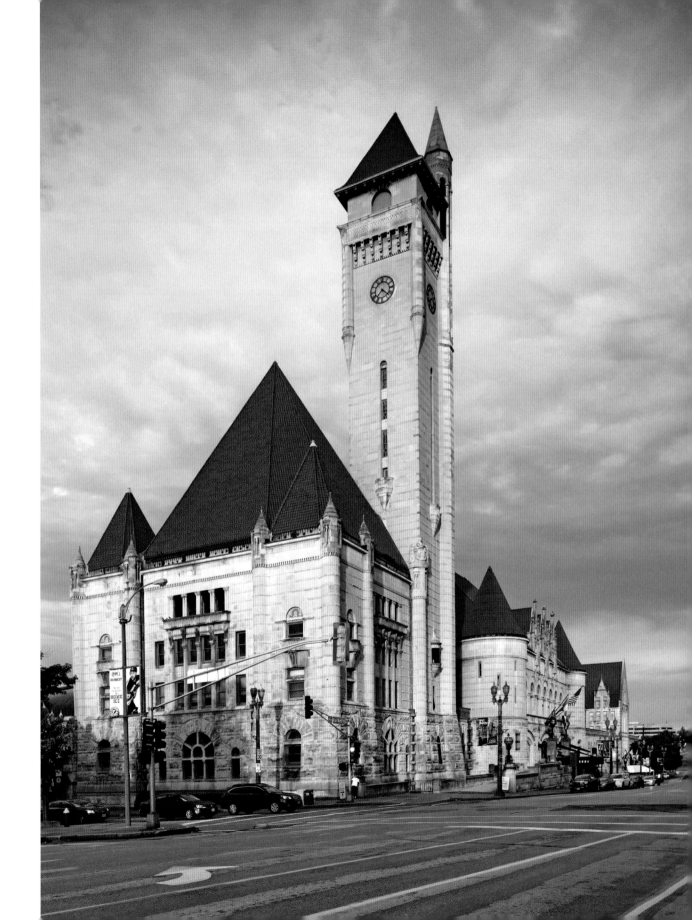

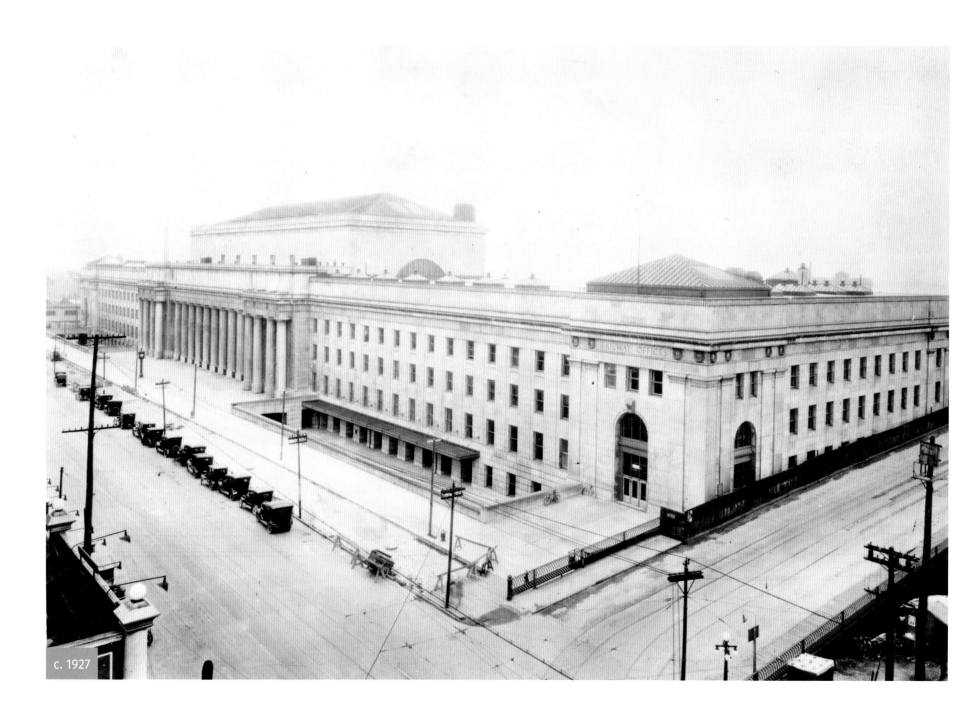

c. 1927

TORONTO | UNION STATION
Opened in 1927 by the Prince of Wales

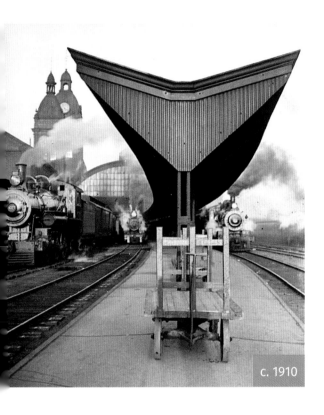

c. 1910

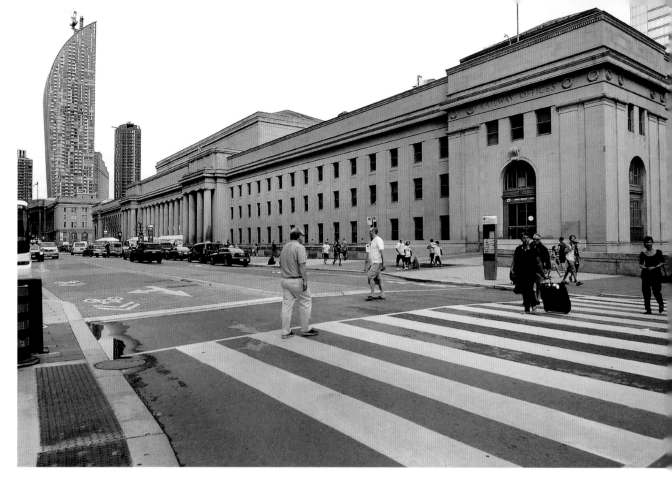

1917

OPPOSITE AND LEFT: Two views of Union Street on Front Street. The photo directly left shows the station under construction in 1917, and the larger photo shows the progress made in ten years. In the early decades of the twentieth century, almost everyone entered or departed Toronto by train. As a result, Union Station was considered the main gateway to the city. Toronto's first train station was a mere shed on Front Street. The second station was east of the shed, between Simcoe and York Streets, and the first to be named Union Station. The third was constructed in 1873, on land that was also between York and Simcoe, but a short distance further west. The Union Station of today was officially opened on August 6, 1927, by the Prince of Wales, who later became King Edward VIII. However, the station was not fully operational until January 1930. During World War II, many Canadian soldiers departed for overseas and returned home through Union Station. The photo above left shows the third Union Station of 1873.

ABOVE: Union Station was designed in the Beaux-Arts style by the architects H. G. Jones and J. M. Lyle. Its monumental facade on Front Street contains 22 enormous pillars, 40 feet in height, weighing 75 tons each. The ceiling of the Great Hall soars 88 feet and is faced with glass-like Guastavino Tiles whose colors match the walls. The floor of the Great Hall and the stairways leading to the exits and entrances are of Tennessee marble. Though originally built as a rail terminal to serve those who traveled between cities throughout Canada and the United States, it is now used by VIA Rail for its commuting passengers, and is the central hub of the ever-expanding GO Transit system. In 2010, massive renovations commenced to improve the services that the station offers, at a cost of half a billion dollars. It was completed July 2015 in time for the Pan Am Games. It is a designated National Historic Site, owned by the City of Toronto.

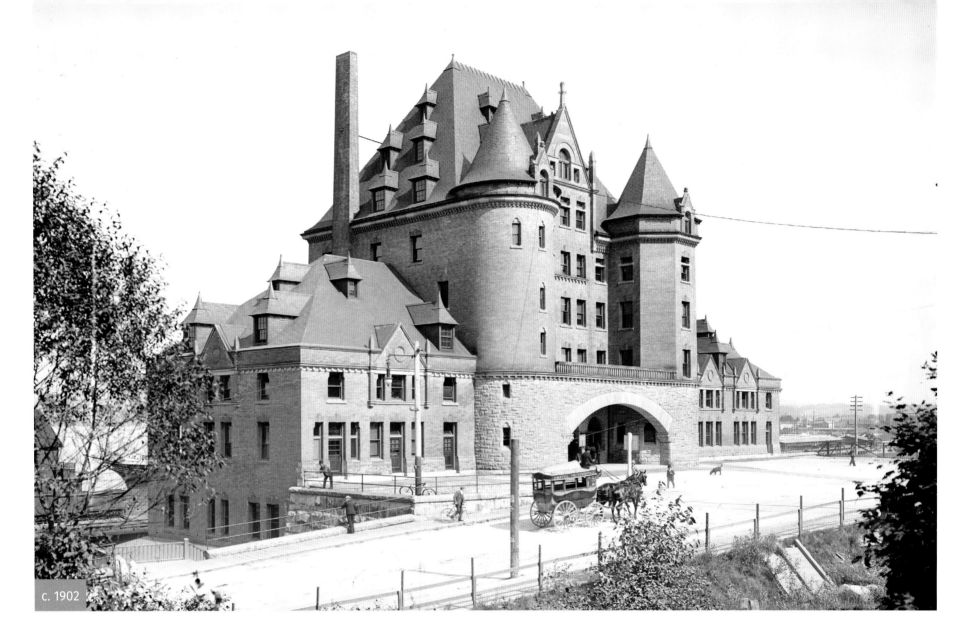

c. 1902

VANCOUVER | CANADIAN PACIFIC/WATERFRONT STATION

Waterfront Station was due for demolition but found a fitting new lease on life

ABOVE: The arrival of the Canadian Pacific Railway at the foot of Granville Street in 1887 guaranteed Vancouver's future. It strengthened the bonds of the new country, and positioned Vancouver as Canada's gateway to the Far East, connecting the transcontinental railway with Pacific ocean liners. This station, the second on this site, was built in the Canadian Chateau style by architect Edward Maxwell,

and operated from 1899 to 1914. The early form of electric lighting required daily replacement of the stick of carbon that provided the incandescent light. The pavement in front was made of wood blocks, the first in Vancouver, with sections of Australian gumwood, spruce, fir, and cedar laid in sections to test which was most durable.

c. 1910

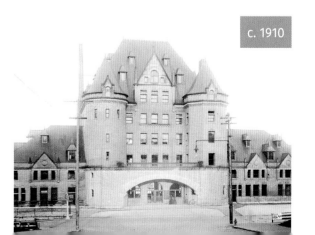

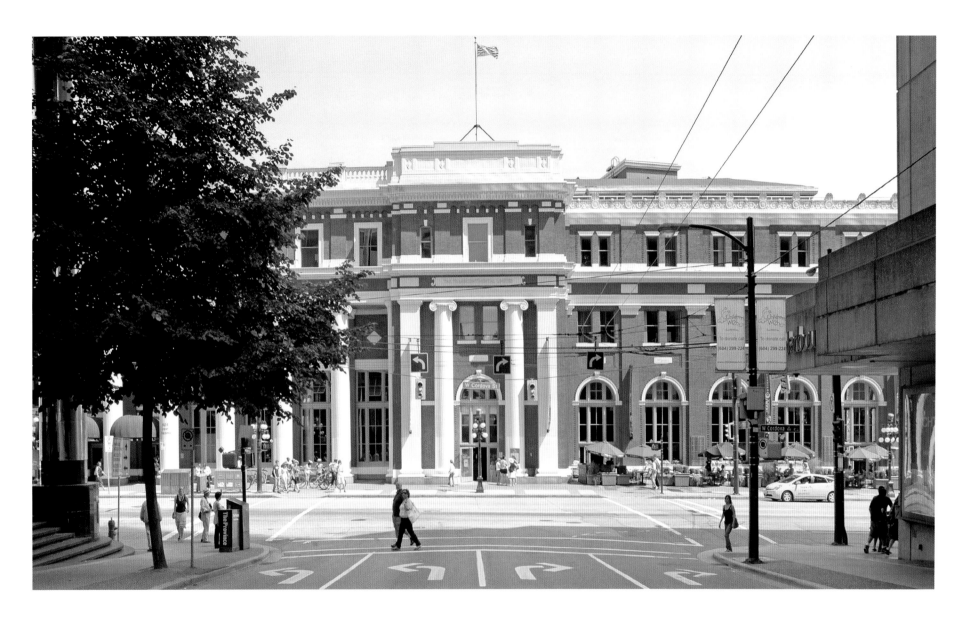

ABOVE: Vancouver's boom in the early years of the century led to construction of a new station, just to the right of the old one, which opened for business August 1, 1914. Designed by the architectural firm Barott, Blackader, and Webster, this $1 million neoclassical brick-and-stone building is wedgeshaped to make maximum use of its irregularly shaped site. Epic murals, 150 feet in length, were painted in the waiting room in 1916. In the 1970s, rail service declined and the impending threat of demolition loomed. Instead it was completely refurbished between 1976 and 1978 for a new career as a transport hub. Commuter rail terminates here, with the 400-passenger catamaran SeaBus to North Vancouver starting service in 1977, and the SkyTrain, Vancouver's rapid transit, beginning service from here on a growing number of lines from 1985. Buses and numerous shops and services are now also supported by this station.

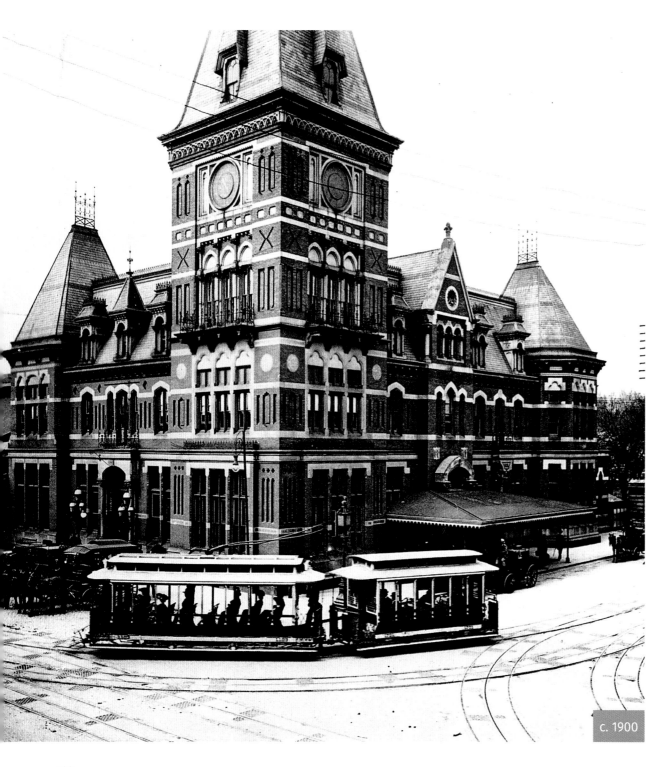

c. 1900

WASHINGTON, D.C. | BALTIMORE AND POTOMAC RAILROAD STATION

From railroad depot to the National Gallery of Art

LEFT AND BELOW: These photos show what was once the transportation hub of Washington, the Baltimore and Potomac Railroad Station at Sixth and B Streets (now Constitution Avenue). Built in 1873 as the Washington terminal for what would become part of the Pennsylvania Railroad's vast network, its departure tracks stretched south across the Mall parallel to Sixth Street. The station received its place in the history books on July 2, 1881, when President James Garfield was shot in a waiting room by Charles Guiteau, a disgruntled and deranged lawyer who had come to Washington seeking a job appointment. Garfield died two months later.

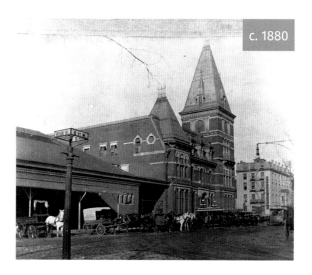

c. 1880

ABOVE: In 1902, through mergers, the Baltimore and Potomac Railroad became the Philadelphia, Baltimore, and Washington Railroad. The PB&W joined forces with the Baltimore and Ohio Railroad, the B&P's chief competitor in Washington, to build a new shared transportation hub, Union Station. It opened in 1907 and rendered the original terminals of both companies surplus to requirements. By 1908 both had been demolished. On the B&P site now stands the West Building of the National Gallery of Art, a branch of the Smithsonian Institution. If the dome and portico of the present building bring the Jefferson Memorial to mind, it is because they were both designed by John Russell Pope. The building was the gift of banker Andrew W. Mellon, who, like Pope, died before its completion, having donated his personal collection of paintings and sculptures to be the basis of the new national collection.

WASHINGTON, D.C. | UNION STATION

Boasting the largest station concourse when it was built

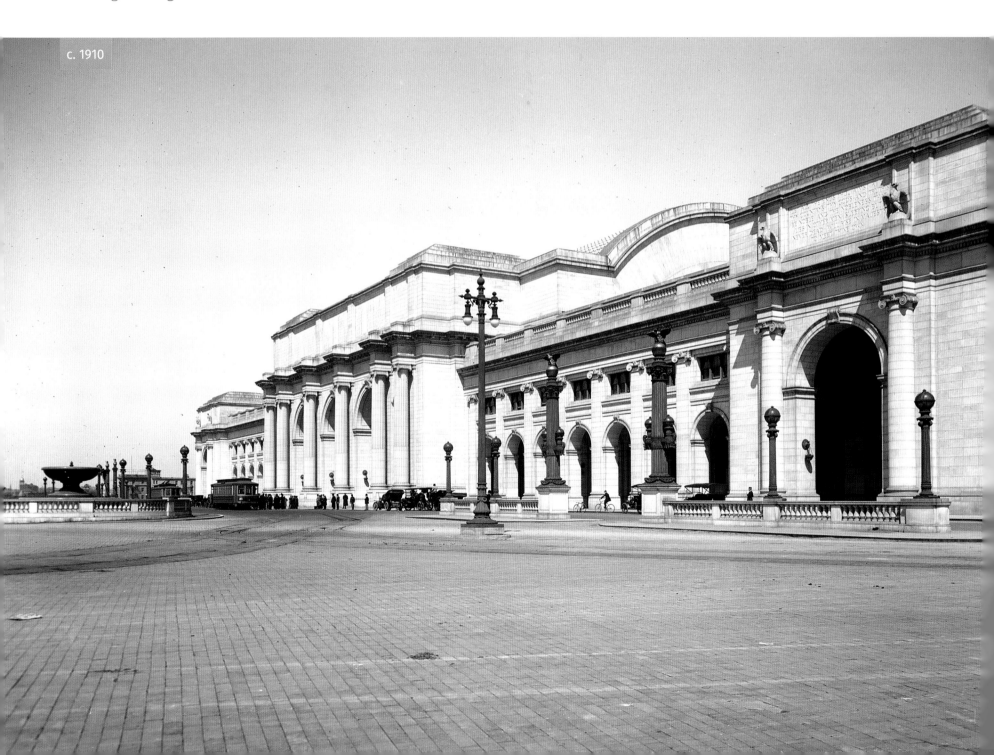

c. 1910

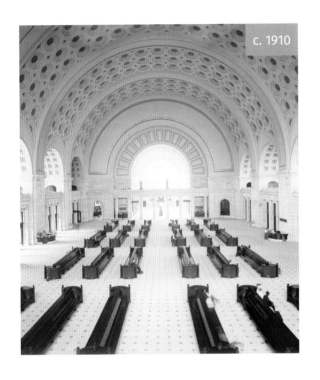

c. 1910

OPPOSITE AND LEFT: Construction of Washington's Union Station began in 1903; it received its first train on October 27, 1907, and was completed the following year. It was the product of cooperation between two rival railroad companies, the Baltimore and Ohio, and the Baltimore and Potomac (by then owned by the Pennsylvania Railroad Company). The new shared terminus, at the junction of Massachusetts and Delaware Avenues, was the result of the expansion of railroad traffic to and from the city. The B&O and B&P stations were simply too small, and the tracks leading to them from the south were preventing the development of the Mall. With a concourse measuring 760 feet by 130 feet (said to be the largest room of any kind in the world when it was built), Union Station is slightly larger than the nearby Capitol Building. It was the first large-scale structure to be built of granite from Bethel, Vermont, because the previous owner of the quarry there had reserved all the stone from it for tombstones—his son had died in a railroad crossing accident.

BELOW: Architect Daniel Burnham based his design on the grand classical entrances of European terminals such as London's Euston Station. Burnham's firm also oversaw the construction of the globe-topped Columbus Fountain in front of Union Station, designed by sculptor Lorado Taft in 1912. Lorado was a cousin of President William Taft, who in 1909 was the first to use the station's palatial Presidential Suite. The sheer scale of the building was justified by the human traffic passing through it—40,000 a day by 1937, and up to 200,000 a day during World War II. But the decline in rail travel after the war saw the building fall into disuse. Although it was designated a potential fallout shelter in 1961, a 1977 survey found it to be in imminent danger of collapse. In the 1980s, the building was turned over to the Federal Department of Transportation and dramatically redeveloped into a combined passenger terminal and commercial retail center, with enormous success.

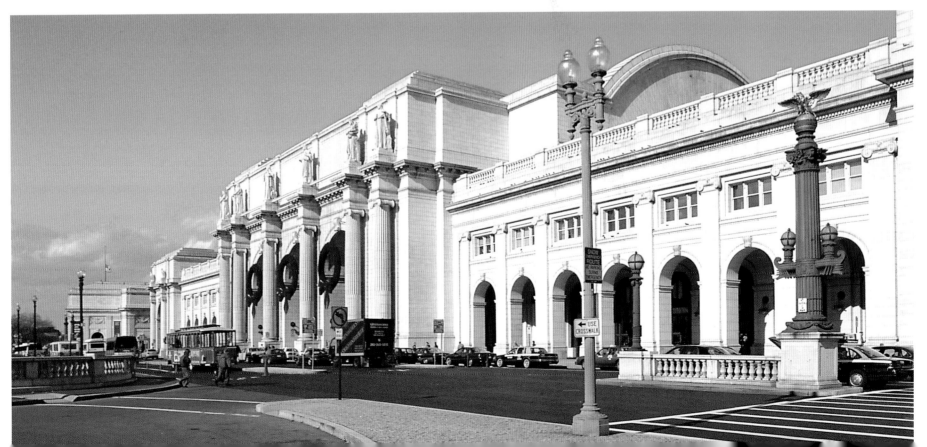

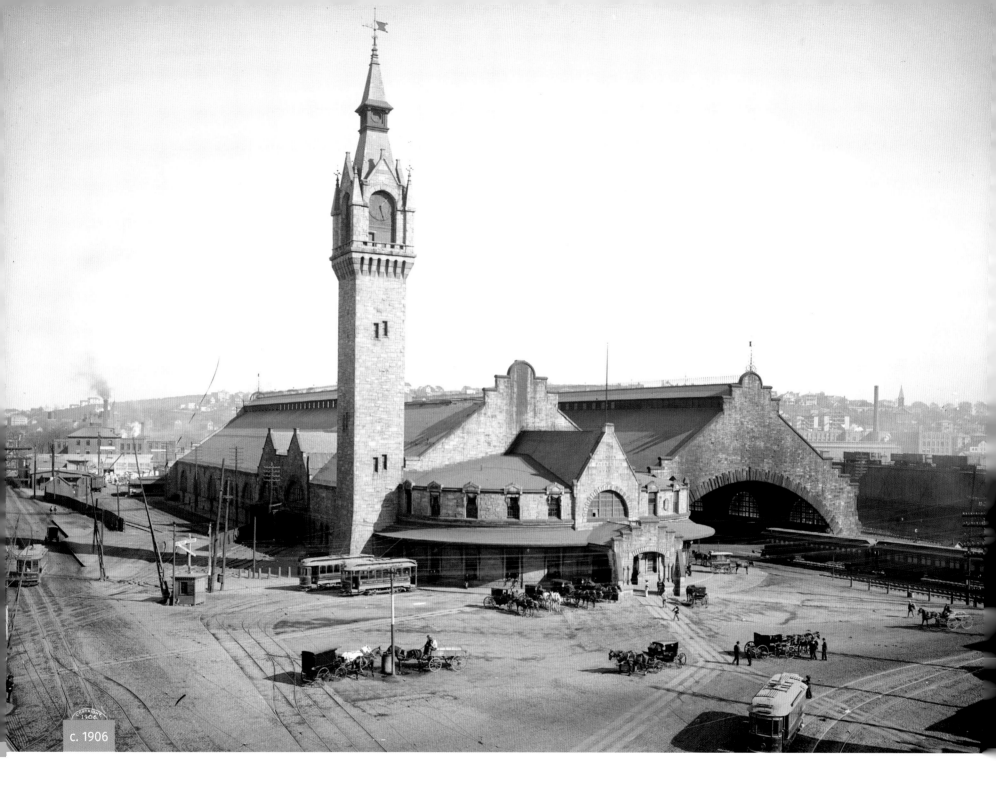

c. 1906

WORCESTER, MA | UNION STATION AND NEW UNION STATION

The magnificent granite clock tower of the 1875 station overlooked its successor

c. 1915

LEFT: The original Union Station in Manchester with its imposing granite clock tower opened in 1875. It served nine railroads including the short local line, the Worcester and Shrewsbury. With the expansion of rail services after the turn of the century it was superseded by a new Union Station to the West of the original site. The old trainsheds were demolished in 1911 and the stone was sold to the Reverend Ekstrom of the Swedish Evangelical Lutheran Church for his building in Belmont Street. Despite the removal of the sheds, the magnificent clock tower lived on. New Union Station (above) was built in the Beaux-Arts style and cost a reputed $1 million dollars. However problems with the foundation of the towers caused by excessive vibration from the locomotives led to structural faults in both towers and they were removed in 1926 on safety grounds (as evidence by the postcard below). Ironically, the much taller granite tower of 50 years earlier had no such weakness.

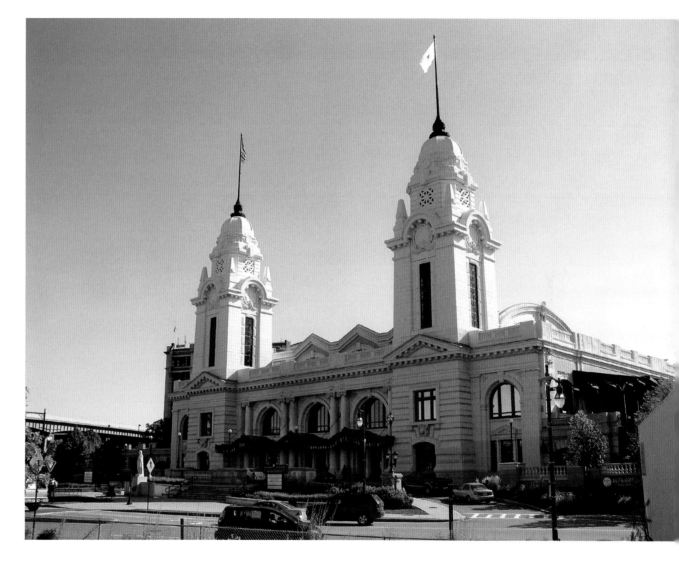

UNION STATION, WORCESTER, MASS.

ABOVE: Like all stations, the Union suffered a post-war decline which saw service discontinued in 1965 and the building close and fall into disrepair. The old granite clock tower of the original station that had overlooked the city for nearly a century finally fell to the wrecking ball in 1959, but not without putting up a fight. Demolition crews failed to contain some of the falling granite blocks which damaged nearby cars and injured watching spectators. The New Union Station of 1911 was subsequently acquired by the Worcester Redevelopment Authority and a $32 million restoration program began in the late 1990s. This included the re-erection of the two towers that had been missing since the 1920s. The renovated station opened in July 2000, and it now includes an intercity and local bus terminal which was added in 2006 at a cost of $5.2 million. There are plans for it to become the northern terminus of the proposed Boston Surface Railroad between Boston and Providence, Rhode Island.

INDEX

Alameda Street (Los Angeles) 69
Albuquerque 8–9
Alvarado Hotel and Station (Albuquerque) 8–9
Arctic Avenue (Atlantic City) 17
Arkansas Avenue (Atlantic City) 17
AT&T Building (Charlotte) 33
Atlanta 10–15, 124
Atlantic Avenue (Atlantic City) 17
Atlantic Avenue (Boston) 28
Atlantic City 16–17
Atlantic City Convention Center (Atlantic City) 17
B Street (San Diego) 123
B Street (Washington, D.C.) 138
Bacon, Ed 105
Balboa Park (San Diego) 122
Baldwin, E. Francis 23
Baltimore 18–25
Baltimore and Potomac Railroad Station (Washington, D.C.) 138–139
Baltimore Sun building 19
Basin Street (New Orleans) 93
Bath Street (Baltimore) 19
Bell Centre (Montreal) 85
Benton Gude, Thomas Hart 63
Birmingham, Alabama 26–27
Borofsky, Jonathan 25
Boston 28–29
Broad Street (Philadelphia) 105
Broad Street Station (Philadelphia) 91, 104–105
Bromo Seltzer Tower (Baltimore) 21
Burnham, Daniel 45, 93, 141
Calhoun Avenue (Memphis) 75
Calvert Station (Baltimore) 18–19
Camden Station (Baltimore) 20–21
Canadian Pacific Station (Vancouver) 136–137
Canal Street (Chicago) 35, 37
Canal Street (New Orleans) 93
Capistrano Depot (Orange County) 100–101
Central of Georgia Passenger Station (Savannah) 124–125, 127
Central Station (Memphis) 75
Charles Street (Baltimore) 24
Charleston 30–31
Charlotte, South Carolina 32–33
Chicago 34–41, 91, 93
Chicago and North Western Depot (Milwaukee) 76–77
Chicago and North Western Terminal (Chicago) 34–35
Chrysler Building (New York) 95
Church Street (Orlando) 103
Church Street Depot (Orlando) 102–103
Clinton Street (Chicago) 35
Columbus 42–45
Columbus Fountain (Washington, D.C.) 141
Columbus Street (Charleston) 31
Commodore Hotel (New York) 94

Concourse Building (Chicago) 39
Congress Square (Portland) 115
Constitution Avenue (Washington, D.C.) 138
Convention Center (Philadelphia) 107
Corput, Max 12
Crawford Street (Houston) 58
Dallas 46–47
Dearborn Street Station (Chicago) 40–41
Delaware Avenue (Washington, D.C.) 141
Denison, Sir Edward 115
Denver 48–51
Denver and Rio Grande Depot (Salt Lake City) 116–117
Detroit 52–53
Eads Bridge (St. Louis) 133
East Bay Street (Charleston) 31
Eidlitz, Cyrus 41
Eighteenth Street (St. Louis) 131
Eisenman, Peter 45
El Tovar Hotel (Grand Canyon) 54
Elliott Bay (Seattle) 129
Enron Field (Houston) 59
Eutaw Street (Baltimore) 21
Federal Reserve Building (Baltimore) 21
First Avenue (Birmingham) 27
Forbes, John 111
Forsyth Street (Atlanta) 15
Forty-second Street (New York) 94
Four Gateway Center (Pittsburgh) 113
Fourth Avenue (Seattle) 131
Fremont Street (Las Vegas) 67
Frisco Bridge (Memphis) 75
Front Street (Toronto) 135
Frost, Charles S. 35
Furness, Frank 105
G. E. Patterson Boulevard (Memphis) 75
Garfield, James 138
Gaughan, Jackie 67
General Passenger Depot (Atlanta) 12
Georgia State Railroad Museum (Savannah) 125
Geppi's Entertainment Museum (Baltimore) 21
Gordon, William Washington 125
Gould, George Jay 113, 117
Grand Canyon Station 54–55
Grand Central Depot (New York) 94
Grand Central Hotel (Baltimore) 19
Grand Central Hotel (Houston) 57
Grand Central Station (Houston) 56–57
Grand Central Station (New York) 58, 94–97
Granger, Alfred H. 35
Granville Street (Vancouver) 136
Greater Columbus Convention

Center (Columbus) 45
Guiteau, Charles 138
Gulf Freeway (Houston) 57
Harriman, E. H. 131
Harvey Curio Museum (Albuquerque) 9
High Street (Columbus) 45
Houston 56–59
Howe, Henry 45
Hunt, Jarvis 46, 62
Hyatt Regency Hotel (Columbus) 45
Illinois Central Station (Memphis) 74–75
Indianapolis 60–61
International and Great Northern Depot (San Antonio) 118–119
Jackson Place (Indianapolis) 60
Jackson Street (Seattle) 131
Jahn, Helmut 35
Jefferson National Expansion Memorial Arch (St. Louis) 133
Jones, H. G. 135
Kansas City 62–63
Kessler, George 46
Kimball, Francis H. 107
Kimball House Hotel 15
King Street Station (Seattle) 128–129, 131
Lagrange, Lucien 39
Las Vegas 64–69
Lincoln Memorial Drive (Milwaukee) 77
Link, Theodore 112, 132
Los Angeles 68–71, 120
Louisville 72–73
Louisville and Nashville Railroad Station (Birmingham) 26–27
Lovett, Robert S. 131
Lyle, J. M. 135
M&T Bank Stadium (Baltimore) 21
Madison Square Garden (New York) 99
Madison Street (Chicago) 35
Main Street (Las Vegas) 67
Main Street (Memphis) 75
Male/Female statue (Baltimore) 25
Maple Street (Louisville) 73
Market Square (Houston) 57
Market Street (Newark) 91
Market Street (Philadelphia) 107
Market Street (St. Louis) 132
Martin Luther King Boulevard (Savannah) 127
Marye, P. Thornton 11
Maryland Institute College of Art (Baltimore) 21
Massachusetts Avenue (Washington, D.C.) 141
Maxwell, Edward 136
McQuarrie, John 57
Mellon, Andrew W. 139
Memorial Stadium (Baltimore) 21
Memphis 74–75
MetLife Building (New York) 95

Michigan Central Station (Detroit) 52–53
Michigan Street (Milwaukee) 79
Milburn, Frank 31, 127
Milwaukee 76–79
Milwaukee Road (Seattle) 131
Milwaukee Road Depot (Minneapolis) 80–81
Minneapolis 80–81
Minute Maid Park (Houston) 59
Mitchell, Alexander 77, 79
Mitchell Building (Milwaukee) 79
Mitchell Street (Atlanta) 11
Mix, Edward Townsend 79
Montfort, Richard 87
Montreal 82–85
Moore, Leon 87
Morris Avenue (Birmingham) 27
Mount Royal Station (Baltimore) 21, 22–23
Mowbray, F. W. 73
Murchison, Kenneth MacKenzie 24
Nashville 86–87
National Gallery of Art (Washington D.C.) 139
National Mall (Washington D.C.) 138, 141
Newark, New Jersey 88–91
New Orleans 92–93, 120
New Union Station (Worcester) 142–143
New York 58, 91, 94–99
Northwestern Station (Chicago) 35
O'Donnell Park (Milwaukee) 77
Ogilvie Transportation Center (Chicago) 35
Old City Hall (Houston) 57
Orange Avenue (Orlando) 103
Orange County, California 100–101
Oregon and Washington Station (Seattle) 131
Oriole Park (Baltimore) 21
Orlando 102–103
Page, Harvey L. 119
Park Avenue (New York) 94
Parkinson, Donald 69
Parkinson, John 69
Patapsco River 21
Patterson, Daniel J. 131
Pegram, George 132
Penn Center (Philadelphia) 105
Penn Station (New York) 91, 95, 98–99
Pennsylvania Station (Baltimore) 25
Pennsylvania Station (Newark) 90–91
Pershing Road (Kansas City) 63
Philadelphia 91, 104–7, 110
Phoenix 108–109
Pine Street (Orlando) 103
Pioneer Square (Seattle) 129
Pittsburgh 93, 110–13
Place Viger (Montreal) 82–83
Pope, John Russell 139

Port Covington 19, 21
Portland, Maine 114–115
Préfontaine, Raymond 83
Price, Bruce 83, 85
Ramsey, Joseph 112
Raymond Plaza (Newark) 91
Reading Railroad Depot (Atlantic City) 16–17
Reading Terminal (Philadelphia) 105, 106–107
Richard B. Russell Federal Building & U.S. Courthouse (Atlanta) 11
Richardson, H. H. 28
Rio Grande Cafe (Salt Lake City) 117
Russell, Richard B. 11
Ruth, Babe 21
Ruth, George Herman Sr. 21
St. Louis 132–133
St. Paul Avenue (Milwaukee) 79
St. Paul Street (Baltimore) 24
Salt Lake City 116–117
San Antonio 118–121
San Diego 122–123
Santa Fe Depot (San Diego) 122–123
Savannah 124–127
Savannah College of Art and Design (Savannah) 125
Seattle 128–131
Seventh Street (Houston) 57
Simcoe Street (Toronto) 135
Sixth Street (Philadelphia) 107
Sixth Street (Washington, D.C.) 138
Smith Tower (Seattle) 129
South Station (Boston) 28–29
Southern Railway Station (Charlotte) 32–33
Southern Railway Station (New Orleans) 92–93
Spring Street (Atlanta) 11
Storyville (New Orleans) 93
Stough, Oliver 123
Suburban Station (Philadelphia) 105
Sullivan, Louis H. 93
Summer Street (Boston) 28
Sunset Depot (San Antonio) 120–121
Sunset Station (San Antonio) 121
Taft, Lorado 141
Taft, William 141
Telfair Road (Savannah) 127
Tenth Street (Louisville) 73
Terminal Station (Atlanta) 10–11
Texas Street (Houston) 58
Third Avenue (Minneapolis) 81
Third Street (Milwaukee) 79
Toledo and Ohio Railway Station (Columbus) 42–43
Toronto 134–135
Train Gulch (Atlanta) 12–13
Twelfth Street (Philadelphia) 107
Twentieth Street (Birmingham) 27
Union Pacific Station (Las Vegas)

66–67
Union Plaza Hotel (Las Vegas) 67
Union Station (Atlanta) 11, 12, 14–15
Union Station (Atlantic City) 17
Union Station (Baltimore) 24–25
Union Station (Charleston) 30–31
Union Station (Chicago) 36–39, 91, 93
Union Station (Columbus) 44–45
Union Station (Dallas) 46–47
Union Station (Denver) 48–51
Union Station (Houston) 58–59
Union Station (Indianapolis) 60–61
Union Station (Kansas City) 62–63
Union Station (Los Angeles) 68–71
Union Station (Louisville) 72–73
Union Station (Milwaukee) 77, 78–79
Union Station (Nashville) 86–87
Union Station (Pittsburgh) 93, 110–111
Union Station (Phoenix) 108–109
Union Station (Pittsburgh) 110–111
Union Station (Portland) 114–115
Union Station (St. Louis) 132–133
Union Station (Savannah) 126–127
Union Station (Seattle) 130–131
Union Station (Toronto) 134–135
Union Station (Washington, D.C.) 91, 93, 139, 140–141
Union Station (Worcester) 142–143
Union Station Plaza (Portland) 115
Van Horne, Sir William 85
Vancouver 136–137
Vanderbilt, Cornelius 94
Vanderbilt, William 97
Villard, Henry 129
Vincent, Edward Arista 12
Wabash-Pittsburgh Terminal 112–113
Warren, Whitney 53, 58, 97
Washington Avenue (Houston) 57
Washington Avenue (Minneapolis) 81
Washington D.C. 91, 93, 138–141
Waterfront Station (Vancouver) 136–137
West Trade Street (Charlotte) 33
Westside Multimodal Transit Center (San Antonio) 119
Wetmore, Charles D. 53, 58, 97
Whitehall Street (Atlanta) 12
Wilson, Francis W. 54
Windsor Hotel (Baltimore) 19
Windsor Station (Montreal) 84–85
Wisconsin Avenue (Milwaukee) 77
Worcester, Massachusetts 142–143
Wright, Frank Lloyd 93
Wynkoop Street (Denver) 49, 51
York Street (Toronto) 135
Zeidler Park (Milwaukee) 79